How Do I
Do That In
Photoshop?

The Quickest Ways to Do the Things
You Want to Do, Right Now!

Scott Kelby

Author of the top-selling digital photography
book ever—*The Digital Photography Book*, part 1

How Do I Do That In Photoshop?

The *How Do I Do That in Photoshop Book* **Team**

MANAGING EDITOR
Kim Doty

COPY EDITOR
Cindy Snyder

ART DIRECTOR
Jessica Maldonado

PHOTOGRAPHY
Scott Kelby

PUBLISHED BY

Rocky Nook

Rocky Nook, Inc.
1010 B Street, Suite 350
San Rafael, CA 94901

Composed in Univers and Avenir (Linotype) by KelbyOne.

Trademarks
All terms mentioned in this book that are known to be trademarks or service marks have been appropriately capitalized. Rocky Nook cannot attest to the accuracy of this information. Use of a term in the book should not be regarded as affecting the validity of any trademark or service mark.

Photoshop and Lightroom are registered trademarks of Adobe Systems Incorporated.

Warning and Disclaimer
This book is designed to provide information about Photoshop. Every effort has been made to make this book as complete and as accurate as possible, but no warranty of fitness is implied.

The information is provided on an as-is basis. The author and Rocky Nook shall have neither the liability nor responsibility to any person or entity with respect to any loss or damages arising from the information contained in this book or from the use of the discs or programs that may accompany it.

THIS PRODUCT IS NOT ENDORSED OR SPONSORED BY ADOBE SYSTEMS INCORPORATED, PUBLISHER OF ADOBE PHOTOSHOP, PHOTOSHOP ELEMENTS, AND PHOTOSHOP LIGHTROOM.

ISBN: 978-1-68198-079-9

10 9 8 7 6 5 4 3 2 1

Printed and bound in the United States of America
This book is printed on acid-free paper
Distributed in the US by Ingram Publisher Services
Distributed in the UK and Europe by Publishers Group UK

Library of Congress Control Number: 2016941042

www.kelbyone.com
www.rockynook.com

*This book is dedicated
to my dear friend, Erik Kuna.
Your wise counsel, support,
and friendship mean more
than you know.*

Acknowledgments

Although only one name appears on the spine of this book, it takes a team of dedicated and talented people to pull a project like this together. I'm not only delighted to be working with them, but I also get the honor and privilege of thanking them here.

To my amazing wife Kalebra: You continue to reinforce what everybody always tells me— I'm the luckiest guy in the world.

To my son Jordan: If there's a dad more proud of his son than I am, I've yet to meet him. You are just a wall of awesome! So proud of the fine young man you've become. #rolltide!

To my beautiful daughter Kira: You are a little clone of your mom, and that's the best compliment I could ever give you.

To my big brother Jeff: Your boundless generosity, kindness, positive attitude, and humility have been an inspiration to me my entire life, and I'm just so honored to be your brother.

To my editor Kim Doty: I feel incredibly fortunate to have you as my editor on these books. In fact, I can't imagine doing them without you. You truly are a joy to work with.

To my book designer Jessica Maldonado: I love the way you design, and all the clever little things you add to everything you do. Our book team struck gold when we found you!

To my dear friend and business partner Jean A. Kendra: Thanks for putting up with me all these years, and for your support for all my crazy ideas. It really means a lot.

To Erik Kuna: For taking the weight of the world on your back, so it didn't crush mine, and for working so hard to make sure we do the right thing, the right way.

To my Executive Assistant Lynn Miller: Thanks for constantly juggling my schedule so I can actually have time to write. I really appreciate all your hard work, wrangling, and patience.

To Ted Waitt, my awesome "Editor for life" at Rocky Nook: Where you go, I will follow. Plus, you owe me dinner at Tony's Napoletana. Maybe two.

To my publisher Scott Cowlin: I'm so delighted I still get to work with you, and thankful for your open mind and vision. Here's to trying new things with old friends.

To my mentors John Graden, Jack Lee, Dave Gales, Judy Farmer, and Douglas Poole: Thank you for your wisdom and whip-cracking—they have helped me immeasurably.

Most importantly, I want to thank God, and His Son Jesus Christ, for leading me to the woman of my dreams, for blessing us with such amazing children, for allowing me to make a living doing something I truly love, for always being there when I need Him, for blessing me with a wonderful, fulfilling, and happy life, and such a warm, loving family to share it with.

About the Author

Scott is Editor, Publisher, and co-founder of *Photoshop User* magazine, and co-host of the influential weekly photography talk show, *The Grid*. He is President of KelbyOne, the online education community for creative people.

Scott is a photographer, designer, and award-winning author of more than 80 books, including *The Adobe Photoshop Book for Digital Photographers*, *Professional Portrait Retouching Techniques for Photographers Using Photoshop*, *The Adobe Photoshop Lightroom Book for Digital Photographers*, *Light It, Shoot It, Retouch It: Learn Step by Step How to Go from Empty Studio to Finished Image*, and *The Digital Photography Book*, parts 1, 2, 3, 4, and 5. The first book in this series, *The Digital Photography Book*, part 1, has become the top-selling book on digital photography in history.

For six years straight, Scott has been honored with the distinction of being the world's #1 best-selling author of photography technique books. His books have been translated into dozens of different languages, including Chinese, Russian, Spanish, Korean, Polish, Taiwanese, French, German, Italian, Japanese, Dutch, Swedish, Turkish, and Portuguese, among others.

Scott is Training Director for the Adobe Photoshop Seminar Tour, and Conference Technical Chair for the Photoshop World Conference. He's featured in a series of online courses (from KelbyOne.com), and has been training photographers and Adobe Photoshop users since 1993.

For more information on Scott, visit:

His daily blog at **scottkelby.com**

Twitter: **@scottkelby**

Instagram: **@scottkelby**

Facebook: **facebook.com/skelby**

Google+: **scottgplus.com**

Table of Contents

Table of Contents

Table of Contents

Table of Contents

Chapter 7 145
How to Adjust Your Image
Tweaking Your Image

Chapter 8 157
How to Fix Problems
And There Will Be Problems. With Your Images. Not with Photoshop. Well, Hopefully

Chapter 9 171
How to Make Beautiful Prints
Here's How It's Done

Table of Contents

Table of Contents

Chapter 12 225
How to Sharpen Your Images
If It's Not Sharp, It's Blurry

Chapter 13 235
Other Stuff You'll Want to Know
All That Other Stuff? It's in This Chapter

If You Skip This One Page, You'll Regret It For...

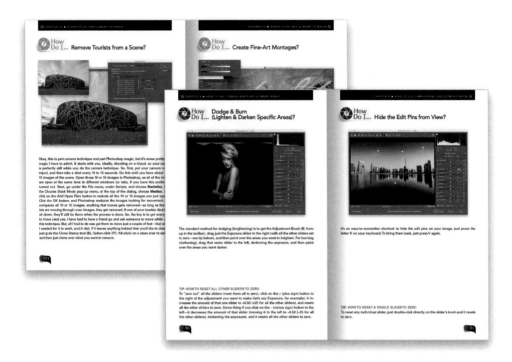

(1) Okay, it's possible that I exaggerated a bit in that headline...as a ruse to get you to read this quick intro, but only because it's for your own good. Well, technically it's for both our goods (goods?), because if you skip this, you might not totally grock (grock?) how this book was designed to be used, which is different than most other books for a number of reasons, the first being most other books don't try to trick you into reading the intro. But, in this case, I had to do it (and I feel semi-bad about it, sort of, kinda, in a way), because (a) I want you to get the most out of this book (another selfish author only wanting for himself), and (b) you want you to get the most out of it (you paid for it, or at the very least, shoplifted it), so it's for both our goods (thankfully, my editor doesn't require me to use real words). Anyway, in short, here's how to use this book:

Don't read it in order. It's not that kind of book. This is more like an "I'm stuck. I need help right now" book, so when you're working in Photoshop and need to know how to do a particular thing right this very minute, you just pick it up, turn to the chapter where it would be (Layers, Problems, Special Effects, etc.), find the thing you need to do, and I tell you exactly how to do it, pretty succinctly ($5 word—bonus points!), and you're off and running back in Photoshop. If I did my job right, you should only be in this book for like a minute at a time—just long enough to learn that one important thing you need now, and then you're back to lounging on your yacht (at least, that's how I imagine your life will roll after buying this book).

Same Thing Over Here. Regret (or Worse). Ack!

(2) There's something in here that, depending on your general disposition, might make you mad. Well, maddish. This is my second book with the awesome folks at Rocky Nook, so I might be reaching a new audience (perhaps this is the first book of mine you've purchased, but I hope that's not the case because my son is going to an out-of-state college, and it's crazy expensive, so it'd really help with his tuition if you bought, I dunno, at least six or 22 of my previous books). Anyway, I do this thing that either delights readers or makes them spontaneously burst into flames of anger, but it has been a tradition, so now it's a "thing" I can't get out of: how I write the chapter intros. In a normal book, they would give you some insight into what's coming in the chapter. But, mine…um…well, they don't. Honestly, they have little, if anything, to do with what's in the chapter, as I've designed them to simply be a "mental break" between chapters, and these quirky, rambling intros have become a trademark of mine. Luckily, I've relegated the "crazy stuff" to just those intro pages—the rest of the book is pretty regular, with me telling you how to do things just like I would tell a friend sitting beside me. But, I had to warn you about these, just in case you're a Mr. Grumpypants and all serious. If that sounds like you, I'm begging you, please skip the chapter intros—they'll just get on your nerves, and then you'll write me a letter to tell me how the book was "unreadable" because of those few pages, and you'll mention my mother, my upbringing, etc. So, read them at your own risk. Okay, that's pretty much it. You're now fully certified and cross-checked (flight attendant lingo) to use this book and I really hope you find it helpful in your Photoshop journey.

How to Get Around Like a Pro

Photoshop's Interface

I think it's only fair that I warn you once again about a long-standing tradition of mine, and that is to write chapter intros that have little or nothing to do with what's actually in the chapter. I want you to think of these as a "mental break" between chapters and not something that actually adds any value to the book, or to your life, whatsoever. That being said, I am breaking with another one of my long-standing chapter opener traditions and that is to name the chapter after a song, TV show, or movie, which is something I've done in nearly all my books. So, for example, in one of my previous Photoshop books, I had a chapter on editing video in Photoshop, and I named the chapter "Video Killed the Radio Star," after the 1979 hit song by the Buggles (which, in case you have an interest in music history, was the first video aired when MTV debuted in August of 1981, but here's an even lesser known piece of music trivia: Did you know that the original video they planned to air was actually "Rush Rush" by Paula Abdul? But, the executives at the network felt that with Paula being a judge on *American Idol*, there might be a conflict of interest. As it turned out, they went with the Buggles song, which was a good call since Paula Abdul's "Rush Rush" wasn't recorded until June of 1991, nine years after MTV debuted, not to mention the fact that *American Idol* didn't air until 2002, which I have to admit has me frankly a bit concerned about how far you would go in a high-stakes game of music trivia. Look, if we're going to do this thing together, you're going to have to tighten up your music trivia quite a bit because I'm not going to sit in the audience and watch you go down in flames when they ask, who did the song "Smells Like Teen Spirit" and you guess "Taylor Swift?" Now, if you're wondering what any of this has to do with navigating your way around Photoshop, it's important that you re-read the first sentence in this opener, and you will instantly receive total consciousness.

How Do I... Open Panels?

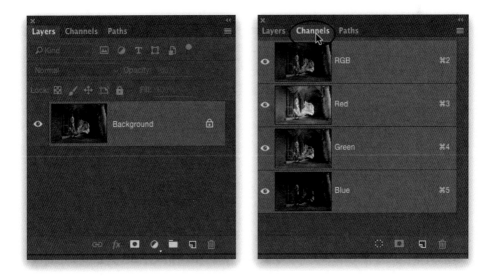

Many of Photoshop's features are found within the panels (they're kind of like palettes that pop out from the side of the screen), and the most-often-used panels are already visible onscreen by default (like the Color panel, the Swatches panel, the Libraries panel, the Layers panel, and so on) and appear on the far right of the window. There's also a thin horizontal panel across the top of the window called the Options Bar (when you're using one of Photoshop's tools, it shows all the options for that tool here). To keep your screen from being totally cluttered with panels, some panels are nested behind other panels, so all you see is a small tab sticking up with the name of the panel (see above left, where you see the Layers panel, and to the right of its tab you see two other tabs for panels that are nested with it—the Channels panel and the Paths panel). To see one of these nested panels, just click on its tab, and the full panel appears (see above right, where I clicked on the Channels tab, and now you see the Channels panel). Of course, there are a lot more panels than what you see onscreen at first. To open any closed panel (there are around 30 in all), go under the Window menu (at the top of the screen), and you'll see all of them. Choose one and it opens onscreen, alongside the existing panels that are already open.

TIP: HOW TO MAKE PANELS "FLOAT"

If you want a particular panel to be detached from the rest, so it "floats" on its own, just click-and-drag a panel tab away from the rest of the panels and it "floats."

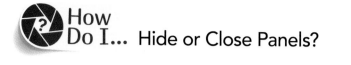

How Do I... Hide or Close Panels?

Open *Collapsed* *Icons Only*

You don't have to work with all your panels open all the time. You can collapse them down to just their icons and names, like you see above center (just click on the two little right-facing arrows in the top right of a panel, shown circled in red above left), or collapse them even further, so only their icons are showing (once you've collapsed them, click on the left edge of the panel group and drag to the right until just the icons are showing, as seen above right). Collapsing these panels gives you a larger working area for your images, but your panels are still just one click away (click on any icon and that one panel pops out to full size). If you want to expand all the collapsed panels as a group (like you see above left), click on the two little left-facing arrows in the top right of the panel header. If you actually want to close a panel (not just collapse it; you want it off-screen altogether), click on the panel's tab and drag it away from the panels it's nested with (this makes it a floating panel), and now an "x" appears in the top-left corner of the panel. Click on that to close it. To reopen it, go under the Window menu and choose it.

How
Do I... Create a New Document?

Go under the File menu and choose **New** to bring up the New dialog. This is where you choose the size and resolution of your new document—just type in the Width and Height you want, along with the Resolution (in this case, I choose 240 Pixels/Inch for printing to an inkjet printer). You can also choose the color you want for your background (in case you don't want it to be white), and a color profile, if you like. At the top of the dialog is the Document Type pop-up menu, which contains presets with common image sizes and resolutions already in place—you can choose web presets, print presets, video presets, and so on. If you have a particular custom size you use (like maybe for printing on 13x19" paper), you can save that as your own custom preset. Just enter the size and resolution you want (again, I use 240 ppi for inkjet printing), and click the Save Preset button at the top right. Name your preset and now it will appear in the Document Type pop-up menu for next time.

How Do I... See More Than One Image at a Time?

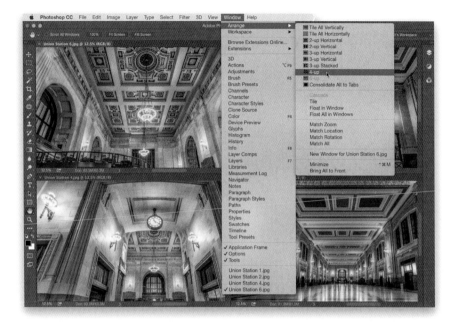

When you open multiple images, they open kind of like panels do—you see the active image in front, and then little tabs (in the top of the image window) for the other open images behind it (if you have this tabbed viewing set in your Preferences). If you want to see all the images onscreen at the same time, go under the Window menu, under **Arrange**. At the top of the menu are a bunch of choices for how you can display them: show them all in thin vertical tiles or horizontal tiles, or display two, three, four, or six images equally (like the four images I have onscreen here. When I choose 4-Up, it instantly resizes the image windows, so all four open images fit onscreen. You'll see that I also have Application Frame turned on, here, in the Window menu [on a Mac]). If you look a little further down in the Arrange menu, you'll see some controls for making all those image windows open on-screen work together—what you do to an image window you click on, happens in all the other windows. For example, if you click on an image window and zoom in on that photo, then choose Match Zoom, the other three open images all zoom in the exact same way.

How Do I... Organize All These Panels?

Here's how they look when docked

Nesting tabs (note the blue outline)

Docking to the bottom (note the solid blue line)

When you choose to add a panel to what you see onscreen, in most cases, it just appears onscreen next to the ones you already have open. In many cases, they attach to the left edge of your already open panels, and they start to cover more and more of your image area. I personally prefer to keep all my panels in groups over on the right side of the window, so I have as much room for my images as possible. If you like keeping things tidy like this, there are two things you can do: (1) You can group (nest) panels together by clicking on a panel's tab and dragging it onto another panel's tab. As you're dragging over onto the other panel you want to nest it with, you'll see a blue stroke appear around the group of panels (as seen above left). Once you see that, just release your mouse button and it joins that group. So, you're pretty much dragging tabs together to form a group. Easy enough. (2) You can also attach panels directly below any open panel, pretty much the same way. But, in this case, you'll drag the tab to the bottom of a panel. When it's about to "dock," you'll see a solid blue line appear along the bottom of the panels you're about to dock with (as seen above center). Now, just release the mouse button and it attaches to the bottom of the existing panels to form a vertical group (as seen above right).

How Do I... Use Guides?

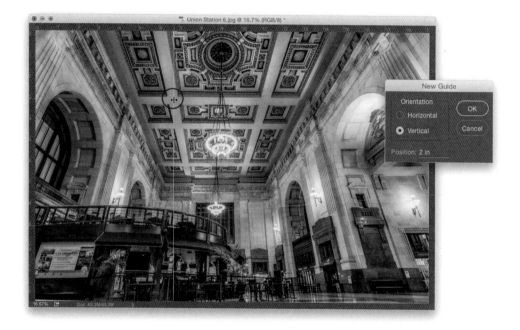

Anytime you need to line things up, you can drag out horizontal or vertical guides over your image. To get to these guides, first you have to make Photoshop's Rulers visible (press **Command-R [PC: Ctrl-R]**), then click-and-hold directly on the top or left-side ruler and drag out a guide, positioning it right where you want it. You can reposition them using the Move tool (**V**; when you move your cursor over a guide, it will change into a double-headed arrow with two lines in the middle [seen circled above]. That's your cue that it's ready to move). If you want to add a guide based on a measurement (for ex-ample, you know you want a vertical guide added 2" into your image or 35 pixels into it, etc.), you can have Photoshop place it exactly at that position for you: Go under the View menu and choose **New Guide**. In the dialog (seen in the inset above), enter the measurement you want (enter the number, then a space, then "in" for inches, or "px" for pixels, etc.), click OK, and it places it precisely for you. To delete a guide you don't want anymore, just drag it back to the ruler where it came from. To delete all your guides at once, go up under the View menu and choose **Clear Guides**.

How Do I... Change the Color Outside My Image Area?

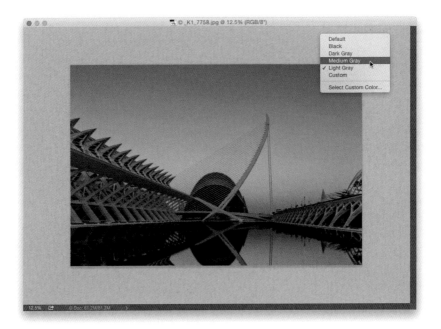

If you want to change the color of the workspace background outside your image, just Right-click anywhere outside your image (if you're using Application Frame with tabbed documents, you may need to shrink your image view a bit [zoom out]; if not, click-and-drag out your image window, so you can see the canvas area), and a pop-up menu will appear with choices. Choose the one you want and you're good to go.

How Do I... Change the Color of Photoshop's Interface?

Go under the Photoshop CC (PC: Edit) menu, under Preferences, and choose **Interface**. When the Preferences dialog opens, in the Appearance section, choose a new interface color from the Color Theme color swatches. You don't really get to choose a new color here, you're just changing the lightness of the default gray color.

How Do I... See My Image at Full-Screen Size?

©DOLLARPHOTOCLUB/DMITRY LOBANOV

Press the letter **F** on your keyboard twice. The first time you press it, it just hides the window that surrounds your image. But, the second time, it hides everything and displays your image full-screen size. Now, for some reason, one thing it doesn't hide in Full Screen mode is Photoshop's Rulers. So, if you have them visible, once you're in Full Screen mode, press **Command-R (PC: Ctrl-R)** to hide them. To return to the regular size view (and see the rest of Photoshop), just press F again.

How Do I... Make Those Pop-Up Tool Tips Go Away?

Go under the Photoshop CC (PC: Edit) menu, under Preferences, and choose **Tools**. When the Preferences dialog opens, in the Options section, turn off the Show Tool Tips checkbox (as shown here). You owe me for this one. ;-)

How Do I... Make the Rulers Visible?

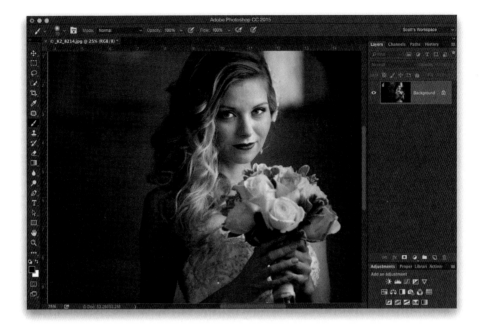

Just press **Command-R (PC: Ctrl-R)** and rulers appear across the top and left side of your image window. That's it.

ADVANCED TIP: CHANGE STARTING MEASUREMENT

If, for some reason, you don't want the top-left corner of the image to be measured starting at the 0x0" point, you can click-and-hold directly in the top-left corner of the image window (not in the image, in the window—right where the vertical and horizontal rulers meet), and drag the starting point to a new location (for example, if you want to start measuring 2" into your image, you could drag the axis of those two rulers to that point and it starts measuring from there). Again, this is an advanced tip for you advanced folks who are advanced, and since you're advanced, all of that made sense. Hope that advances your advanced Photoshop skills.

How Do I... Have Objects Snap to the Rulers or a Grid?

When you're lining things up using a guide, you can have Photoshop take anything you're dragging (like an image, or type, or a shape, etc.), and have it automatically snap to that guide when you get near it. It helps to make things perfectly line up without you having to "eye it"—moving it back and forth a pixel or two at a time to get it to line up. To turn this feature on, go under the View menu, and choose **Snap**. Then, go under the View menu, again, under Snap To, and you'll see a list of things you can snap to. Choose **Guides** to turn on guide snapping. Now, when you drag something near a guide (like the text above), it will snap right to it (you'll feel it "tug" the text or image kind of like a magnet). You can also snap to other things. For example, if you turn on the grid (under the View menu, under Show), then turn on Snap To Grid, as you drag, your object will snap to the grid of squares to help you line things up. If you want to have things snap to the edges of your image window, choose Document Bounds. Also, you can toggle this Snap feature on/off using the keyboard shortcut **Command-Shift-; (PC: Ctrl-Shift-;).**

How Do I... Use Guides to Create a Layout?

If you want to get all fancy, and have Photoshop build a guide layout for your entire image (for example, you want a vertical guide every three inches across your entire image, and a horizontal guide across the center), go under the View menu and choose **New Guide Layout**. In the dialog that appears (seen above), enter the exact number of columns and rows you want. In this case, I wanted six columns and two rows (it actually adds two guides for each instance, with a small gutter [space] between them). To change the amount of space between each of these double-guides, lower or raise the amount in the Gutter fields. If you want just one guide, enter 0 for your gutter.

How Do I... Save How I've Set Up All My Panels?

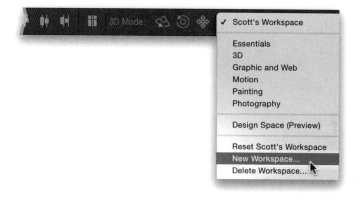

Once you have all the panels you want open, and organized the way you want them (by the way, you can click-and-drag the Toolbox from the left side of the window [grab it right at the top] and have it either float or dock it with the panels on the right side. You can also click-and-drag the Options Bar from the top of the window and position it at the bottom, if you want), you can save this layout (Photoshop calls this custom layout a workspace) by going to the right end of the Options Bar and clicking on the pop-up menu of workspaces (it probably says "Essentials," but it could say something else if you've already played around with workspaces). From that pop-up menu, choose **New Workspace** (as shown above), and it brings up a dialog where you can name and then save your layout (you can have multiple workspaces saved as presets, so you can set up one for retouching, one for doing illustration, one for image editing, etc.). Now, to get that exact layout back anytime, just choose it from that same pop-up menu. Also, when you bring up your workspace, you can still make changes on the fly (like changing the location of a panel, or making a panel float). If at any time you want to get back to your saved workspace, just choose Reset from that same pop-up menu (I named my workspace, "Scott's Workspace" [I know. Real original], and that's why you see "Reset Scott's Workspace" in that pop-up menu), and it resets your workspace. Of course, it's unlikely yours will say "Scott's Workspace," but you knew that, right? ;-)

How Do I... Hide Guides and Things from View?

There's a handy shortcut that pretty much hides everything and gives you a clean, unobstructed view of your image: it's **Command-H (PC: Ctrl-H)**. It's easy to remember—H for hide. *Note:* If you're a Mac user, the first time you press Command-H, a dialog pops up (seen in the overlay above) and asks you if you want this shortcut to hide extras in Photoshop or do you want it to hide Photoshop altogether (because Command-H is a global Mac OS standard shortcut for hiding the current application from view). I went ahead and clicked Hide Extras to switch it, so Command-H hides my guides and stuff in Photoshop, but of course, the one you choose (the red pill or the blue pill) is entirely up to you and your workflow. Again, this only affects Mac folks, so if you're a Windows user, your keyboard shortcut is just plain ol' uncomplicated Ctrl-H.

How Do I... Move Around When I'm Zoomed In?

Press-and-hold the **Spacebar** and you temporarily switch to the Hand tool. Now you can just click-and-drag right where you want. This is so much faster than using the scrollbars, which work fine when you're zoomed out, but stink when you're zoomed in tight—they're a nightmare (well, that might be a bit of an exaggeration, but only a bit). When you're done moving, release the Spacebar and you return to your last-used tool.

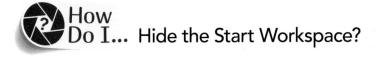

How
Do I... Hide the Start Workspace?

If you're using Application Frame (under the Window menu on a Mac) and want to hide the Start workspace that appears when you launch Photoshop or when you don't have anything open, go under the Photoshop CC (PC: Edit) menu, under Preferences, and choose **General**. When the Preferences dialog opens, in the Options section, turn off the Show "Start" Workspace When No Documents Are Open checkbox (as shown above). You can also turn off the Recent Files workspace here, as well, by turning off the checkbox below.

How Do I... Get My Image to Fit Fully on the Screen?

My favorite way is to just double-click on the Hand tool in the Toolbox, but you can also press **Command-0** (zero; **PC: Ctrl-0**), if you prefer to use a keyboard shortcut. Also, if you switch to the Hand tool (the shortcut is the letter **H**), you'll see three buttons up in the Options Bar for zooming the overall image: (1) 100%, (2) Fit Screen, and (3) Fill Screen. You could go under the View menu, as well, and choose the size you want manually, but...don't waste time digging around in menus, just use one of the first two methods.

How Do I... See My Image at a Full 100% Size?

If you double-click on the Zoom tool (its icon looks like a magnifying glass) in the Toolbox, your image zooms to a 100% actual size view. You can also press **Command-1 (PC: Ctrl-1)** to get that same 100% view, or press **Z** to get the Zoom tool and then click on the 100% button up in the Options Bar, but that's a lot slower than just double-clicking on the Zoom tool in the first place.

How Do I... Hide All the Panels?

Hit the **Tab key**, and it hides all the panels, including the Options Bar up top and the Toolbox, as well. If you just want to hide the panels on the right side (or shall I say, "everything but the Toolbox and Options Bar"), then press **Shift-Tab**. You only have to press the Tab key again, in either case, to bring back the hidden panels.

How Do I... Have Hidden Panels Automatically Pop Out?

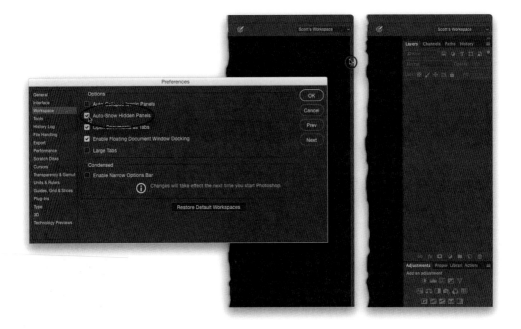

Go under the Photoshop CC (PC: Edit) menu, under Preferences, and choose **Workspace**. When the Preferences dialog opens, in the Options section, turn on the Auto-Show Hidden Panels checkbox (as shown above left). Now when you move your cursor to the far-right edge of the screen where the panels are hidden (above center), the hidden panels pop out (above right).

How Do I... Zoom In and Out of My Image?

There are a bunch of ways to do this, but I'll start with my two favorites: To quickly zoom in/out without changing tools, press **Command-+** (plus sign; **PC: Ctrl-+**) to zoom in and **Command--** (minus sign; **PC: Ctrl--**) to zoom out. Another popular way is to switch to the Zoom tool (its icon looks like a magnifying glass, but you can just press the letter **Z** to get it), then just either click (to instantly zoom in) or click-and-hold (for more of a cinematic zoom) on the spot where you want to zoom in (like I did above), and it zooms in to that area. To zoom back out, press-and-hold the **Option (PC: Alt) key** and do the same thing (click or click-and-hold), and it zooms back out. As I mentioned earlier in this chapter, you can zoom in to a 100% actual size view by double-clicking on the Zoom tool itself right in the Toolbox.

How to Use Photoshop's Tools

Toolbox Tips

When you first look at Photoshop's Toolbox, it's just that skinny little bar along the left side of the window, and you think, "That doesn't look too hard to learn," until you realize that there are actually 64 tools in all because many are hidden behind other tools. The phrase Adobe uses to describe any tool that is hidden behind another tool is an "Atelier Cloister Element," or ACE for short. That's why you may have read some photographers bragging online about being an "Adobe ACE," which just means they have passed an in-depth online test (with a minimum score of 82 or higher) based on properly identifying each of the Atelier Cloister Element tools when only displayed onscreen for a fraction of a second, with the tool's icon lightly tattooed on the side of a bat-eared fox, as it moves through its natural habitat (this is harder to do than it sounds, which is why Adobe ACEs tend to brag about passing the test). In the Photoshop community, passing the ACE test is akin to landing an F/A-18 on the deck of a moving carrier, so it's a pretty big deal if you score an 82 or higher. I don't mind telling you, I've been at this a while and I only scored an 84, so I can confirm first-hand, it's a pretty challenging test. But, at least when you're done with this chapter, you'll already be able to score in the 36 to 37 range, but that's because as photographers: (a) we don't need to use all 64 tools, (b) most of the tools are for designers anyway, and (c) photographers as a group are somewhat gullible, because I made this whole "Atelier Cloister Element" thing up. Totally. Now, I would feel bad if you had fallen for it, but since you didn't (and you were snickering right along with me the whole time), I think we're all good, right? No harm, no foul, right? Hello? Anybody there?

How Do I... See Just the Tools I Actually Use?

Although you see a whole bunch of tools in Photoshop's Toolbox, along the left side of the window, you probably only use a few of them. Luckily, you can hide all those that you don't use and have a smaller, less-cluttered Toolbox. Here's how: Go under the Edit menu and choose **Toolbar** (near the very bottom of the menu) to bring up the Customize Toolbar dialog (seen above). You'll see two columns: the left side lists all the tools in Photoshop, and when you see a tool you're not going to use, drag-and-drop it over to the column on the right, and it's hidden. When you're finished, click Done, and now you've got a smaller, cleaner Toolbox with just the tools you actually use.

TIP: USE SINGLE-KEY TOOL SHORTCUTS
You can select most tools in Photoshop's Toolbox using a single key on your keyboard, and some of them actually make sense. For example, press **B** to get the Brush tool, or **C** to get the Crop tool, or **T** for the Horizontal Type tool, or **P** for the Pen tool. But then, of course, there's **J** to get the Healing Brush tool, or **O** to get the Burn tool, so don't get used to it making sense. Anyway, to find out any tool's one-key shortcut, just click-and-hold on it in the Toolbox, and when its flyout menu pops out, it will list the shortcut. If there are multiple tools that use the same shortcut (like T for all four Type tools), then just add the Shift key (so, it's Shift-T) to toggle through the different tools associated with it.

How Do I... Select Square or Rectangular Areas of My Image?

If you want to edit just a particular part of your image (rather than editing the entire image), make a selection of the area where you want to work, and then any changes you make will only affect that selected area. There are lots of different selection tools in Photoshop for helping you make precise selections and one of the most popular is the Rectangular Selection tool (it's actually called the Rectangular Marquee tool because it adds a selection that looks like a Hollywood marquee with flashing lines running around it). To use it, choose it from the Toolbox (as seen above; or just press **M**) and click-and-drag it out over the area you want to select. By default, it draws a rectangle, but if you want a perfect square instead, press-and-hold the Shift key and it constrains the selection to a perfect square. To reposition your selection once you've drawn it, just click the same tool anywhere inside that flashing marquee area and drag it to a new location. To move what's inside that rectangle (or square), picking up a chunk of your image and moving it, switch to the Move tool (**V**; the first tool at the top of the Toolbox), click inside that flashing marquee area, and drag it. To remove your selection (called "deselecting"), press **Command-D (PC: Ctrl-D)**.

How Do I... Make a Free-Form Selection?

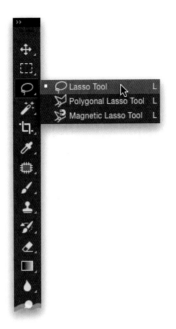

If you want to select something that isn't square, maybe an object in your image, you need to make a free-form selection (a selection that isn't square [or round]) using the Lasso tool (its icon looks like a rope lasso). Just choose it from the Toolbox (or press **L**) and trace along the edges of the object you want to select. If you need to add to the selection (once you've drawn it), press-and-hold the **Shift key** and keep tracing. Anything you trace around while you're holding that Shift key gets added to what you already selected. If you make a mistake and trace around an area you didn't mean to (you "painted outside the lines"), then press-and-hold the **Option (PC: Alt) key** instead, and trace around the area you want to remove. To deselect your selected area, press **Command-D (PC: Ctrl-D)**.

How
Do I... Make Really Precise Selections?

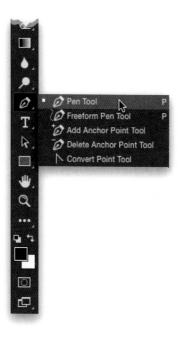

The king of all selection tools (well, in my mind anyway) is the Pen tool **(P)**, because it makes precise selections, which can be easily adjusted after the fact. Best of all, it makes perfect curves around objects, which is a bigger deal than it sounds. There are actually five Pen tools, but you'll use the regular Pen tool about 95% of the time. It kind of works like a "connect-the-dots" tool, in that you click once to choose your starting point, then you move your cursor somewhere else and click again, and it draws a straight line between those two points (perfect for selecting a wall or a box or anything with straight lines). If you come to a part of the object you're selecting that has a curve to it (imagine you're selecting a camera—parts of it are straight, but the top and the lens are round), just click-hold-and-drag, and as you drag, a perfect curve appears. Two little handles appear that let you adjust the exact amount of curve later (you adjust your curve after you've made it all the way around the object). That's basically how the Pen tool works: Click-click-click makes straight lines; click-hold-and-drag makes a curve. When you get around the object, back to the first point where you started, you'll see a tiny circle appear in the bottom-right corner of the Pen tool's cursor. That lets you know you've come "full circle." Click directly on the first point and it connects the last point to it, so the whole thing is connected. However, what you now have isn't a selection, it's a path—straight lines and curves that are not flashing (well, not yet anyway). To turn that path into a selection, press **Command-Return (PC: Ctrl-Enter)**. On the next page, we'll look at how to adjust that path before you turn it into a selection.

How Do I... Adjust My Pen Tool Path?

Once you have a path in place, you can adjust it using two different arrow tools, both found in the Toolbox, a couple of spots below the Pen tool. The first is called the Path Selection tool (**A**; its icon looks like a solid black arrow), which is used to pick up and move your entire path (in case you want to move it to a new location) or, if you have more than one path in the same image, it lets you switch between paths. The second tool is the Direct Selection tool (**Shift-A**; its icon looks like a solid white arrow), and it's the one you'll use the most. It lets you click on any point created by the Pen tool and adjust that one point. So, for example, if you traced along an edge with the Pen tool, but part of your path wasn't snug up against the edge of what you were tracing, you'd click on one of the points and move it up, so the path was flush against the edge. Also, if you created a curved point, you'll see one to two little levers (handles) coming off that point—those are there to let you adjust the amount of bend on the left or right side of that curved segment (it kind of works like a teeter-totter). To adjust the bend, click on the little dot at the end of either lever and drag up/down to adjust the curve until it fits the edges of the object you're tracing around. If there's too much bend, click-and-drag that lever in toward the point in the center. To add more curve, pull the end of that lever out away from the point. So, in short: the solid black arrow moves your entire path; the solid white arrow adjusts individual parts or points along your path.

How Do I... Delete, Add, or Change Points?

If you've created a curve along your path and you want it to be perfectly straight, or if you have a straight path and need it to become curved, there's a tool that switches one to the other. It's called the Convert Point tool, and it's found in the Toolbox nested with the Pen tool (it's the bottom tool in the flyout menu; its icon looks like the point of an arrow). To use it, click on a curved point and it becomes straight (you'll see the little teeter-totter levers go away and the lines straighten instantly), or to make a straight point curved, click-and-hold directly on it, and drag to pull out a curve. If you need to add more points to your curve, there's a tool for that, as well. It's called the Add Anchor Point tool, and it's found in the same Pen tool flyout menu (it looks like the Pen tool, but has a small + [plus sign] next to its cursor). Click anywhere along any path, and it adds a point. Of course, if there's a tool to add points, there's one to take them away. This one is called the Delete Anchor Point tool (it also looks like the Pen tool, but has a small – [minus sign] next to its cursor). Click on an existing point and it deletes that point.

TIP: DRAW YOUR PATH INSIDE THE EDGE
For better results with the Pen tool, "dig in a little" to the edge of what you're tracing, instead of going right along the edge. This will help keep you from having small white gaps along the edges when you turn the path into a selection.

How Do I... Draw a Free-Form Path?

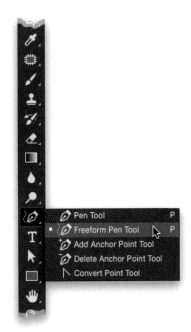

If you want to create a free-form path that you draw like you're using the Lasso tool, there's a special Pen tool just for that. It's called the Freeform Pen tool, and it's nested with the Pen tool (its icon looks like the Pen tool, but with a little "S" coming out of the end of the pen tip). To use it, just start tracing along the edge of the object you want to select and, as you draw, it automatically lays down the points for you. Once your path is done (you've connected the final point with the point you started with), you'll see the points it created and you can now adjust them using the Direct Selection tool (**Shift-A**; the solid white arrow).

How Do I... Get to the Custom Brushes?

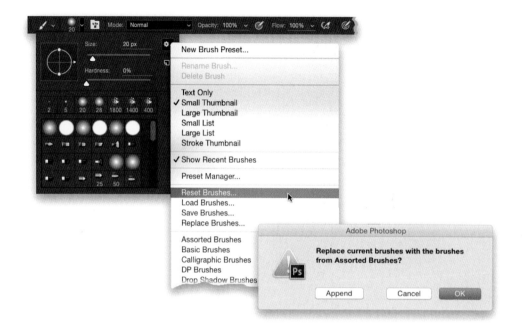

In the Options Bar, click on the brush thumbnail (it's the second icon from the left) to open the Brush Picker, then click on the gear icon in the top-right corner of the Picker. In the bottom half of the pop-up menu that appears, you'll see all the different collections of custom brushes you can load. When you choose a set to load, a dialog pops up asking if you want to replace (delete) the current brushes and use these instead, or just add (Append) these new custom brushes to the end of the current default set of brushes. Here's the good news: you can feel free to try out these brush sets because you're always just one click away from re-loading the default brush set. In that same pop-up menu, you'll see **Reset Brushes**. Choose that and it returns you to the default set of brushes.

 How Do I... Pick My Brush Size?

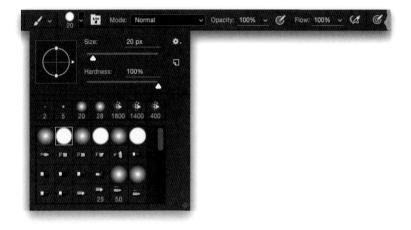

Once you select any tool that uses a brush tip (like...well...the Brush tool, of course, but also the Clone Stamp tool, the Dodge and Burn tools, the Pencil tool, the Eraser tool, etc.), you can choose the type (hard or soft) and size of the brush from the Brush Picker up in the Options Bar. Click on the brush thumbnail (it's the second icon from the left) and the Brush Picker appears (it pops down), where you have a default collection of brushes you can choose from, along with Size and Hardness sliders. You'll also see a preview of each brush tip, so you can easily see which ones are smooth, hard-edged brushes, and which ones are soft-edged (their previews look blurry).

TIP: USE THE BRACKET KEYS TO CHANGE BRUSH SIZE

You don't have to use the Brush Picker to change a brush tip size. You can also use the bracket keys on your keyboard (to the right of the P key). The [(Left Bracket key) makes the brush tip smaller; the] (Right Bracket key) makes it larger. You can also press-and-hold Option-Control (PC: Alt-Ctrl), click on your image and (1) drag up/down to visually change the hardness and (2) drag left/right to change the size. Lastly, if you Right-click your brush anywhere in the image, the Brush Picker appears right at that spot for you (saves you a trip up to the Options Bar).

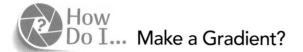

How Do I... Make a Gradient?

This is going to seem amazingly obvious, but you make gradients using the Gradient tool **(G)**. Click-and-drag it to create a gradient between where you started dragging and where you stop. By default, it builds a gradient going from your current Foreground color to your Background color. So, to change the color, just change your Foreground and Background colors. But, there are a bunch of other gradients to choose from. In the Options Bar, click on the down-facing arrow to the right of the gradient thumbnail to open the Gradient Picker, and you'll see all the different default gradients you can choose from. Just click on the one you want. Of course, there are other sets of gradients you can load (just like there are other sets of brushes you can load). Click on the gear icon in the top right of the Gradient Picker and, in the bottom half of the pop-up menu that appears, you'll see all the different gradient sets you can add. When you choose a set to load, a dialog pops up asking if you want to replace (delete) the current gradients and use these instead, or just add (Append) these custom gradients to the end of the current set. You can return to the default set anytime, by choosing **Reset Gradients** from the same pop-up menu and it returns you to the default set of gradients.

TIP: CHOOSE FROM FIVE DIFFERENT STYLES OF GRADIENTS
There's a linear gradient (a straight line between colors), a radial (circular) gradient, an angular gradient, a reflected gradient, and a diamond-shaped gradient. To choose one, click on its icon to the right of the gradient thumbnail in the Options Bar.

How Do I... Edit a Gradient?

Get the Gradient tool **(G)**, then click on the gradient thumbnail in the Options Bar (don't click on the little down-facing arrow, click right on the gradient thumbnail itself). This brings up the Gradient Editor. Click on a gradient preset, at the top of the dialog, to use it as your starting point for editing (for example, if you want to create a gradient with three different colors, click on a gradient preset that looks like it has three colors [I clicked on the Blue, Yellow, Blue preset above]—it just saves you a step). Once the gradient you want to edit appears in the gradient ramp, you'll see icons appear right below it (they look like little houses to me, but technically, they're called color stops). You drag these color stops to the right or left to change the balance of a particular color in your gradient (you want more or less of a color), and the little diamond-shaped icon that appears between two colors controls the midpoint between them (drag one of them and you'll instantly "get it"). To edit the color of one of these color stops, double-click on a little house icon and the Color Picker appears. To add more color stops, click directly beneath the gradient ramp. To delete a color stop, click on it and drag it away from the gradient ramp. The two opacity stops above the gradient ramp are for adding transparency. For example, if you wanted to go from black to transparent, rather than from black to a color, you would click on the opacity stop you wanted to be somewhat transparent, then choose the amount of opacity in the Opacity field near the bottom.

 How Do I... **Create Things Like Arrows, Talk Bubbles, Stars, and Other Custom Shapes?**

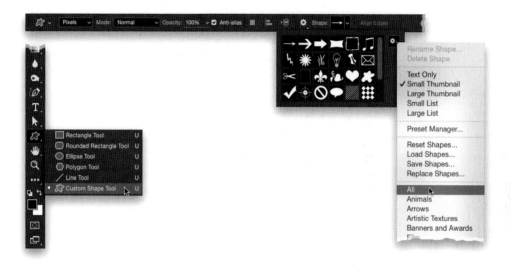

To create things like talk bubbles, arrows, or shapes, you use the Custom Shape tool. It's found right above the Hand tool in the Toolbox—just click-and-hold on the Rectangle tool and choose it from the flyout menu (it's the last one in the menu) or press **Shift-U** until you have it. Now look up in the Options Bar, and you'll see a preview of the currently selected custom shape appear in the Shape thumbnail. Click on the thumbnail and the Shape Picker of custom shapes will appear. To use one, just click on it, and then click-and-drag it out to the size you want in your image. By default, it will appear on the current layer, so if you want it on its own separate layer, click on the Create a New Layer icon at the bottom of the Layers panel to make a new blank layer first. Also, on the left side of the Options Bar, you'll see a tool mode pop-up menu where you can choose to create your custom shape as a Shape layer, or a Path (these options are more for graphic designers), or Pixels, which is more for us photographers (it treats your shape like any other image). By the way, you can load more sets of custom shapes by clicking on the gear icon in the top-right corner of the Shape Picker. A pop-up menu will appear that lists all the different custom shape sets you can add (append) to the end of the current set of shapes, or you can replace (delete) the current shapes and use these instead. I generally just choose All from this menu to load every set at once, so I can scroll through them all (and I leave them loaded all the time—it just saves time). You can return to the default set of custom shapes anytime, by choosing **Reset Shapes** from that same pop-up menu.

How Do I... Use Colors That Are Already in My Image?

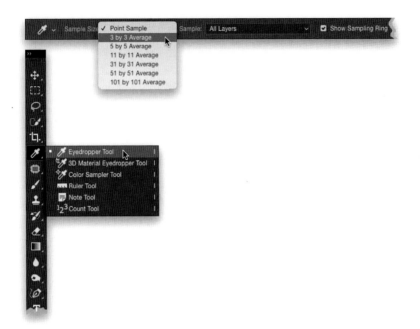

To "steal" a color from your current open image, get the Eyedropper tool (**I**) from the Toolbox (its icon looks like a small eyedropper), then just click it once over the color in your image you want to use, and that color now becomes your Foreground color (you'll see this at the bottom of the Toolbox). Okay, now that you know that, I have a tweak that will probably make this tool work better for you: By default, it picks up the color of a single pixel. But, if you've ever really zoomed in tight on an image, you've noticed that even a tiny area of color is made up of a bunch of slightly different colors, so it's possible you might click and get a color that doesn't look quite right. That's why I set my Sample Size option for this tool (up in the Options Bar) to **3 by 3 Average**, rather than leaving it set to the default Point Sample. That way, you get an average of the color in that area, rather than picking up the color from a random stray pixel. In short, I think you'll get better, more predictable results.

How Do I... Choose a Color?

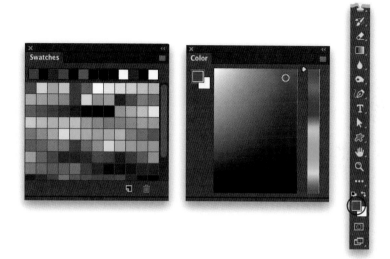

Well, there are a couple of ways: There is the Swatches panel (go under the Window menu and choose **Swatches** to open it), which has a bunch of color swatches already there. To use one of those colors, just click on it and it becomes your Foreground color (your Foreground color is the color that things now appear in. So, if you clicked on a red color swatch, and used the Brush tool, it would paint in red, or if you created some type, it would appear in red, and so on). You can load different sets of color swatches by clicking on the little icon (with the four lines) in the top-right corner of the panel, and a flyout menu of other color swatch sets appears. If you create a new color you want to save as a color swatch, go to the Swatches panel and click on the Create New Swatch of Foreground color icon at the bottom of the panel, and now it's a swatch, too. There is also a Color panel (choose **Color** from the Window menu). This has a vertical hue slider on the right, where you pick your basic color, and the large rectangle in the middle is where you choose your saturation (how vivid the color will be) by just clicking-and-dragging in that rectangle. The color you create here becomes your new Foreground color. Also, near the bottom of the Toolbox, you'll see two overlapping squares. The one in front is your Foreground color, and to change that color (without having to pull up either the Swatches or Color panel), just click on it and the Color Picker appears (it looks like a larger version of the Color panel). Choose a color here and it becomes your Foreground color.

How Do I... Make Lines?

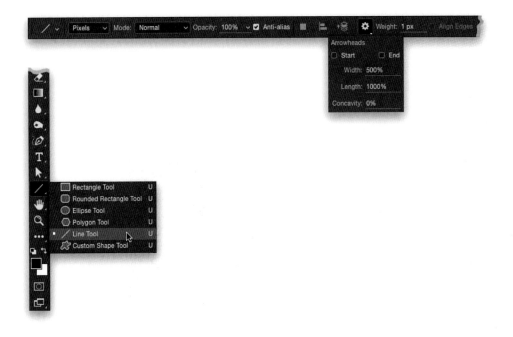

You use the Line tool (I know, that seems too obvious). It's found just above the Hand tool in the Toolbox, nested with the Rectangle tool (it's the diagonal line), or press **Shift-U** until you have it. Just click-and-drag and it draws a line. Up in the Options Bar, you can choose the thickness of your line in the Weight field—the higher the number, the thicker the line. If you look on the left side of the Options Bar, you'll see Shape selected in the tool mode pop-up menu. Click-and-hold on that pop-up menu and choose **Pixels** to get a more "photographer friendly" line, made up of pixels like our images (otherwise, it creates a path, like you drew it with the Pen tool, or a special Shape layer, both of which are more for graphic designers). There is one extra thing you'll want to know: You can add arrowheads to the start or end of any line (hey, ya never know), by clicking on the little gear icon toward the right end of the Options Bar. Here, you can turn on arrowheads and choose their thickness.

How Do I... Create Text?

Get the Horizontal Type tool **(T)**, click it somewhere within your image, and just start typing. You can choose your font and point size up in the Options Bar (when you start typing, it uses the last font and size you used. So, if you want to change your text font, just highlight it first, then choose a new font from the pop-up menu). If you really want to access some serious type features, go under the Window menu and choose **Character** to bring up a panel with a ton of type controls (baseline shift, superscript, kerning, OpenType features, etc. Now, if all of that sounds like, "Huh?" you can probably skip opening this panel). When you start typing, it types in one long line, so you have to put in your own line breaks by hitting the **Return (PC: Enter) key** before your text goes past the edge of your image. If you know you want your text to fit in a particular area, even before you start typing, then take the Horizontal Type tool and click-and-drag out a text box with the amount of space you want. Now, as you type, your text will automatically wrap to the next line (like you're working in a regular text app).

TIP: USE THE MOVE TOOL TO RESIZE TYPE

Once your type is in place, easily change its size by getting the Move tool from the Toolbox, then pressing **Command-T (PC: Ctrl-T)** to bring up Free Transform (it puts handles and a box around your type). Press-and-hold the Shift key (if you want to keep it proportional), grab a corner handle, and drag inward (to shrink your text) or outward (to make it larger). When you're done, press the **Return (PC: Enter) key** to lock in your transformation.

How Do I... Draw a Single Thin Line of Pixels?

You could use the Line tool, and set it to a Width of 1 pixel (see page 40), but for stuff like this, you might want to use the Pencil tool (it's nested in the Toolbox with the Brush tool; or press **Shift-B** until you have it). It draws a 1-pixel hard-edged line, by default—you just get the pencil and start drawing free-form with it. If you want to create a straight line, press-and-hold the Shift key first, click the Pencil tool where you want your line to start, move your cursor to where you want it to end, click again, and it connects the two. It's kind of a like a "connect-the-dots" tool at this point.

How Do I... Erase Something?

Why, you'd use the Eraser tool **(E)**, of course. Its icon looks like an eraser, and it simply eras-es pixels (it won't work on erasing type because type isn't made up of pixels. If you need to erase some type or parts of type, go to the Layers panel, Right-click on the type layer, and choose **Rasterize Layer**. That turns your type from a shape to pixels, and now you can use the Eraser tool at will). By default, it erases with a hard-edged brush tip (like a real eraser), but if you want a soft-edged eraser, you can choose one from the Brush Picker up in the Op-tions Bar (just click on the brush thumbnail to open the Brush Picker).

How Do I... Select the Background Behind My Subject?

Get the Magic Wand tool from the Toolbox (its icon looks like a wand...with magic; or press **Shift-W** until you have it) and click it once in the area you want to select. If it's a solid, contiguous area of color, like a nice blue sky or a solid-colored wall, it'll probably select the entire thing with one click, and now you can edit just that area. If it selected part of it, but not all of it, press-and-hold the **Shift key** (this lets you add to what you currently have selected) and click on the part that didn't get selected (for example, if your blue sky had clouds, it may not have selected them, so press-and-hold the Shift key and click on each area of clouds to add them to your selection). Now, if it selected too much (it spilled over into areas you didn't want to be selected), there are three things you can do: (1) Deselect the area you selected by pressing **Command-D (PC: Ctrl-D)** and start over by clicking on a different part of what you wanted to select (for example, if you clicked on the right side of the sky and it selected too much, deselect and maybe start by clicking on the left side of the sky and see how that looks. It works more times than you'd think). (2) Deselect, then go up to the Options Bar and lower the Tolerance amount from its default setting of 30. This determines the range of colors it will include, so typing in a lower number (like 20 or 10 or 5) means it won't expand out so far and will include fewer colors. Or, (3) switch to the Lasso tool (**L**), press-and-hold the Option (PC: Alt) key and draw over the areas that the Magic Wand tool selected that you didn't want selected. This removes those areas from the selection.

How Do I... Get Help Making a Selection?

I use the Quick Selection tool for selecting stuff that's a little complicated, and when I want Photoshop to do most of the work. Get the tool from the Toolbox (it's nested with the Magic Wand tool; or just press **W**), simply paint over the object you want selected, and as you paint, it starts selecting. It may look like it's doing a really bad job at first, but after a moment or two, it reanalyzes the edges of the object and it usually readjusts itself fairly well. It usually won't make a perfect selection—it's just supposed to help you make your selections quicker by sensing the edges of things you're painting over (and the more defined the edge, the better it works). Once it gets fairly close, switch to the Lasso tool **(L)**, press-and-hold the Shift key (to add to what it currently selected), and draw over any areas it missed to add them to your selection. Use the two of these tools together and you'll save a lot of time.

How Do I... Crop My Image?

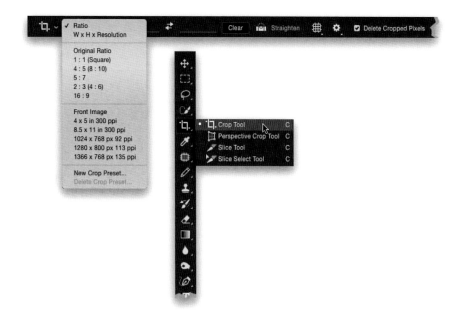

You get the most-used tool in all of Photoshop—the Crop tool. When you click on it in the Toolbox (or press **C**), it instantly puts a rule-of-thirds grid over your image (if you have this overlay option preference selected in the Options Bar), and it adds little cropping handles on the sides and corners. To crop, grab one of those side or corner handles and just start dragging. The areas that will be cropped away now appear darker. If you want your crop to remain proportional, press-and-hold the Shift key while you drag. When you're done, to lock in your crop, press the **Return (PC: Enter) key**. There are also a bunch of built-in cropping ratios to choose from, if you already know the size or aspect ratio you want. You can find these up the Options Bar, in the pop-up menu on the left, while you have the Crop tool selected.

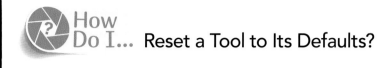

How Do I... Reset a Tool to Its Defaults?

The "Reset" button for tools is totally hidden, and I don't know why. To reset any individual tool to its factory-fresh default settings, select the tool, then in the left side of the Options Bar, you'll see an icon of your currently selected tool. Right-click on that icon and a hidden pop-up menu will appear with two choices: Reset Tool, which is what you want to choose if you want to reset just this one tool, or Reset All Tools, which resets every Photoshop tool to its factory default settings. That's it.

How Do I... Straighten an Image?

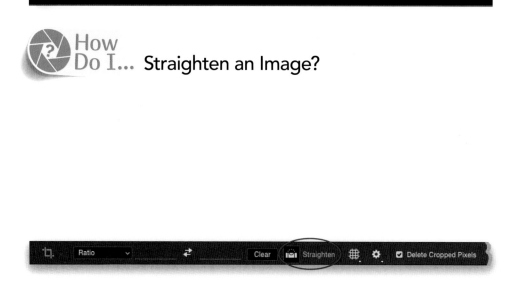

Press **C** to get the Crop tool, then go up to the Options Bar and click on the Straighten tool (its icon looks like a level). Take that tool and drag it along an edge that should be straight (either horizontally or vertically), and it instantly rotates your crop so it's perfectly straight. To lock in this straightening, press the **Return (PC: Enter) key**.

How Do I... Make Part of My Image Brighter or Darker?

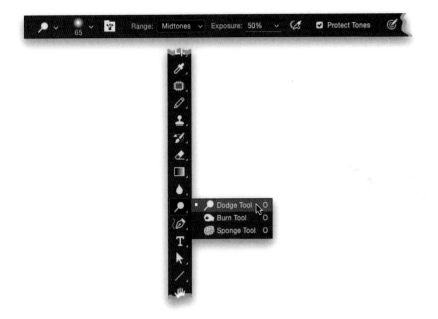

There are probably a dozen or more ways to brighten (dodge) or darken (burn) individual parts of your image in Photoshop, but you can also use a couple tools to do it. Choose the Dodge tool **(O)** from the Toolbox and just paint over areas in your image you want brighter. The strength of this brightening is controlled by the Exposure setting up in the Options Bar (the higher the number, the more strength each stroke has. Your strokes do build up as you paint over them, as long as your Exposure setting isn't 100%—by default, it's 50%). To darken an area, use the Burn tool (it's nested with the Dodge tool in the Toolbox, or just press **Shift-O** until you have it). It works the same way the Dodge tool does, but it darkens instead of brightens. *Note:* Make sure you leave the Protect Tones checkbox, in the Options Bar, turned on all the time, otherwise it reverts to some old math and the results will be pretty horrid.

How Do I... Undo Changes in Just One Part of My Image?

Believe it or not, you can "paint" an undo (as long as you haven't resized your image or changed its color mode from RGB to CYMK or something like that, because in that case, it no longer works). You do this using the History Brush tool (**Y**; its icon looks like a brush with a circular back arrow, subtly indicating that you're going "back in time"). You just grab it, paint over an area, and it returns that area to how it looked when you first opened the image (how cool is that?). If, when you go to paint, it gives you an "oh no you don't!" icon, it means you did something to the image (resized it, cropped it, etc.) that precludes it from painting back to the original state you opened the image in. So, you're out of luck in that case.

TIP: CHOOSE HOW FAR TO PAINT BACK

By default, the History Brush tool paints back to how your image looked when you opened it, but if you open the History panel (under the Window menu), you can click to the left of any of your last 20 edits and paint from that point in time instead. Lastly, if at any time in your editing process you think you might want to paint back to a particular point in your list of edits, click on the Create New Snapshot icon (it looks like a camera) at the bottom of the History panel to create a snapshot of what your image looks like at that moment. Now you don't have to worry about only going back 20 steps in time— you can paint back to what your image looked like in that snapshot any time.

How Do I... Save My Favorite Settings for a Tool?

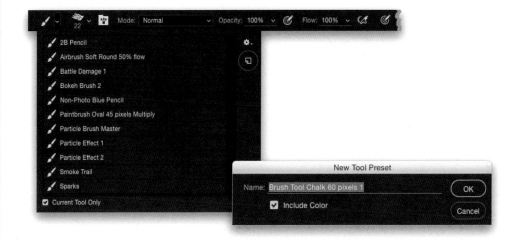

If you've found a particular set of settings that you really like for a particular tool (for example, let's say you like to use the Brush tool, with a custom brush you loaded or created, with a particular hardness setting, and a particular opacity), you can save all of that as a Tool preset. Then, that brush, with all those custom attributes, will always be just one click away. You do this by setting up the tool the way you want it first, then going up to the Options Bar, and clicking on the tool icon on the left. When the Preset Picker appears (Adobe put some default presets there, but you can delete them), click on the Create New Tool Preset icon (it's right under the gear icon in the top right). You can now name your preset, and even choose to include your current Foreground color, if you like. Click OK and now when you want to get that custom tool, just go up to that Preset Picker, choose it from the list, and off you go!

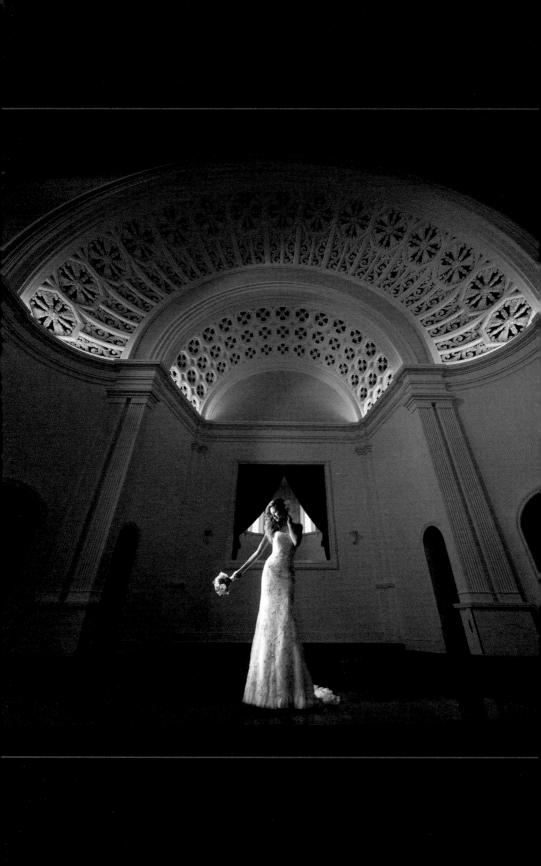

How to Use Camera Raw Like a Boss

Many photographers are surprised to pick up a book on Photoshop and see so much emphasis on Camera Raw, but to be honest with you, this is where most of our basic editing work is done today. Later in the book, we do cover a little bit of Levels and Curves, but for the way today's photographers process their images (whether they shoot in RAW format or not), using Levels and Curves is really kind of old-fashioned. Really "old school." Now, you're probably familiar with the phrase, "Ain't no school like the old school!" but that phrase is actually referring to something much different than Photoshop. Just in case, I went online to Urban Dictionary to see how they described the phrase "old school," and here's what they say, "Anything that is from an earlier era and looked upon with high regard or respect. Can be used to refer to music, clothing, language, or anything really." It's that last part, "anything really," that kind of loops Photoshop up in that big net. Now, understand that I have great respect for Curves and Levels, and I've written entire chapters on both in previous books while listening to old school rap (*"I wanna rock right now. I'm Rob Base and I came to get down. I'm not internationally known, but I'm known to rock a microphone!"*), which is precisely why those chapters had so many inadvertent references to rocking immediately, getting lower, and only being locally recognized. Anyway, the important thing is this: Do you want to learn the way we "used to do things back in the day" (old school) or how we actually do things today (by the way, we no longer use stagecoaches or butter churns, but at one time they were "state of the art")? So, stick with it for these two chapters, and it will "rock your world" (please don't look that up on Urban Dictionary because I don't mean it like their description, which made me wash out my eyes with soap and say 10 Hail Mary's. Ack!).

How Do I... Expand the Tonal Range of My Image?

In the Basic panel, press-and-hold the Shift key and double-click directly on the Whites slider, and then do the same for the Blacks slider. This automatically expands out the whites and blacks to their farthest points without clipping the highlights (well, that's the plan. Occasionally, the whites do create some minor highlight clipping), which expands your overall tonal range. If you've used Photoshop in the past, you might remember doing this same type of thing (though not automatically like this), but we used to use the Levels dialog to do it, and it was called "setting your white and black points." This is the same thing; it's just automated (which is awesome). You might want to consider making this the first thing you do when you start to tweak an image, because you'll be starting with an expanded tonal range. Then, you can go back and tweak your Exposure amount (making the overall image brighter or darker), once the white and black points are set.

How Do I... Adjust the Overall Exposure?

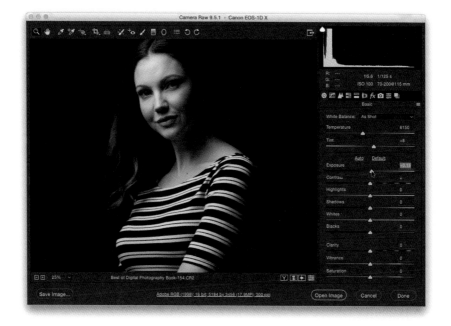

While there isn't just one slider that does this, the closest one is the Exposure slider (found in the Basic panel). It doesn't cover the darkest areas (blacks) or the brightest (whites), but it covers the all-important midtone range (and then some). So when it comes to exposure, it has the biggest overall effect on your image. In earlier versions of Camera Raw, there wasn't an Exposure slider. Instead, this slider was called "Brightness," and it controlled the overall brightness (although the math has been updated since it was Brightness). But, knowing that old name helps give you some idea of what this slider mostly does—it controls the brightness. Drag it to the right, your image gets brighter; drag it to left, it gets darker.

How Do I... Deal with Clipped Highlights?

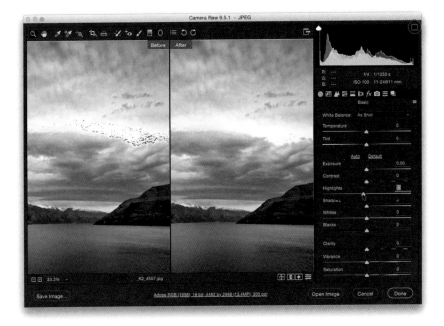

In the Basic panel, drag the Highlights slider to the left until the white triangle up in the top-right corner of the histogram turns solid black. If you have to drag it way, way over to the left, it will start to affect the overall look of your image too much. So, if you find yourself having to drag it way over to the left, first try lowering the Whites slider a bit and see if that helps (that way, you avoid getting the "over-edited" look that you get from dragging any slider in Camera Raw all the way to the far left or far right). If that doesn't work, and you are still clipping the highlights, another thing you can try is lowering the Exposure slider a little bit. (See page 75 for more on clipping.)

How Do I... Fix Flat-Looking Photos?

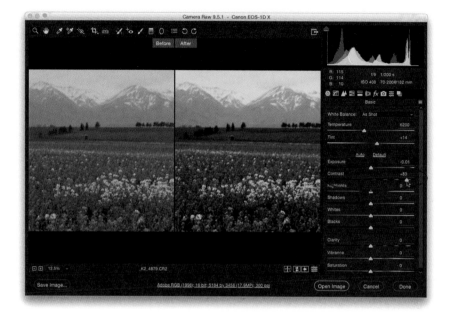

If your photo looks kind of flat (especially compared to the image you saw on the back of your camera when you took it), one of the best quick-fixes is simply to increase the amount of contrast by dragging the Contrast slider (found in the Basic panel) to the right. This does a number of things, besides just making the darkest areas of your image darker, and the brightest areas brighter (which is pretty much what adding contrast does), because it makes the colors in your image appear much richer and more vibrant, and our eyes perceive a more contrasty image as a sharper image, as well. Personally, I just use the Contrast slider, but if you feel you need more control, or more "juice" than just this one slider will provide, you can go to the Tone Curve panel and either use one of the Point Curve presets from the pop-up menu, or you can make the shape of any of those "S-curve" presets that have more contrast by clicking-and-dragging the points until the "S-shape" is steeper (the steeper the S-shape, the more contrast it creates). This Tone Curve contrast is stacked on top of anything you've already done with the Contrast slider, so you can go contrast crazy (once again, I rarely ever have to use this Tone Curve method because the Contrast slider by itself is actually very good. But, if you get in a low-contrast situation, at least you know another place you can go to get more).

How Do I... Bring Out Texture in My Image?

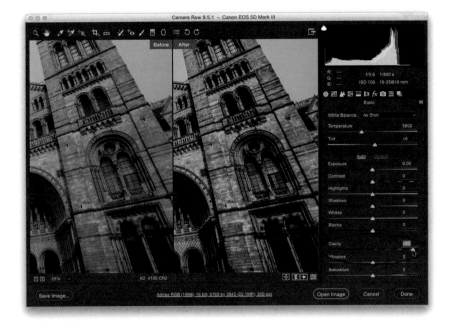

In the Basic panel, just drag the Clarity slider over to the right and any texture in the image gets immediately enhanced. Keep an eye on the screen as you drag this slider because if you drag it too far, you'll start to get a black glow or halo around the edges of objects in your image, which is warning you that you're editing this image to death. How far you can go with it really just depends on the image—images like landscapes, cityscapes, automotive images, anything with lots of very well-defined hard edges can take lots of Clarity. Other images, like portraits or flowers or things of a softer nature, can sometimes take very little.

How Do I... Get My Color (White Balance) Right?

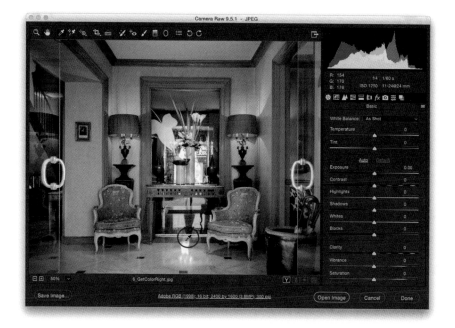

Get your white balance right and everything else falls into place. There are three ways to do this: (1) Try the White Balance preset pop-up menu (at the top of the Basic panel). By default, the menu is set to As Shot, which means you're seeing the white balance as set in the camera when you took the shot. Click on that menu and a full list of white balance choices you could have chosen in-camera appears (the full list only appears if you shot in RAW. If you shot in JPEG, you'll only see As Shot, Auto, and Custom, and by the way, custom means "do it yourself by moving sliders," so it's really not a preset). Choose the preset that best matches the lighting when you took the shot. If you choose one that precisely matches the lighting situation (e.g., you shot in an office with fluo-rescent lights, so you choose Fluorescent), but it doesn't look good, just pick a different one. Who cares about the name? Choose the one that looks right to you. (2) The second method is to get as close as you can using one of those presets, and then tweak the color using the Temperature and Tint sliders. The sliders themselves show you which color is added by dragging one way or the other, so drag the slider toward the color you want more of (for example, dragging toward yellow gives you a warmer look; dragging to-ward blue gives you a cooler look). (3) The third method is my favorite: get the White Balance tool (I; the eyedropper in the toolbar at the top of the window), and just click it on something light gray in your image (as shown above). If there's nothing light gray, try and find something neutral (not too dark, not too bright, not too colorful).

How
Do I... Boost the Overall Color?

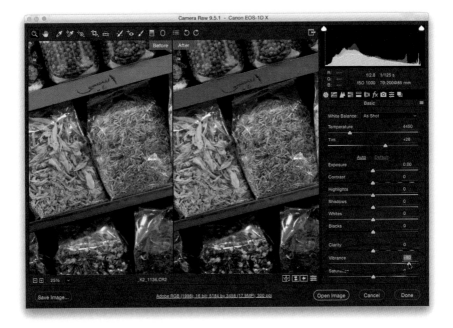

Don't touch the Saturation slider—that will just make your image look too colorful. You just want "more colorful," which is why you want the Vibrance slider (found in the Basic panel) instead. It's kind of a "smart color booster" because when you drag it to the right, it makes any dull colors more vivid. It hardly affects already vibrant colors (which is good), and it tries to avoid flesh tones altogether, so it doesn't make people in your photos look sunburned or jaundiced. It's also good for desaturating just a little bit if you have an overly colorful image—just drag it to the left a bit.

How
Do I... Boost Just One Color?

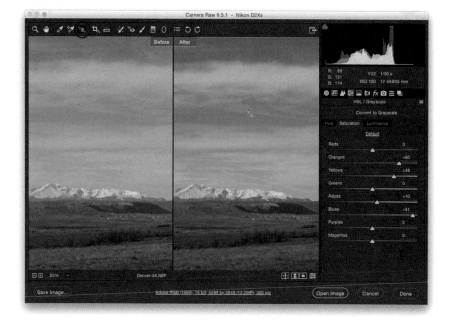

Click on the HSL/Grayscale icon under the histogram (it's the fourth one from the left). When the panel appears, click on the Saturation tab ("HSL" stands for Hue, Saturation, and Luminance), then go to the toolbar, at the top of the window, and you'll see a tool whose icon looks like a small target with a + (plus sign) at the top left (it's the fifth one from the left). That's the TAT (Targeted Adjustment Tool). Click on it to activate it, then move it out over the area in your image that has an individual color you want to boost (or desaturate, for that matter)—like a blue sky or green grass or someone with a yellow shirt—and just click-and-drag it upward to increase the amount of that color (and any associated colors. For example, the sky might be made up of not just blues, but aquas, as well. It knows and will move both sliders for you automatically as you drag). Click-and-drag downward to reduce the vibrance of that color. To change the brightness of the colors, click on the Luminance tab, then click-and-drag the TAT downward, and the color gets deeper and richer. If you want to actually change the color (for example, you want that yellow shirt to be green), first click on the Hue tab up top, then click-and-drag the TAT up/down until the color changes to what you're looking for. *Note:* This doesn't just change that one color in that one area, it changes all the similar colors in the image. So, if you have a blue sky, and your subject is wearing a blue shirt, know that both the sky and the shirt will change when you make an adjustment to one of them.

How Do I... Fix Backlit Photos?

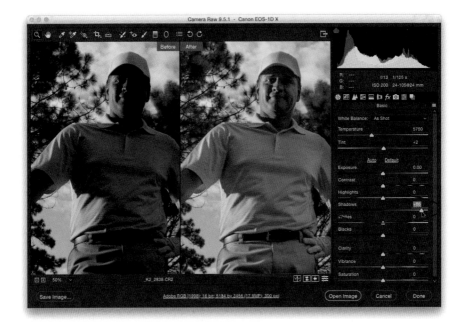

To open up those shadows to be more like what our eyes saw when we took the photo, go to the Basic panel and click-and-drag the Shadows slider to the right. This backlit problem happens a lot because our eyes are so amazing that they can correct for a huge range of tones, tremendously more than even the most expensive camera sensor. So, while we're standing there in front of our subject, they don't look like a silhouette—we see them properly exposed. When we look through our DSLR camera's viewfinder, they still look properly exposed. But, when we press the shutter, and it passes the image to our sensor—which captures a much narrower tonal range—the result is your subject winds up looking like a silhouette. Luckily, that Shadows slider works wonders—just drag it to the right and watch the magic happen. If you have to drag really far to the right to bring your subject out of the shadows, you run the risk of having the image look a bit washed out. So, if you see that happen, just increase the contrast (drag the Contrast slider to the right) until it doesn't look washed out.

How Do I... Crop My Photo?

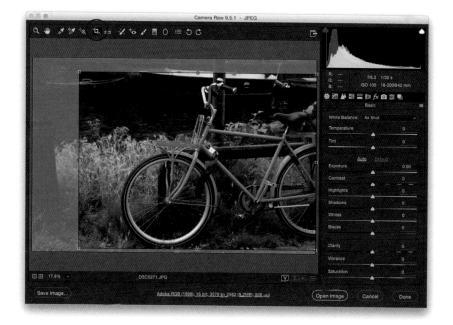

Start by clicking on the Crop tool **(C)** up in the toolbar at the top of the window, then just click-and-drag it out over the area of your image you want to keep. The areas that will be cropped away now appear back-screened. To change your crop, just click-and-drag on any of the little handles that appear on the corners and sides of the cropping border. To move the entire cropping border, just click inside it and drag it where you want it. To resize it proportionally, press-and-hold the Shift key, then click-and-drag a corner handle in/out. To flip your crop from wide to tall (or vice versa), just press the **X key** on your keyboard. To rotate it, move your cursor outside the cropping border and its icon changes into a double-headed arrow. Click-and-drag to rotate the entire crop border. When the crop is set like you want it, press the **Return (PC: Enter) key** to lock it in. Lastly, to delete your cropping border altogether, just hit the **Delete (PC: Backspace) key**.

How Do I... Crop to a Specific Size?

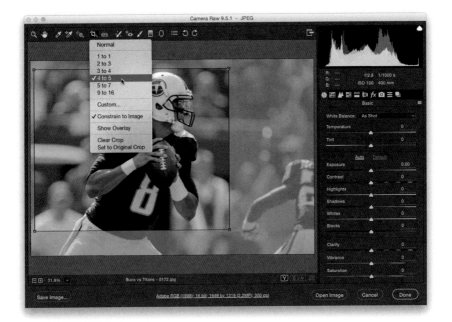

Click-and-hold on the Crop tool (up top in the toolbar), and a pop-up menu with a bunch of cropping options will appear. The first option in the menu, Normal, is just regular ol' free-form cropping. To choose a particular crop ratio, choose it from that pop-up menu (like 4 to 5, for example), and now when you click-and-drag with the Crop tool, it's constrained to a 4 to 5 ratio size. Once your cropping area is in place, you can change to any other cropping ratio by just choosing it from that same menu, and it'll instantly change to that ratio. To remove your crop altogether, just hit the **Delete (PC: Backspace) key**.

How Do I... Straighten a Crooked Photo?

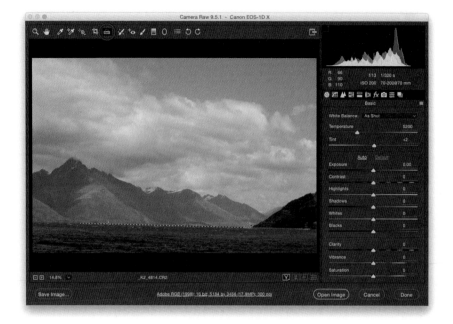

There are three ways: (1) Start by clicking on the Straighten tool **(A)** up in the toolbar (at the top of the window; it's the seventh tool from the left), then just drag it along an edge you want to be straight (for example, in a landscape photo, you'd drag it along the horizon line), and it straightens your photo. The second method (2) is to let Camera Raw auto-straighten it for you. Click on the Lens Corrections icon (it's the sixth icon from the left) beneath the histogram, then click on the Manual tab, and under Upright, click on the Level icon (it's the one in the center). Lastly, (3) you could just do it yourself by rotating the photo until it's straight: click on the Crop tool **(C)** in the toolbar, move your cursor outside the cropping border, and then click-and-drag in the direction you want to rotate. Stop dragging when the image looks straight, then press **Return (PC: Enter)** to lock in your crop.

How Do I... Remove Darkening in the Corners?

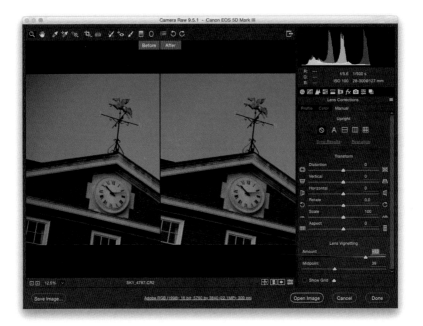

To get rid of edge vignetting (a problem caused by your lens), click on the Lens Correc-tions icon (it's the sixth icon from the left) beneath the histogram, then click on the Profile tab, and turn on the Enable Lens Profile Corrections checkbox (your lens brand and model should appear in the pop-up menus below. If it doesn't, see the tip below). That will often fix the problem right there, but if it doesn't quite do the trick, there's a Vignette slider at the bottom of the panel that lets you fine-tune the amount, so try that and see if it helps. If that still doesn't do the trick, then you'll have to do it manually: Click on the Manual tab and near the bottom you'll see two Lens Vignetting sliders. Drag the Amount slider to the right to brighten the corners of your image, removing the vignetting problem. The next slider, Midpoint, controls how far your edge brightening extends into your image. If it's just in the corners, drag the slider way over to the right. If it's a bit farther out, drag it to the left (basically, drag the Midpoint slider back and forth a few times and you'll see what I mean).

TIP: SELECT YOUR LENS IF CAMERA RAW DOESN'T DO IT AUTOMATICALLY

If you turn on the Enable Lens Profile Corrections checkbox and nothing happens, it just means, for whatever reason, Camera Raw couldn't find the built-in lens profile to fix your lens problem automatically. All you have to do is go to the Lens Profile section and choose your brand (Canon, Nikon, Sony, Fuji, etc.), and it'll almost always find the profile for you (well, as long as it actually exists in Camera Raw's database). If it doesn't, then you'll have to choose your lens yourself from the Model pop-up menu.

How Do I... Sharpen My Image?

Click on the Detail icon (it's the third one from the left) beneath the histogram and, at the top of the panel, you'll find the Sharpening controls. The Amount slider controls the amount of sharpening (please forgive me for explaining what this slider does). The Radius slider determines how many pixels out from an edge the sharpening will affect, and I usually leave this set at 1.0. If I run into an image that needs to be super-sharp, I'll occasionally move it up to 1.2, or even as high as 1.3, but that's about as high I'll go. The next slider down is Detail. I recommend leaving this set as-is (I'm not usually a fan of default settings, but this one is actually good). This slider, set where it is, allows you to apply a higher amount of sharpening without seeing a halo around the edges of objects in your image (a typical side effect of too much sharpening), so it's an improvement over Photoshop's Unsharp Mask filter. If you want sharpening that looks more like the Unsharp Mask, then raise this slider to 100 and it's pretty much the same (you can expect to see halos fast if you set the Amount slider too high). Last is the Masking slider. I only use this when sharpening objects where I don't want the entire image sharpened equally—I just want the edges sharpened. For example, if I'm sharpening a portrait of a woman, I want to sharpen her eyes, eyebrows, teeth, lips, etc., but avoid sharpening her skin because it brings out texture we don't want to enhance (we want to keep it smooth). By raising the Masking amount, it narrows the sharpening to just the edges. Press-and-hold the Option (PC: Alt) key as you drag the slider to see what it's affecting. Areas that turn black (as seen in the inset above) are not being sharpened—only the white areas get sharpened.

How Do I... Adjust a Bunch of Images at Once?

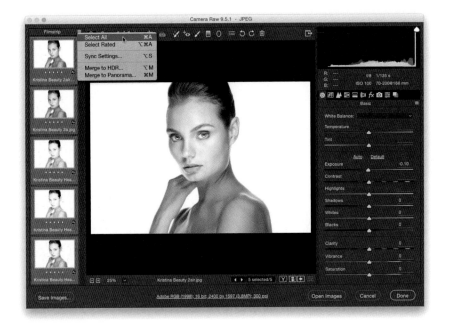

First, select a bunch of images you want to edit in Adobe Bridge, then press **Command-R (PC: Ctrl-R)** to open them all in Camera Raw, and the images will appear in a filmstrip along the left side of the Camera Raw window. By default, you'll only be editing whichever of those images in the filmstrip is currently selected, so if you want to edit them all, click on the icon to the right of the word Filmstrip at the top left, and choose **Select All** from the pop-up menu that appears (or just press **Command-A [PC: Ctrl-A]**). Now, click on the image in the filmstrip you want to work on, and any changes you make to this image (which Adobe calls "the most-selected image") will be immediately applied to all your other selected images at the same time. It's pretty much a "change one, it changes them all" type of edit, but it's one of those things that can save loads of time, especially when changing things like exposure or white balance across a lot of images all at once. When you're done, either click the Open Images button to open all the selected images in the filmstrip in Photoshop, or click the Done button to apply those changes without actually opening any of the images.

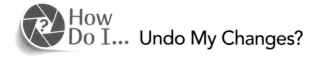

How Do I... Undo My Changes?

You can use the regular ol' Undo keyboard shortcut of **Command-Z (PC: Ctrl-Z)** to undo just your last change, but Camera Raw lets you undo any change you've made because it keeps track of all the changes you've made to your image in the background. To undo each step, one at a time, just press **Command-Option-Z (PC: Ctrl-Alt-Z)**, and it undoes your last step. Press it again, and it undoes the previous step to that, and so on.

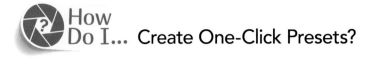

How Do I... Create One-Click Presets?

To create a preset, click on the Presets icon (it's the second one from the right) beneath the histogram, and then, at the bottom right of the panel, click on the Create New Preset icon (it looks like a little page with the bottom-left corner turned up). This brings up the New Preset dialog where you choose which things you've done to the image you want it to save to your preset (this is ideal if you've tweaked your image, and you want to get this same look again, without having to remember all the settings. You'll now be able to get that look with one click). By default, it has every single checkbox turned on (just to be safe, it remembers everything, even if you didn't touch a particular slider). You can leave it like that, and it'll remember what you applied, or if you want a more efficient preset (one that only includes the things you actually did to this image), you can choose one of the presets from the Subset pop-up menu at the top of the dialog. For example, choose Basic, and it just leaves the checkboxes turned on for things you might have done in the Basic panel (like Exposure, White Balance, Highlights, etc.). These are just shortcuts to save you time—you can uncheck/recheck any setting you like. When you're done, give your preset a descriptive name (like Cool Blue Look, or High-Contrast Effect, etc.), click OK, and now that preset will appear in the list in the Presets panel. To apply that preset to a different image, open the image in Camera Raw, click on the Presets icon, then click on that preset and it applies that exact same look to the image.

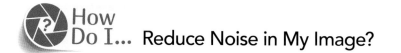

How Do I... Reduce Noise in My Image?

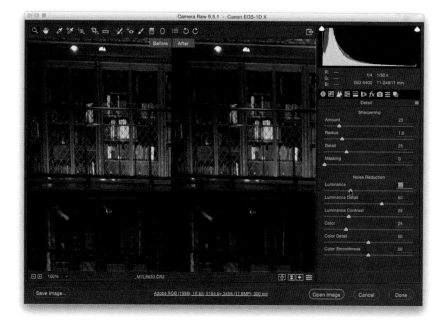

Click on the Detail icon (it's the third one from the left) beneath the histogram, and you'll see the Noise Reduction section right below Sharpening. There are two parts to this section: The Luminance slider reduces the noise specks you see in the image by slightly blurring the image (that's pretty much what noise reduction does—it hides the noise behind a blur). If you drag the Luminance slider to the right, and you start to see that you're losing either detail or contrast in the image, you can use the two sliders right below to add them back. You'd use the Color slider if you saw red, green, and blue specks in your image—this does a good job of desaturating them, so you don't see them. Dragging this slider too far to the right can, once again, cause a loss of detail, so you can bring back some of that detail using the Color Detail slider below. The Color Smoothness slider is different—it doesn't bring back stuff. You'd use this to smooth out larger patches of color noise—just drag it to the right to help smooth those patchy areas out (you probably won't see these larger patches unless you're brightening up a really dark area in your image). Keep this one thing in mind when you're reducing noise: using this feature blurs your image, from a little to a lot, depending on how far you drag the sliders. So, think of this as a balancing act—your job is to find that amount at which the noise is reduced without the image getting too soft.

How Do I... Make My RAW Image Look More Like a JPEG?

Click on the Camera Calibration icon (it's the third one from the right) beneath the histogram, and go through the different profiles in the Camera Profile pop-up menu to find the one that looks the most like your JPEG file. Why would you want your RAW image to look like a JPEG image? It's because JPEG images, in the camera, are sharpened, and more contrasty, and more colorful, and they all have this stuff added in-camera to make them look great. When you switch your camera to shoot in RAW mode, you're telling it to turn all that sharpening, and contrast, and stuff off, and just give you the RAW photo (so you can add your own amount of sharpening, etc., using Lightroom or Photoshop, or whatever). So, your images look flatter when you shoot in RAW. What's worse is, even though you're shooting in RAW, your camera still shows you the nice, colorful, sharp JPEG preview on the back LCD, so you only see the flat version once you're in Camera Raw. By the way, the way I find a profile that most looks like the JPEG preview is to take a few shots in RAW + JPEG mode (so your camera creates both a fully processed JPEG photo and the more flat-looking RAW image at the same time). Open both of those images in Camera Raw, then click on the RAW image in the filmstrip and try out the different profiles, and then compare it to the JPEG until you find the one profile that looks the most like the JPEG. You can then save that as a preset (see page 70) and apply that look to your RAW images with just one click.

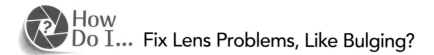

How Do I... Fix Lens Problems, Like Bulging?

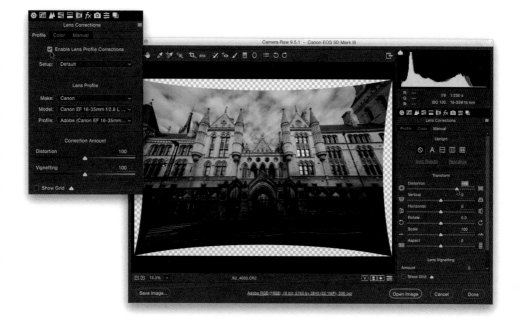

To fix that lens distortion that causes things like doorways and buildings to look like they're bulging outward toward the viewer, click on the Len Corrections icon (it's the sixth one from the left) beneath the histogram, then click on the Profile tab, and first try turning on the Enable Lens Profile Corrections checkbox (as seen in the inset). That alone will sometimes fix the problem (make sure you see your lens make and model in the pop-up menus below the checkbox. If you don't, choose it from those menus—usually just choosing the brand will be enough for it to find the exact lens you used from its internal database). If the profile correction helped, but not quite as much as you'd like, in the Correction Amount section is a Distortion slider that lets you fine-tune the amount—just drag it to the right. If that still isn't enough of a fix, click on the Manual tab, and then drag the Distortion slider at the top to the right until the bulging flattens out (yes, you'll have to crop the edges away when you're done).

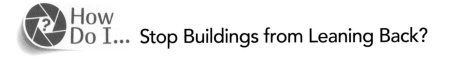

How Do I... Stop Buildings from Leaning Back?

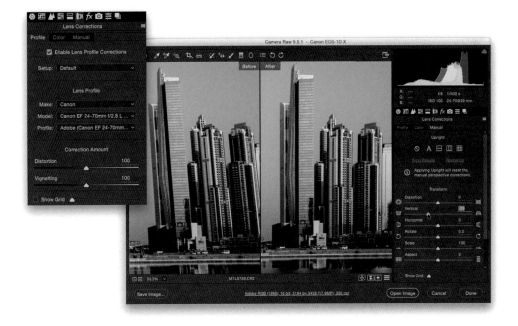

To get rid of this keystoning effect, click on the Lens Corrections icon (it's the sixth one from the left) under the histogram, click on the Manual tab, and then click-and-drag the Vertical slider to the left until the building looks straight (it stops looking like it's leaning). There's an automated method, too: click on the Profile tab, and turn on the Enable Lens Profile Corrections checkbox (as seen in the inset. Your lens make and model should appear in the pop-up menus below. If it doesn't, just choose it yourself). Next, click on the Manual tab, and in the Upright section, first click on the Auto (A) icon and see how that looks. Chances are it fixed the leaning back problem. If it didn't, then click on the Vertical icon (the second one from the right). If neither of these did the trick, click on the Off icon, then use the Vertical slider below to do it manually, like I mentioned at the beginning of this tip.

How Do I... See Which Areas of My Photo Are Clipping?

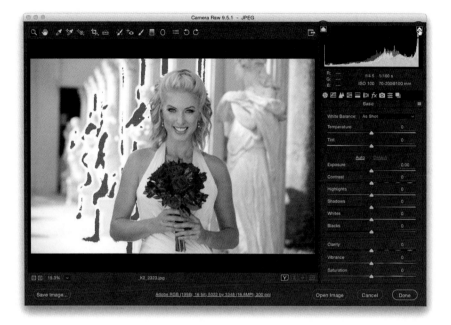

In the Basic panel, click on the little triangle in the top-right corner of the histogram to see areas that are clipping the highlights, or the little triangle in the top-left corner for shadow areas that have turned solid black. Now, any areas that are clipping in the highlights will appear in red (as seen above), and you can drag the Highlights slider to the left to reduce, or hopefully remove, that clipping. If you turned on the shadows clipping warning, those areas will appear in blue, and you can fix them by dragging the Shadows slider to the right.

How Do I... Get Rid of the Purple & Green Fringe on the Edges of Things in My Image?

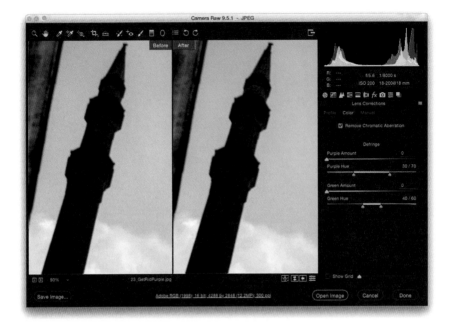

Click on the Lens Corrections icon (it's the sixth one from the left) beneath the histogram, click on the Color tab, and then turn on the Remove Chromatic Abberation checkbox. That alone might do the trick, but usually you'll have to go to the Defringe section below and drag the Purple or Green Amount sliders to the right until you see the fringe disappear (well, the edges turn gray instead of purple or green, so it just blends right in). While I normally don't have to do this next step, you'll want to know it, just in case: if you move a slider (the purple or green) and it doesn't affect the purple or green fringe, you can move the Purple or Green Hue sliders to find the exact shade of the fringe color. Again, I hardly ever have to move the Hue sliders, but it's nice to know they're there in case you do.

How Do I... See a "Before" of Just the Panel I'm Working In?

If you want to see what your image looked liked before you made edits in the current panel (for example, if you applied some sharpening in the Detail panel, and you want-ed to see a before/after of just the sharpening—not all the changes you made since you first opened the image in Camera Raw), then click on the fourth icon from the left beneath the bottom right of the preview window (shown circled above) or just press **Command-Option-P (Ctrl-Alt-P).** That will toggle on/off a before/after view of just the edits you made in that one panel. Of course, if you want to see a true before/after of *all* your changes (no matter where you made them), press the letter **P** on your keyboard. To see a side-by-side before/after, press the letter **Q** to toggle through the different be-fore/after layouts (side by side, top and bottom, or split screen).

How to Use Camera Raw's Adjustment Brush

There's More Than Just One

I thought about calling this chapter "Advanced Camera Raw," but thought that would make it sound like this stuff is hard, and it's not—it's just probably what you'd want to do next after learning the Basic panel in Camera Raw. Now, the title is slightly misleading because this chapter is about more than just the Adjustment Brush. It's about a number of important brushes and features that are kind of like brushes, but are not really brushes, like the Graduated Filter, for example. If it was actually a brush, they would have named it the Graduated Brush, which unfortunately would have been misleading, because while you drag it to use it, it's not a brush. You don't paint with it, however, you can use a brush to erase areas that you don't want affected, so it has a brush component with it. But, most folks don't even know that brush exists because Adobe kinda snuck it into Camera Raw one night during a late-night update when everybody was watching *The Walking Dead* (I think it was the show before the season finale) and nobody was really paying that much attention. Since I brought it up (spoiler alert), were you surprised when Glenn pulled out that laptop (which somehow hadn't lost its battery charge during the entire apocalypse, mind you), and he launched Photoshop CC, went straight to Camera Raw, and tried to fix the white balance in those pics he took of Daryl? I kept yelling at the screen, "You need a lot more magenta in his skintone!" But, he didn't even touch the White Balance eyedropper the entire episode. I had to stop watching the show altogether after that episode, and don't even get me started about the lack of cyan on *Fear the Walking Dead*!

How Do I... Dodge & Burn (Lighten & Darken Specific Areas)?

The standard method for dodging (brightening) is to get the Adjustment Brush (**K**; from up in the toolbar), drag just the Exposure slider to the right (with all the other sliders set to zero—see tip below), and then paint over the areas you want to brighten. For burning (darkening), drag that same slider to the left, darkening the exposure, and then paint over the areas you want darker.

TIP: HOW TO RESET ALL OTHER SLIDERS TO ZERO

To "zero out" all the sliders (reset them all to zero), click on the + (plus sign) button to the right of the adjustment you want to make (let's say Exposure, for example). It increases the amount of that one slider to +0.50 (+25 for all the other sliders), and resets all the other sliders to zero. Same thing if you click on the – (minus sign) button to the left—it decreases the amount of that slider (moving it to the left to –0.50 [–25 for all the other sliders], darkening the exposure), and it resets all the other sliders to zero.

How Do I... Hide the Edit Pins from View?

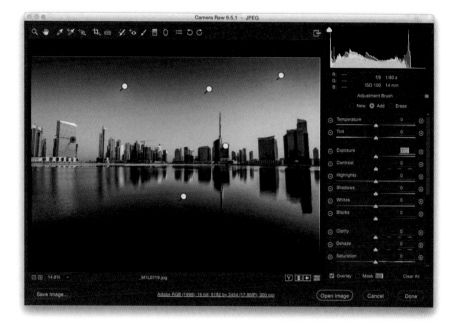

It's an easy-to-remember shortcut: to hide the edit pins on your image, just press the letter **V** on your keyboard. To bring them back, just press V again.

TIP: HOW TO RESET A SINGLE SLIDER TO ZERO
To reset any individual slider, just double-click directly on the slider's knob and it resets to zero.

How Do I... Fix Noise in Just One Area?

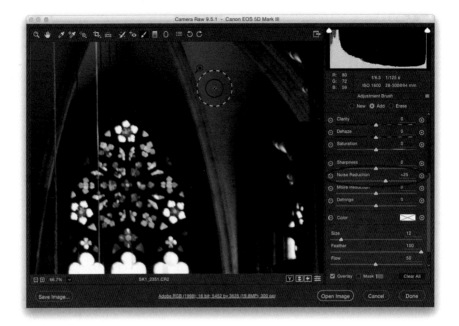

There's no sense in blurring the entire image just to fix one noisy area in your photo (that's what noise reduction essentially does—it blurs the whole image a bit to hide the noise). Instead, get the Adjustment Brush **(K)** and click on the + (plus sign) button to the right of Noise Reduction (to set it to +25 and reset all the other sliders to zero), then paint over just the noisy areas in your image. That way, only the areas where the noise is most visible get blurred, rather than the whole image (by the way, if I use noise reduction at all, this is exactly how I do it—by just addressing the area or areas where noise is most visible).

How Do I... Remove Spots and/or Specks?

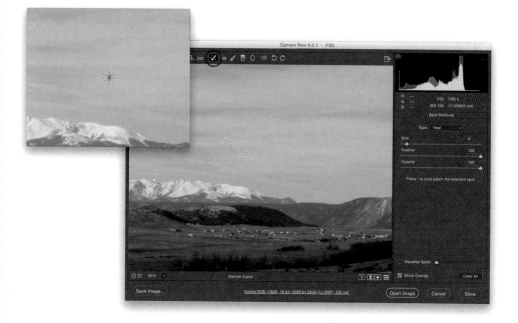

Click on the Spot Removal tool **(B)** up in the toolbar, size your brush so it's a little bit larger than the speck or spot you want to remove (as seen in the inset above), and just click once. The tool will sample a nearby area to use as a source for the removal (see the green circle above? That's where it's sampling from). If for any reason the fix looks odd (it picked a bad spot to sample from, which definitely happens from time to time), you can just click-and-drag that green circle—the one it's sampling from—to a different location to get better results. Also, you can click-and-drag the green circle to resize it, and you can click-and-drag the red circle (the one where you clicked) if you were a little off when you first clicked over the spot you want to fix.

TIP: GET CAMERA RAW TO RESAMPLE AUTOMATICALLY

You just learned that if you use the Spot Removal tool and you don't like the results (maybe it sampled the repair from a bad area), you can click-and-drag that green (sampled) circle to a new spot. But, you can also have Camera Raw do that for you automatically. Just press the **/ (forward slash) key** on your keyboard and Camera Raw will automatically pick a different area to sample from (moving the sample circle for you). Keep pressing it until it looks good to you.

How Do I... Fix Washed-Out Skies?

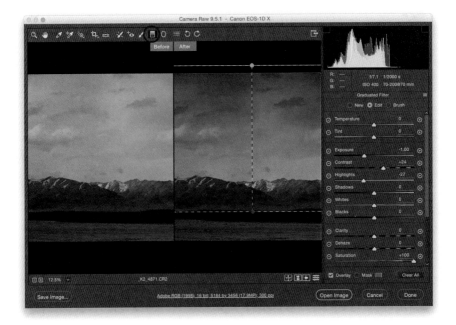

Get the Graduated Filter tool (**G**; it has the same basic settings as the Adjustment Brush, but it's not actually a brush—you click-and-drag it in a direction) from the toolbar, and start by resetting all the sliders to zero (double-click on the – [minus sign] button to the left of Exposure to set it to –1.00 and reset all the other sliders to zero). Now, take the tool and click-and-drag from the top of the image down to the horizon line, and it darkens the top, then gradually fades down to transparent, like a real neutral density gradient filter would do if you put one on your lens. Of course, you can do more than just darken the sky: you can boost the contrast (drag the Contrast slider to the right), or the vibrancy of the color in that part of the sky (drag the Saturation slider over to the right), and increase (or decrease) the highlights in the sky (using the Highlights slider).

How Do I... Fix Red Eye (or Pet Eye) Problems?

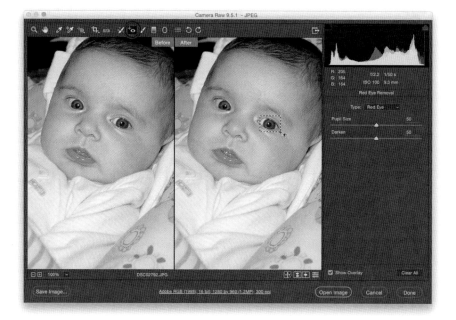

Get the Red Eye Removal tool **(E)** from the toolbar, click it near your subject's eye, and drag outward until it matches the size of the entire eye (not just the pupil and iris area, the whole eye—Camera Raw will detect the pupil within that area). It works the same way with pet eye, but the results are tuned to the green or gold reflection from pets' eyes—just choose **Pet Eye** from the Type pop-up menu at the top of the panel once you have the Red Eye Removal tool selected.

How Do I... Save My Brush Settings as a Preset?

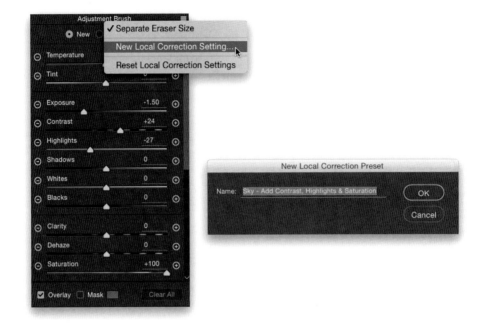

Get the Adjustment Brush **(K)**, then in the panel on the right, click-and-hold on the little icon to the right of the words "Adjustment Brush" and, from the pop-up menu that appears, choose **New Local Correction Setting** (as seen above left). Give your new preset a name (seen above right), and now your brush preset will be added to this menu so you can get to those same brush settings in the future in just one click. (*Note:* You can save Gradient and Radial Filter settings, as well, the same way.)

How Do I... Get Help Finding Spots or Specks?

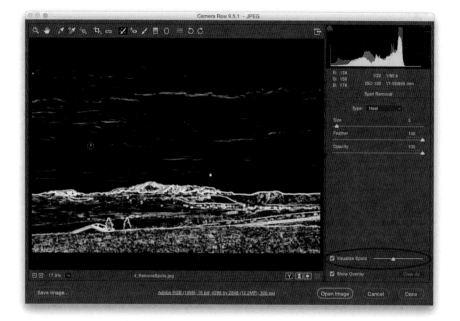

Get the Spot Removal tool **(B)**, and then in the panel on the right, turn on the Visualize Spots checkbox. The image will turn into a black-and-white line drawing (well, it kind of looks like that anyway). Now, drag the Visualize Spots slider back and forth until any spots, specks, or dust are very clear to see—they appear in white against a black background, like the sky, or in black against a white background in brighter areas. This makes those spots really stand out, and you can then remove them with the Spot Removal tool, while you still have this feature turned on.

How Do I... Erase Something If I Make a Mistake?

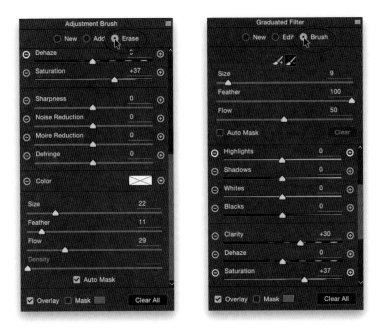

If you make a mistake while painting with the Adjustment Brush, just press-and-hold the **Option (PC: Alt) key** and paint over the area where you messed up. When you do this (hold that key down), you're actually swapping over to a different brush that's set up to erase the mask, and since this is a different brush, it actually has its own separate settings. Once you paint a stroke, you can then click on the Erase radio button at the top of the Adjustment Brush panel, and then set your Size, Feather, or Flow settings for the Erase brush at the bottom of the panel. Again, this Erase brush is only available after you've painted a stroke, then you can access the settings by either: (a) pressing-and-holding the Option key and they toggle, as long as you hold that key down, or (b) you can just click on the Erase radio button (as seen above left). *Note:* You can also erase parts of your Graduated Filter (in case there's an area you don't want to be affected by the filter), but it does it differently for this tool: click-and-drag your gradient, then you'll see a Brush radio button at the top right of its panel (as seen above right)—just click on it and then erase over the areas you don't want affected.

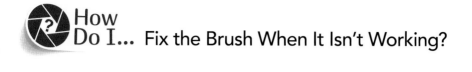

How Do I... Fix the Brush When It Isn't Working?

If you go to your Adjustment Brush and either it doesn't seem to be working right, or it seems very weak, there's a good chance that your Flow and/or Density settings are set very low, or are set to zero. Drag 'em back up (at the bottom of the panel), and you should be up and running again.

How Do I... Know When to Clone Instead of Heal?

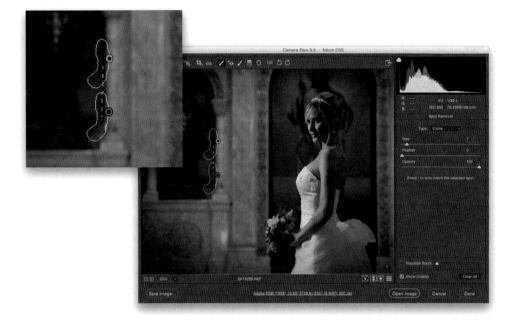

When you're using the Spot Removal tool **(B)** to remove distracting things near the edge of objects using the default Heal setting (which is where you want to keep it most of the time), it tends to smear (as seen in the inset above), and that's your cue to switch to the Clone setting (choose **Clone** from the Type pop-up menu). This changes the method of removal and it usually fixes the smearing problem (as seen above). Also, you might need to drag the Feather slider for the tool to the left and right and see which setting looks best for the current area you're working on—just a simple drag to the left and back to the right and you'll find the sweet spot where it looks best.

How Do I... Draw a Straight Line with the Brush?

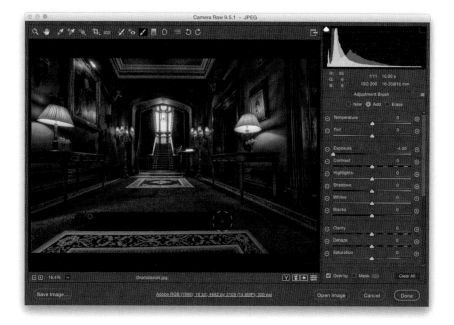

To draw a straight line with the Adjustment Brush, click once with the brush, press-and-hold the Shift key, then move your cursor to where you want the straight line to end, click once, and it draws a straight line between the two points.

How Do I... Keep from Painting Outside the Lines?

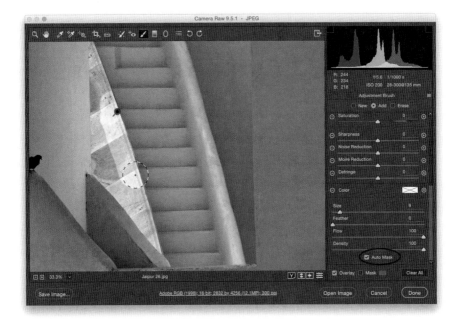

Turn on the Auto Mask checkbox (near the bottom of the Adjustment Brush panel)—this helps to keep you from accidentally having your brush spill over onto areas you didn't want affected by it. With this turned on, only the area under the little plus-sign crosshair in the center of the brush will be affected (see the image above where I'm painting on the wall to the left of the stairs, and even though my brush is clearly extending over onto the stairs, it doesn't brighten the stairs at all because the crosshair is still over on the wall. *Note:* Having this feature on does tend to slow the brush down a bit because it's doing a lot of math while you paint, trying to detect edges as it goes. Also, if you paint over an area and it seems to not cover the area evenly, you might turn off Auto Mask and repaint over that area. As a general rule, I leave Auto Mask turned off most of the time while I'm painting, but as soon as I get near an edge I don't want to affect, I turn it on for just that part of the edit.

How Do I... Keep the Mask Overlay on While I'm Painting?

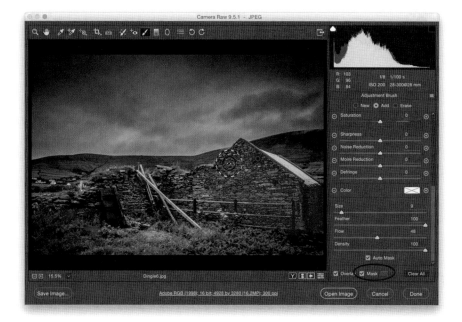

When painting with the Adjustment Brush, you can either press the letter **Y** on your keyboard or you can turn on the Mask checkbox at the bottom of the Adjustment Brush panel. Turning this feature on can be really handy to be able to see the exact area you're affecting, and specifically to see if you missed any areas (that's what I did here, where I saw that I missed an area and was able to quickly paint right over it with the red mask tint turned on).

How Do I... Quickly Change the Size of My Brush?

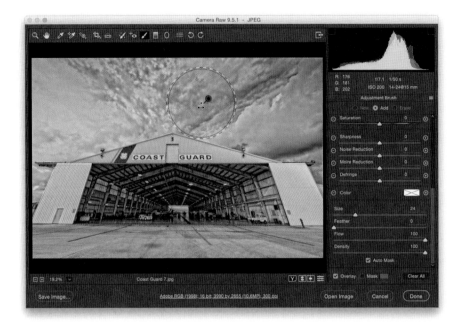

With the Adjustment Brush selected, Right-click on your image, and then drag to the right to make your brush bigger or to the left to make it smaller. You'll totally dig this visual way of resizing, but if for some reason you don't, you can always jump to the next smaller or larger default brush size by using the **Left and Right Bracket keys** on your keyboard (they're located to the right of the letter P). If you're charging by the hour, you can also do it the long way by scrolling to the bottom of the Adjustment Brush panel and moving the Size slider manually.

How Do I... Duplicate an Edit Pin?

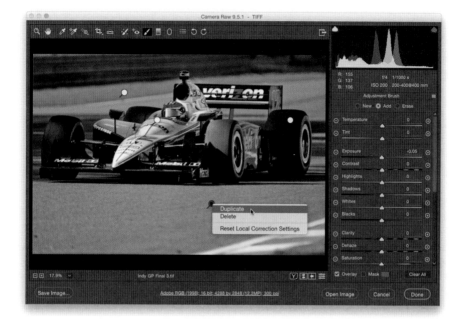

Right-click on the pin you want to duplicate and, from the pop-up menu, choose **Duplicate** (as seen above). This duplicate will appear directly on top of the original, so it'll look like nothing happened, but if you click-and-drag right on the edit pin you duplicated, you'll see you're dragging a copy off to a new location without disturbing the original. Another way to do this is to press-and-hold **Command-Option (PC: Ctrl-Alt)**, click on the pin, and drag it wherever you want it.

How
Do I... Soften Skin?

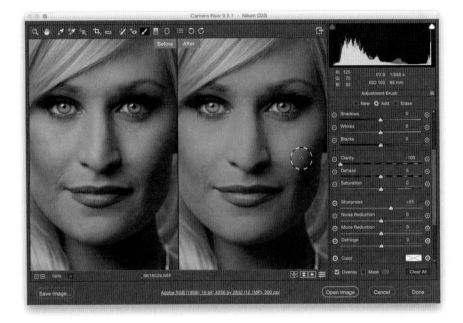

Get the Adjustment Brush **(K)** from the toolbar, and then click on the – (minus sign) button to the left of Clarity four times to reset all the other sliders to zero and set the Clarity amount to –100 (all the way to the left), and then increase the amount of the Sharpness slider to +25. Go ahead and paint over your subject's skin areas (avoiding things like the lips, eyes, eyebrows, hair, eyelashes, nostrils, etc.), and it softens your subject's skin.

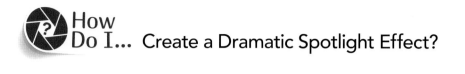

How Do I... Create a Dramatic Spotlight Effect?

Get the Radial Filter **(J)** from the toolbar (it's the fourth icon from the right—it looks like a tall oval), then click-and-drag an oval out over the area of your image where you want to have a spotlight appear. Once you've drawn it, you can resize it using the little handles on the sides, top, and bottom. To move it, just click inside it and drag. To rotate it, move your cursor just outside the oval and your cursor becomes a double-headed arrow—click-and-drag to rotate. With this tool, you have the option to control what happens inside the oval or outside of it. For this effect, we want to affect the outside, so in the Effect section, at the bottom of the Radial Filter panel, click on the Outside radio button (as seen in the inset above). Now, drag the Exposure slider to the left to darken everything outside the oval (as shown above) and this creates the soft spotlight effect.

How
Do I... Fix Foggy or Hazy Areas in My Image?

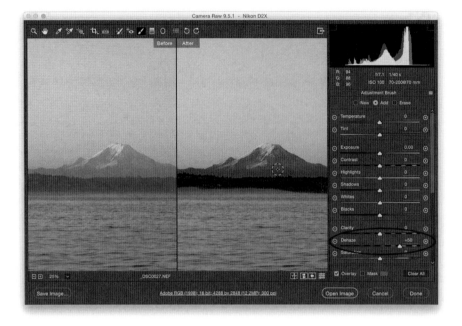

Get the Adjustment Brush **(K)** from the toolbar, and then click on the + (plus sign) button to the right of Dehaze to reset all the other sliders to zero and set the Dehaze amount to +25. Now, paint over areas that are hazy or foggy in your image and the haze goes away (I know, this is a pretty amazing technology). If it doesn't go away enough, increase the Dehaze amount by dragging it to the right. Also, if you actually wanted to add a foggy look (hey, it happens—maybe a nice foggy look to a forest scene), then you'd drag the Dehaze slider to the left and it would now paint hazy fog.

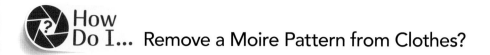

How Do I... Remove a Moire Pattern from Clothes?

Get the Adjustment Brush **(K)** from the toolbar, and then click on the + (plus sign) button to the right of Moire Reduction to reset all the other sliders to zero and set the Moire Reduction amount to +25. Now, paint over any areas of your image that have a visible moire pattern (this often happens on clothing with thin lines in the pattern, like a sports coat, or patterns on luggage or camera bags, where you see a wavy pattern appearing over an area that pretty much messes up everything [as seen above in the Before image]). You can just "paint it away" now (and it usually works pretty remarkably well). If it doesn't go away enough, increase the Moire Reduction amount by dragging it to the right (as I did here).

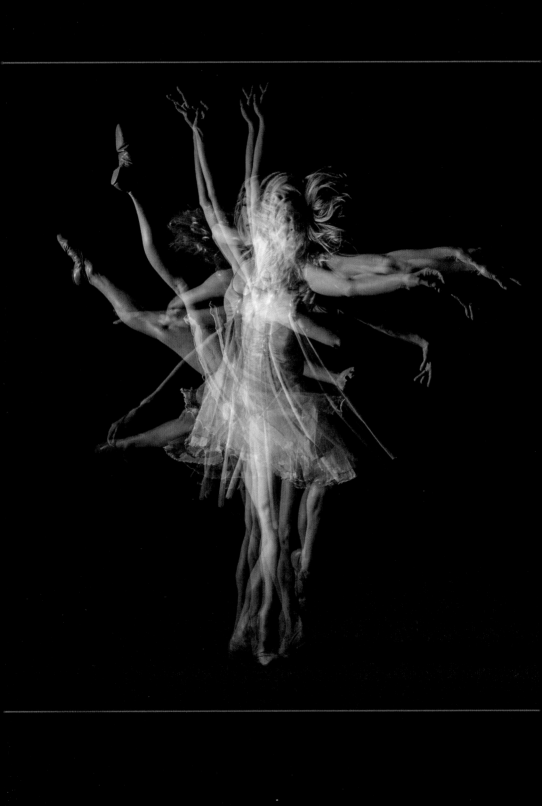

How to Crop, Resize & Stuff Like That

You'll Do This Stuff a Lot

Did you know that the most-used tool in all of Photoshop is the Crop tool? Well, it's true. People apparently crop the daylights out of everything, but there's something else—a word—that we need to focus on here because it's one of the most powerful words in the English language (even more powerful than the word "love"), and that word is "stuff." That's right, you're going to learn some "stuff" and that makes this a very valuable chapter indeed. What exactly is "stuff"? Well, it's not what you think, and most people who have studied linguistics at a university level are surprised to learn that "stuff" is actually not a word, but an acronym that over the years has become so commonly used that it has become a part of our daily vernacular. It stands for "Stuff That Usually Fills Fannies," but for many years what threw researchers off was the fact that an acronym rarely contains the same acronym within the acronym itself (which, by the way, was the inspiration for the 2010 hit movie *Inception*, starring Whoopi Goldberg and Mark Wahlberg). Anyway, over the years, the acronym STUFF has gained such power for its all-encompassing reach to describe a series of random things that *Time* magazine actually chose it as its 2013 "Word of the Year," and His Grace the Duke of Leicester made it a part of the UK's official "Words of Great Distinction" during a coronation in 1998 (which was attended by The Baroness of Heimlich). This honor was just one of many accolades this popular catch-all word has received from academia to governments around the world, who have embraced its charm and usefulness in modern-day society. So, in short, you should embrace this "Stuff That Usually Fills Fannies" with open arms.

How Do I... Crop an Image?

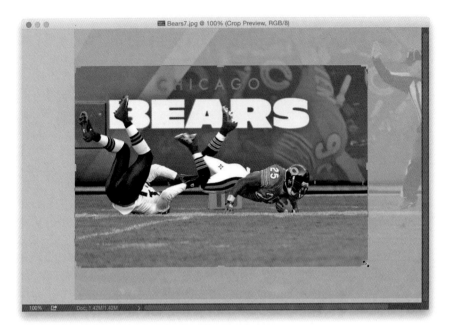

By the way, before I tell you how to crop, if you read the previous chapters on Camera Raw, you might be thinking, "Didn't you just show me how to do all this stuff?" Yes, you can do almost (almost) all of this in Camera Raw, but you shouldn't have to go back to Camera Raw if you need to do a simple crop (interesting fact: once you open a RAW image, and then open Camera Raw as a filter, the Crop feature is no longer there. Weird, I know). Okay, back to cropping in Photoshop. Press **C** to get the Crop tool and it puts a cropping border around your entire image. To crop, click-and-drag on any of the little handles that appear on the sides and corners. To move the entire cropping border, just click inside it and drag it where you want it. To resize the border proportionally, first press-and-hold the Shift key, then click-and-drag on one of those corner or side handles and drag in/out. To flip your crop from wide to tall (or vice versa), just press the **X key** on your keyboard. To rotate your crop, move your cursor outside the cropping border and it changes into a double-headed arrow. Now, you can click-and-drag to rotate the entire crop border. To delete your cropping border altogether, just press the **Esc key** on your keyboard. When the crop is set up just like you want it, press the **Return (PC: Enter) key** to lock in your crop.

How Do I... Crop to a Specific Size?

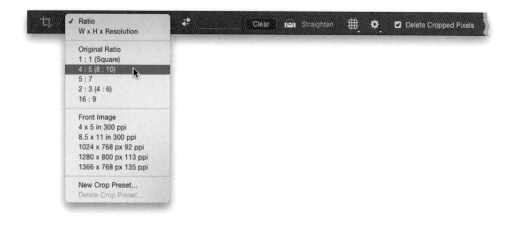

At the left end of the Options Bar, click-and-hold on the preset pop-up menu and a bunch of cropping ratios and sizes will appear. To select a particular crop ratio or size, just choose it from that pop-up menu (like 4 : 5 [8 : 10], for example), and now when you click-and-drag with the Crop tool **(C)**, it's constrained to that 4 to 5 ratio size. If you want to create your own custom ratio or size, just type it in the two fields that appear directly to the right of that pop-up menu (and to quickly clear those figures out, click the Clear button to the right of those fields). By the way, those two little arrows in between the custom ratio fields swaps the two figures (so, clicking on it makes a 5:7 ratio 7:5). If you change your mind and want to reset your crop, hit the **Esc key** on your keyboard. To cancel cropping altogether, hit the **Delete (PC: Backspace) key**.

TIP: MORE CROPPING OPTIONS
Once you have the Crop tool, if you Right-click anywhere inside the cropping border, you'll get a pop-up menu of all sorts of things you can do to your cropping border, including using different preset sizes and resolutions, resetting the crop, etc.

How Do I... Change That Grid over My Crop?

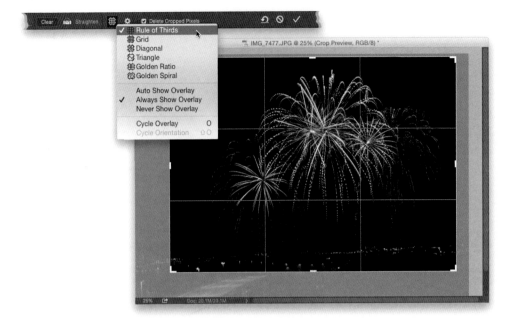

When you start to crop, by default, the Rule of Thirds overlay grid appears over the area you're going to crop to visually help you out (of course, it only helps if you're trying to apply the rule of thirds to your cropping), but you don't have to use that grid—there are a bunch of other choices, like the Golden Spiral, Golden Ratio, Triangle, and others (that would actually make great names for a band). Anyway, you can change your grid pattern, turn it off altogether, or choose when you want to see it by clicking on the Overlay Options icon up in the Options Bar (it's the grid icon just to the right of the word "Straighten") and a pop-up menu of grid patterns appears, along with the option to Never Show Overlay, which hides it.

How Do I... Straighten a Crooked Photo?

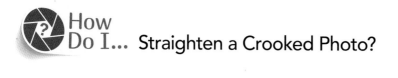

Start by getting the Crop tool **(C)**, and then up in the Options Bar, you'll see the Straighten tool (it says "Straighten" right next to it). Now, just click-and-drag this tool along an edge you want to be straight (for example, in a landscape photo, you'd drag it along the horizon line), and it straightens your photo.

How Do I... Resize an Image?

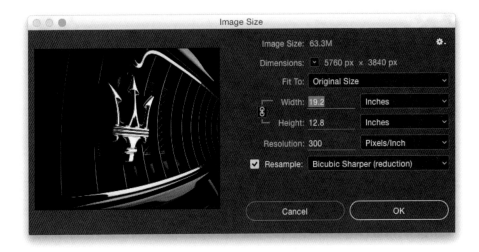

To change the size of your image, go under the Image menu and choose **Image Size** (you might as well learn the keyboard shortcut for this one, because you'll be doing this a lot. Luckily, it's easy to remember: **Command-Option-I [PC: Ctrl-Alt-I]**). This brings up the Image Size dialog where you can type in the size you want (you can change the unit of measurement from the pop-up menus to the right of the Width and Height fields. For example, you can change the measurement from inches to pixels to millimeters, or even a percentage—like decrease the size by 50%). If you click-and-hold on the Fit To pop-up menu near the top of the dialog, you'll find a bunch of presets for common sizes. If you wind up resizing to a certain size often (for example, let's say your website uses images that are 750 pixels wide by 500 pixels deep), you can save this custom size as a preset by choosing **Save Preset** at the bottom of that same menu. When you've input the new size you want, just click the OK button.

How
Do I... Rotate the Crop?

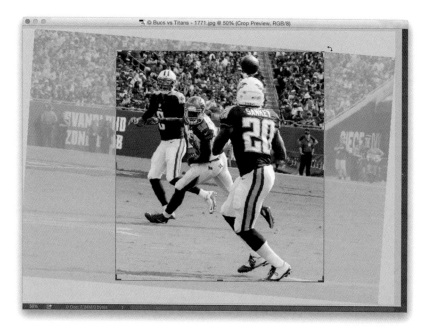

Once you have your cropping border in place, you can rotate it by moving your cursor anywhere outside the cropping border and it will change into a double-headed arrow. Now, you can click-and-drag up/down outside that border to rotate the image (the crop stays in place—it actually rotates your image inside the border).

How Do I... Crop from the Center Inward?

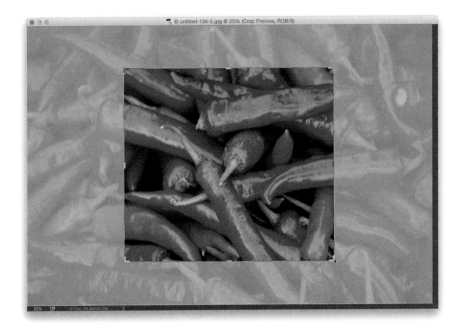

Just press-and-hold the Option (PC: Alt) key before you start to crop, then grab a corner point and drag inward (or outward) and the crop resizes from the center inward (or outward, if you drag out).

How Do I... Add White Space Around My Image?

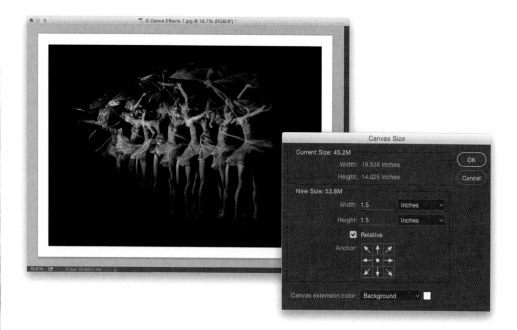

Go under the Image menu and choose **Canvas Size** (the keyboard shortcut is **Command-Option-C [PC: Ctrl-Alt-C]**). This brings up the Canvas Size dialog where you can type in the size of the canvas area you want to add. By default, it shows you the current size, and then lets you type in a new size. For example, if your current image size is 6.2 inches wide by 10.4 inches tall, and you wanted to add 1.5 inches of space all the way around the outside of your image, you'd need to do some simple math and type in 7.7 inches for the width and 11.9 inches for the height. To make this easier, just turn on the Relative checkbox. To then add 1.5 inches of space all the way around, you just type in 1.5 in the Height and 1.5 in the Width fields. No math. Boom. Done. Below that checkbox in the dialog, that little Anchor grid of nine squares is for when you want to choose where to add space. The square with the dot represents your image and, by default, space is added equally around your image (that's why it's in the middle). For example, if you just wanted to add space to the bottom of your image, you'd click on the top-center box of the grid (so now anything you add would appear below your image), and you'd type the amount you wanted to add (we'll say 2 inches) in the Height field only. One more thing: if you want to add space visually, rather than using any math, do this: Click-and-drag out the bottom corner of your image window (to see the area around your image), then press **C** to get the Crop tool, and click-and-drag the cropping border right outside your image to add however much canvas area you want. Press the **Return (PC: Enter) key** and it adds that extra space (in whatever color your Background color is set to).

How Do I... Crop Away Stuff Outside the Edges?

🍎 **Photoshop CC** File Edit **Image** Layer Type Select Filter 3D View

Mode	▶
Adjustments	▶
Auto Tone	⇧⌘L
Auto Contrast	⌥⇧⌘L
Auto Color	⇧⌘B
Image Size...	⌥⌘I
Canvas Size...	⌥⌘C
Image Rotation	▶
Crop	
Trim...	
Reveal All	
Duplicate...	
Apply Image...	
Calculations...	
Variables	▶
Apply Data Set...	
Trap...	
Analysis	▶

In the next chapter (on layers), you'll see that you can have stuff extend right off the screen, so you can't see it, but since it's part of a layer it's still there (you can just click-and-drag it back onscreen. If you're new to layers, this will make a whole lot more sense once you read the layers chapter). To crop away any of that excess stuff that you don't need anymore, just do this: First press **Command-A (PC: Ctrl-A)** to select your entire image area (just what you see onscreen right now). Then, go under the Image menu and choose **Crop**. That crops away any leftover stuff outside the image area.

How Do I... Change the Shading Outside My Border?

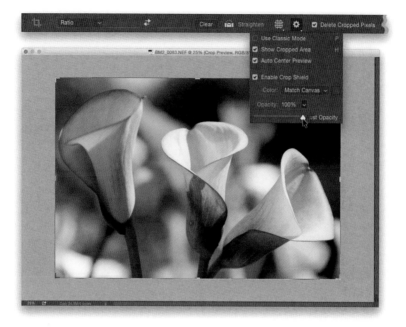

Once you have the Crop tool selected **(C)**, go up to the Options Bar, click on the second icon to the right of the word "Straighten" (it looks like a gear), and a pop-up menu of options appears. Near the bottom of that menu are the Crop Shield options, where you can adjust how dark (or light) the area that you're cropping away appears onscreen before you crop it (by default, it's shaded to 75%). You can change that amount (making it as dark as solid gray, as I did above, to making it completely transparent) using the Opacity slider. You can also pick a different color by choosing Custom from the Color pop-up menu (which might be helpful if you're cropping a black-and-white image. Personally, I don't ever change this color, but don't let that stop you, if you want to).

Chapter 6

How to Work with Layers

This Is Where It Gets Fun

Why did we have to wait until this chapter before things got fun? Here's why: you have to pay your dues. Plain and simple, that's it. Look, if you cracked open the book and starting doing really fun stuff right off the bat, by now you'd be bored. You'd say stuff like, "This was fun when it first started, but now this is just kind of routine," instead of saying what you're thinking right now, which is, "Finally, we're getting to the fun stuff." I think that alone is worth depriving yourself of fun. This was a technique our parents not only invented, but thrived on, and it was literally the fuel in their tank. Remember how, when we were little, our parents used to say stuff like, "One day we'll let you eat solid food like we do, but that's not until you've paid your dues. Now eat your liquefied oatmeal and pea casserole." Man, those were the days. Anyway, they were masters at making us wait for good things, and now we get to pass this time-honored tradition onto our own children by making them always do everything on the Background layer, like back before Photoshop 2.0, before layers were first introduced. But, of course, since the concept of layers hadn't been invented yet, they didn't call the Background layer the "Background layer." Instead (and this is going to sound weird to people who came to Photoshop after version 3.0), they called it simply "Ernie." So, when I did my first few books on Photoshop, when I needed to talk about something happening on that image layer, I'd have to say "head over to Ernie and apply a Levels adjustment" and everybody knew that meant it was time for another serving of liquefied oatmeal and pea casserole. We've waited long enough my friends. Let the fun begin!

How Do I... Create a New Blank Layer? Or Delete One?

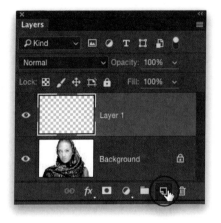

Go to the Layers panel and click on the Create a New Layer icon (it's the second one from the right at the bottom of the panel; its icon looks like a page with the bottom left corner turned up). When you click on that, it creates a new layer above the one you're currently on (as seen above). By default, layers are completely transparent, so at this point your image won't look any different, but you'll see a new empty layer in the Layers panel (named "Layer 1"). By the way, if you press-and-hold the Command (PC: Ctrl) key and click on the Create a New Layer icon, it creates a new layer *below* the current layer, unless of course you're on the Background layer because…well…there's nothing actually under the background. It's the "bottom floor," so to speak. To delete a layer, click on it and then either click on the Trash icon at the bottom of the Layers panel, or just press the **Delete (PC: Backspace) key** on your keyboard.

How Do I... Reorder My Layers?

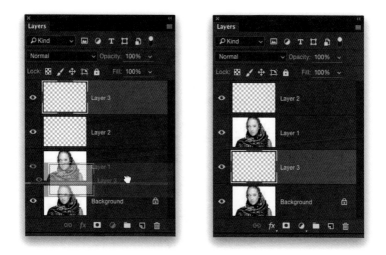

Go to the Layers panel and just click-and-drag the layers into the order you want them (I'm dragging Layer 3 from the top of the layer stack beneath Layer 1 above). They stack bottom to top (like you're stacking papers on a desk), so whatever is on the layer at the top of the stack will cover what is on the layer below it, and so on. Think of your layers as clear sheets of plastic—they're clear until you write on them (for those of you old enough to remember overhead projectors [and you know who you are], it works pretty much the same way—stacking clear sheets of acetate one on top of another. Same idea, just new technology. By the way, don't you miss stagecoaches? And working on a loom? Ahhh, those were the days, am I right, folks? If you're using whiteout to fix mistakes made from your manual typewriter, let me hear a whoop, whoop! Okay, I know, I took it too far. Sorry 'bout that).

How Do I... Hide a Layer from View?

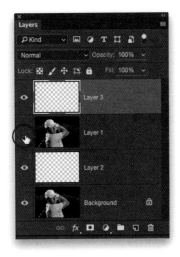

In the Layers panel, just click on the little Eye icon to the left of the layer's thumbnail and it hides that layer from view. To see it again, click where the Eye icon used to be. To see just one particular layer (and hide all the rest), press-and-hold the Option (PC: Alt) key, and then click on the layer's Eye icon. All the other layers will now be hidden, and just that one layer will remain visible. To bring 'em all back, Option-click on that Eye icon again.

How
Do I...
Move a Layer from
One Document to Another?

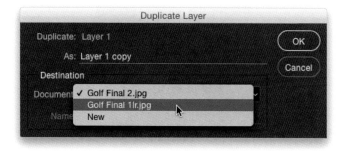

Well, there are a couple ways: (1) Click on the layer you want to copy over to another open Photoshop document, then go under the Layer menu (at the top of the screen), and choose **Duplicate Layer**. When the Duplicate Layer dialog appears, click-and-hold on the Document pop-up menu, and you'll see the name of your other open document (along with the option to create a new one). Choose the document you want this layer copied over to, click OK, and now that selected layer appears in the other document. Or, (2) click on the layer you want to copy over to another open document. Then, us-ing the Move tool (**V**), click-and-hold right on the image itself, in the image window, and drag it onto the other document window. For example, if you have an image of a pear on a layer, click on the pear's layer in the Layers panel, then drag that pear layer right up to the tab of the other open Photoshop document (if you have the Tabs feature turned on in your Photoshop preferences. If not, you'll just drag it right onto the other document). Don't let go yet—keep holding down the mouse button until that document becomes the active document (it'll take just a second or so), then while still holding down the mouse button, move your cursor down into that document. Once your cursor is in the new image area of the other document, let go of the mouse button and your layer appears. It's only kind of funky until you've done it once or twice, and then you'll have the hang of it.

How Do I... Blend My Current Layer with Other Layers?

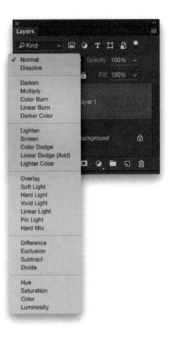

By changing the layer blend mode (from the pop-up menu at the top left of the Layers panel) from Normal (which means, whatever is solid on this layer covers whatever is on the layers below) to any other blend mode (which means, whatever is on that layer now blends in with the layers below, instead of just covering them). For example, if you have a huge image of a peach on your top layer, it'll pretty much cover everything on all the layers below it, but if you change its blend mode, then it blends together with them. How does it blend? Well, that depends on the blend mode that you choose. Here are a few to get you started: Multiply blends while darkening the layer; Screen blends while brightening the layer; Soft Light blends and adds some contrast; Overlay blends and adds a bunch of contrast. To quickly run through all the blend modes to see which one(s) looks good to you, press **Shift-+** (plus sign) and it toggles to the next blend mode. Press **Shift--** (minus sign) to go back to the previous blend mode.

TIP: GET MORE CONTROL OVER BLENDING WITH BLEND IF

In the Layers panel, double-click directly on a layer's thumbnail to bring up the Blending Options in the Layer Style dialog. In the Blend If section, you'll see two sliders with two triangle-shaped slider knobs below them. Press-and-hold the Option (PC: Alt) key, then start dragging any one of those knobs to see how the layer now interacts with the layers below it. *Note:* When you do this, it will split the knob in half. That's what you want, though, as it creates smoother blending.

How Do I... Create a Type Layer?

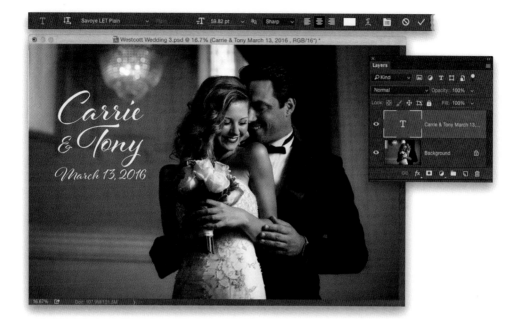

Get the Horizontal Type tool **(T)** from the Toolbox, and then click anywhere in your image and start typing. Boom—you've got a type layer. Now, at this point, as you type, your text will just keep going until it goes right off the edge of your image—it doesn't wrap to the next line like it does in a regular text document (cool thing about layers: things on layers can extend off the image area without getting cut off. Even though you can't see the parts that are off the screen, you can always pull them back into the image area). Back to our story. If you do want your text to wrap to the next line, then don't just click and start typing. Instead, click-and-drag out a text box in the size of the column of text you want. Now when you start typing, when your text hits the end of the text box, it wraps to the next line like usual (as seen above). The rest is pretty much the same: to make changes to your text, highlight it, then up in the Options Bar, choose a new font, style, or size. Most of the type controls you'll use will be up there, including alignment options (left, center, or right), color, etc. But, if you want some more advanced controls, click on the third icon from the right (it looks like a little panel). That brings up the Character and Paragraph panels where there are options to adjust the tracking (space between the letters of a word or words) or kerning (the space between two individual letters), as well as other cool type stuff, like baseline shift, superscript and subscript, horizontal and vertical scaling, and access to ligatures. Now, if any of those made you think, "What? I've never heard of those!" you probably don't need to click on that little panel icon at all. Just stick with the stuff up in the Options Bar, and you'll be good.

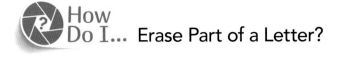

How Do I... Erase Part of a Letter?

First, you have to convert the type from an editible type layer into a layer made of pixels. Then, you can erase it like you drew it with a paint brush. Go to the Layers panel, Right-click on the layer and, from the pop-up menu that appears, choose **Rasterize Type**. That's Adobe speak for "make this type layer into pixels." That's it—it now treats your type like a photo, and you can erase it with the Eraser tool **(E)**, or delete parts of it, and so on. So, the good news is you can convert type into pixels. The bad news is once you do this, you can't go back and edit your type (so, no fixing typos, or changing fonts, etc.). So, make sure you have the font you want, and there are no typos, before you convert your editable type into pixels.

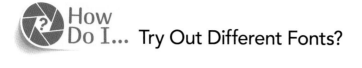

How
Do I... Try Out Different Fonts?

Select your type with the Horizontal Type tool **(T)**, go up to the Options Bar and click on the little down-facing arrow just to the right of the name of the current font, and a pop-up menu of fonts appears. Now, just move your cursor over the menu of fonts, and your type onscreen will change to give you an instant preview of the type in each different font as your cursor passes over it. If you see one that looks good to you, just click on it and your type is now changed to that font.

How Do I... Fill a Layer with a Solid Color?

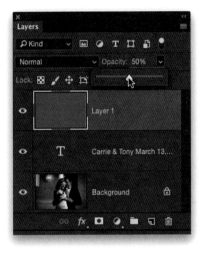

If you want to fill a layer with a solid color, click on the Foreground color swatch at the bottom of the Toolbox to open the Color Picker, choose the color you want to fill the layer with, and click OK. Then, press **Option-Delete (PC: Alt-Backspace)** to fill your current layer with that color. If you want the color to be see-through, then go to the top of the Layers panel and lower the opacity of the layer using the Opacity slider.

How Do I... Make Part of a Layer Transparent?

There are a number of different ways, but what I would suggest is clicking on the Add Layer Mask icon at the bottom of the Layers panel (it's the third icon from the left, circled above). Now, you can take the Brush tool **(B)** and paint away any part of the layer (making it transparent). By default, the Brush tool is set to black, and that makes whatever you paint over transparent. But, unlike just using the Eraser tool (which actually erases things on a layer, and they don't come back), a layer mask is non-destructive, meaning if you mess up and erase too much, you can just switch your Foreground color to white (press the letter **X** to swap your Foreground and Background colors; so, pressing X, at this point, would make your Foreground color white), and paint over those areas you didn't mean to erase, and they come right back. That's because you really didn't erase them in the first place—you put a mask over them when you painted in black. If you didn't want to fully erase part of the layer, but just make part of it a little transparent, then go up to the Options Bar and lower the brush's Opacity setting a bit. The lower the percentage of opacity, the less it erases in one stroke. So, if you want to see through the layer a little, try a low opacity setting for your brush.

How Do I... Duplicate a Layer?

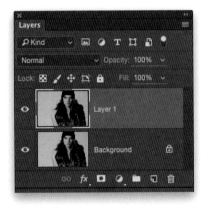

The fastest way is to press **Command-J (PC: Ctrl-J),** and boom—an exact duplicate of your layer, right above the layer you were on. If you're charging by the hour, you can, instead, click on the layer you want to duplicate and drag it onto the Create a New Layer icon at the bottom of the Layers panel (it's just to the left of the Trash icon). That creates a duplicate, too.

 How Do I... Organize My Layers?

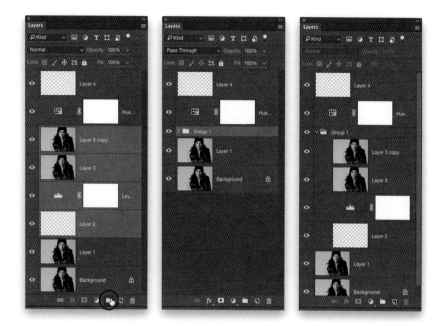

Once you start creating a bunch of layers, you wind up with a long scrolling list in your Layers panel, and it gets hard to quickly find a particular layer in the bunch. So, we do the same thing here for keeping things organized that we do with documents on our computer—we put them into a folder. Folders in the Layers panel are called layer groups, and to add some layers to a folder, first press-and-hold the Command (PC: Ctrl) key, then go to the Layers panel and click on all the layers you want put into the folder. Next, click on the Create a New Group icon (it looks like a folder) at the bottom of the panel (as shown above left; or just press **Command-G [PC: Ctrl-G]**), and it puts all those selected layers into their own folder (well, a "layer group," if you will. As seen above center). This really helps keep your Layers panel tidy (and keeps you from scrolling end-lessly). By the way, you'll notice that when you create the folder it's collapsed, so you don't see the layers inside it. If you want to get to the layers inside, just click on the little right-facing arrow to the left of the folder's name and it expands (as seen above right), so you can access all the layers.

How Do I... Add a Drop Shadow to a Layer?

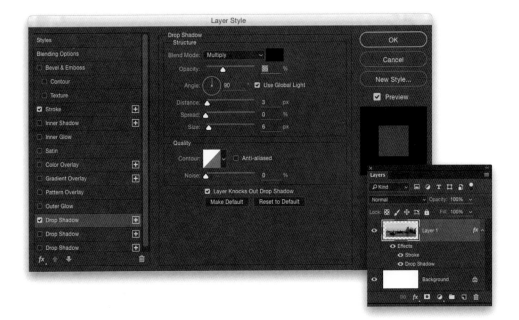

Click on the Add a Layer Style icon (the *fx* icon) at the bottom of the Layers panel and, from the pop-up menu that appears, choose **Drop Shadow**. This brings up the Layer Style dialog and adds a drop shadow to everything on your current layer. To increase the blurriness of your shadow, increase its size by dragging the Size slider to the right. You could change the angle and location using the settings in this dialog, but honestly it's easier to just move your cursor outside the dialog, right into the image itself, and click-and-drag the shadow right where you want it (this is pretty cool—give it a try). Once the shadow is applied, you'll see the word "Effects" appear directly below your layer's thumbnail in the Layers panel, and right below that you'll see Drop Shadow. You'll notice that both have an Eye icon to the left of them. If you click on the Eye icon to the left of Drop Shadow it hides the shadow from view. To make it visible again, click right where that Eye icon used to be. To delete the drop shadow altogether, click-and-drag it down onto the Trash icon at the bottom of the Layers panel. Okay, so what's the "Effects" word mean? Well, a drop shadow is an effect (they're called "layer effects"), but there are other effects you can apply to a layer, like a stroke effect, or a bevel and emboss effect, or an inner or outer glow effect, or a satin effect, and so on. You can apply multiple effects to a single layer (like a stroke and a drop shadow and a pattern). Clicking on the Eye icon to the left of Effects hides all the effects from view at once. Clicking on the Eye icon beside just one of the effects only hides that effect. Get it? (Got it!)

How Do I... Put an Image Inside of Text?

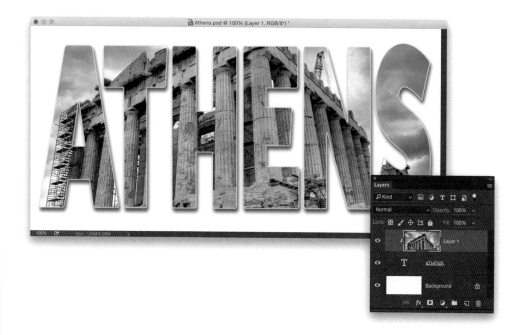

First, get the Horizontal Type tool **(T)** from the Toolbox, click in your document, and create some type (thick bold letters seem to work best for this look). Then, open the photo you want to appear inside this text, and place it into the same document (copy-and-paste it or drag-and-drop it using the Move tool—just get it into the same document). Now, in the Layers panel, make sure your type layer is directly below your photo layer. All you have to do now is press **Command-Option-G (PC: Ctrl-Alt-G),** and it creates a clipping mask, putting the image inside your text. Once it's in there, you can use the Move tool to click-and-drag it around inside the type. To remove the image from the type, use the same shortcut. Also, a cool thing about this is that once your image is inside the type, you can still change your font or size—just click on the type layer in the Layers panel, highlight your type, and then you can change either one.

How Do I... Move the Background Layer (Unlock It)?

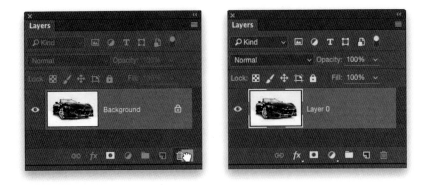

In the Layers panel, click-and-drag the little lock icon (to the right of Background) onto the Trash icon at the bottom of the panel (as shown above left) and it's unlocked (as seen above right). Now you can treat it like any other layer (drag it up or down in the stack of layers).

How Do I... Move Multiple Layers at Once?

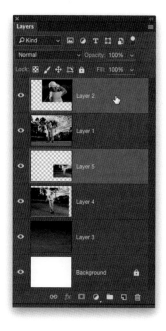

Press-and-hold the Command (PC: Ctrl) key and, in the Layers panel, click directly on the layers you want to move to select them (each layer will become highlighted as you click on it). Once they're all selected, click within one of the selected layers and drag, and everything on all the selected layers will move together as a group.

How Do I... Lock a Layer So It Won't Move?

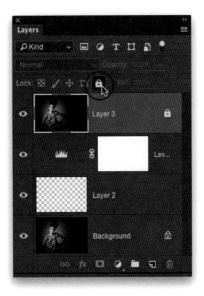

In the Layers panel, click on the layer you want to lock, and then click on the Lock All icon (the little lock) near the top of the panel (as shown above). Now, you won't be able to accidentally move or paint over or basically harm this layer in any way (a little lock icon appears to the right of the layer's name to let you know it's locked). To unlock it, click on that little lock icon to the right of the layer's name.

How Do I... Remove All My Layers and Flatten the Image?

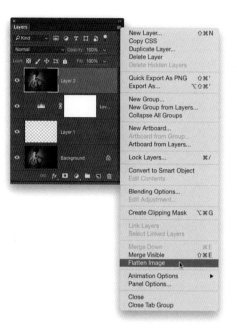

Click on the little icon (with the lines) in the top-right corner of the Layers panel and, from the flyout menu that appears, choose **Flatten Image**. This removes all the layers and just leaves you with the Background layer, which you can now save as a JPEG, TIFF, etc. *Note: There's a shortcut that might work for you, as long as you don't have any layers hidden from view. Press **Command-Shift-E (PC: Ctrl-Shift-E),** which is the shortcut for Merge Visible, and depending on how you have your layers set up, this will usually flatten all your layers down to just the Background layer.

How Do I... Rename a Layer?

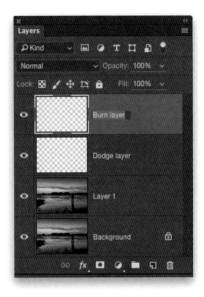

Just double-click directly on the layer's current name (i.e., Layer 1, Layer 2, and so on), and it highlights so you can type in a new name. When you're done, press the **Return (PC: Enter) key** to lock in your new name.

How Do I... Make Two Layers Into Just One Layer?

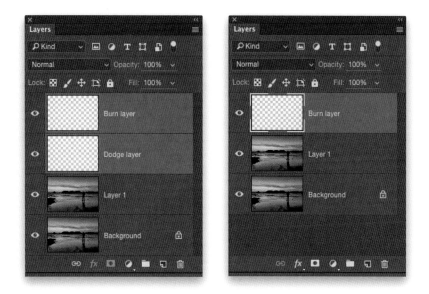

Go to the Layers panel and click on the first layer you want to combine, then press-and-hold the Command (PC: Ctrl) key and click on the other layer you want to combine to select them both. Now press **Command-E (PC: Ctrl-E)** to merge these two layers into one. By the way, this doesn't just work with two layers, you can select as many layers as you'd like, and then use this shortcut to combine them.

How Do I... Separate a Drop Shadow from a Layer?

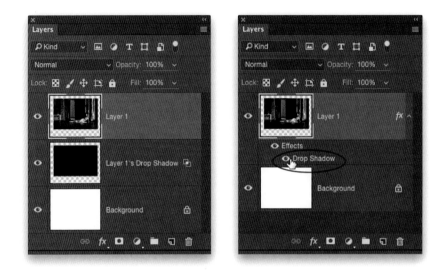

You can remove a Drop Shadow layer style from your current layer and have it appear on its own separate layer (so you can edit it on its own, erase parts of it, etc.) by going under the Layer menu, under Layer Style, and choosing **Create Layer**. Now the drop shadow is no longer attached to the layer—it's on its own separate layer directly below the original layer (as seen above left). They're no longer linked together in any way, so you can treat it as a completely separate layer. If you just want to hide it from view temporarily, click on the Eye icon to the left of the word "Drop Shadow." Click where the Eye icon used to be to bring it back. If you want to remove the drop shadow altogether, click directly on it under the layer and drag it onto the Trash icon at the bottom of the Layers panel.

How Do I... Organize Layers Using Colors?

If you want to visually separate your layers by color (making it easier to spot certain layers), just go to the Layers panel, Right-click on the layer you want to color code and, at the bottom of the pop-up menu that appears, you'll see a bunch of different colors to choose from. Click on the color you want, and you'll see that the left side of that layer (the area with the Eye icon) is now tinted with that color. To remove a color from a layer, do the same thing, but choose **No Color** from the pop-up menu.

How Do I... Lower a Layer's Opacity without Affecting the Opacity of the Drop Shadow?

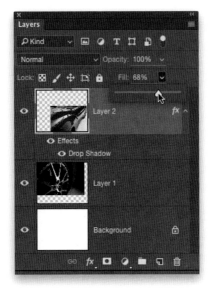

If you lower a layer's Opacity amount (near the top of the Layers panel), it lowers the opacity of everything on the selected layer—your object and its drop shadow (or any other layer style you applied from the Add a Layer Style icon's pop-up menu, see page 126). However, if you want to keep the drop shadow (or other effect) fully at 100%, but want your object to be more transparent, don't use the Opacity slider. Use the slider right below it—the Fill slider—instead. Try this once, and you'll totally get it.

How Do I... Quickly Sort My Layers?

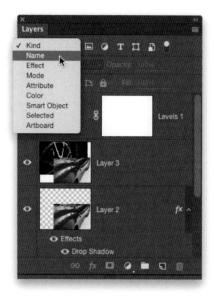

At the very top of the Layers panel is a row of filters that let you narrow things down in the panel. In the top left is the Filter Type pop-up menu where you can choose categories of layers to sort through. For example, the default is Kind, and to the right of it are a bunch of one-click sorting icons: click on the first one to see just your image layers, the next to see just adjustment layers, the next to see your type layers, the next to see shape layers, and the next to see smart object layers. If, instead, you choose **Name** from that pop-up menu, a field appears where you can type in a layer's name (well, if you know it). Each category you choose displays a different set of sorting options to the right of it, and they're all there to help you when you have a huge stack of layers.

How Do I... Change Layers without Going to the Layers Panel?

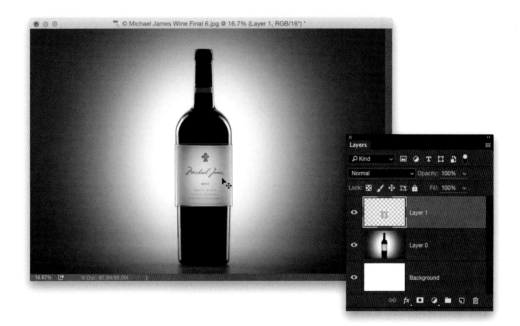

Use this shortcut: Press-and-hold the Command (PC: Ctrl) key and, in the image itself, click on something on the layer you want to jump to (as shown above), and it makes that layer active. It's as easy as that. *Note:* The only time this doesn't work is if you have the opacity of a layer set really, really low, like below 30%. When you Command-click, that less-than-30% area won't have enough opacity to register as a layer. This probably won't happen to you—if it does, it will be very rare—but at least you'll know why, if one day it doesn't work.

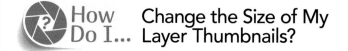

How Do I... Change the Size of My Layer Thumbnails?

In the Layers panel, Right-click in the blank area right below your Background layer (click-and-drag out the bottom of your panel, if needed). This brings up a pop-up menu where you can choose a larger or smaller size for your thumbnails (I use Large Thumbnails for mine, but that's because I don't use a ton of layers. It's rare for me to have more than five or six, so I don't mind having to scroll a bit, if I go beyond that).

How Do I... Blend One Photo with Another?

Start by putting each image on its own separate layer, and make sure they overlap (after all, if they don't touch, they can't blend). Click on the top image layer, then click on the Add Layer Mask icon at the bottom of the Layers panel. Nothing happens visually at this point (except that it adds a mask to the right of that layer in the Layers panel). The next step is where we blend. Get the Gradient tool (G) from the Toolbox, choose Foreground to Transparent from the Gradient Picker in the Options Bar, and click on the Linear Gradient icon next to the Picker. Press the letter X to set your Foreground color to black, and then click-and-drag the tool either from left to right or top to bottom (or both, if you need to). Where you start clicking-and-dragging is where the image on top will appear transparent and, as you drag, the image will blend into the background image (which is what it's doing, by the way). If you don't like how it blends at first try, press **Command-Z (PC: Ctrl-Z)** to Undo and just click-and-drag again. If you don't like the results at all, go to the Layers panel, click on the layer mask's thumbnail, to the right of your layer's thumbnail, and drag it onto the Trash icon at the bottom of the Layers panel.

How Do I... Align or Center Multiple Layers?

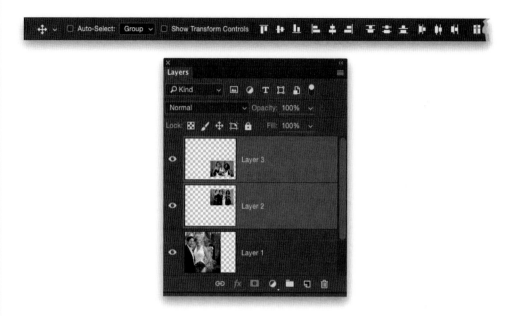

In the Layers panel, click on the first layer you want to center (or align), press-and-hold the Command (PC: Ctrl) key, and then click on any other layers you also want to center or align to select them, as well (I often align things to the document by choosing the Background layer first, then I Command-click on any other layers I want centered). Now press **V** to get to the Move tool, then go up to the Options Bar, and you'll see two sections of alignment icons (just to the right of Show Transform Controls). The icons give you a tiny preview of what each does. In the first section, the second icon centers vertically, and the fifth icon centers your selected layers horizontally. The other icons align the objects on your selected layers to the left or right, or the top or bottom. The second set of icons are for distributing the items on your layers (controlling the space between them equally).

How Do I... Put a Stroke Around Something on My Layer?

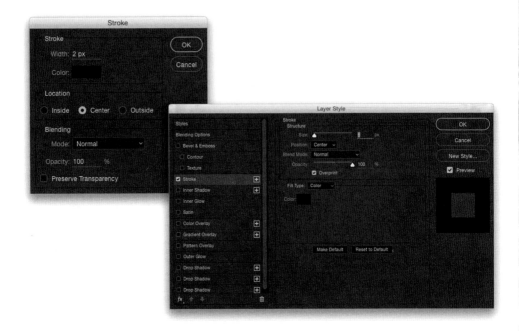

There are two ways: The way I most often do it is to go to the Layers panel, press-and-hold the Command (PC: Ctrl) key, and click directly on the layer's thumbnail. This puts a selection around anything on that layer. Once that selection is in place, I go under the Edit menu and choose **Stroke**. This brings up the Stroke dialog (seen above left) that lets you choose how thick you want this stroke, the color, and the location of where you want it placed (I normally choose Center, so the stroke is half outside the selection and half inside). Click OK and it applies the stroke, but then you'll need to deselect by pressing **Command-D (PC: Ctrl-D)**. The second method is to apply a layer style to the entire layer, and anything on that layer gets an editable stroke. Click on the Add a Layer Style icon at the bottom of the Layers panel, choose **Stroke**, and it brings up the Stroke options in the Layer Style dialog, where you can choose how you want the stroke to look. It now treats that stroke pretty much the same way it would treat a drop shadow you added the same way—you can remove it, hide it from view, and so on, the same way (see page 134).

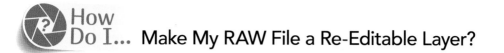

How Do I... Make My RAW File a Re-Editable Layer?

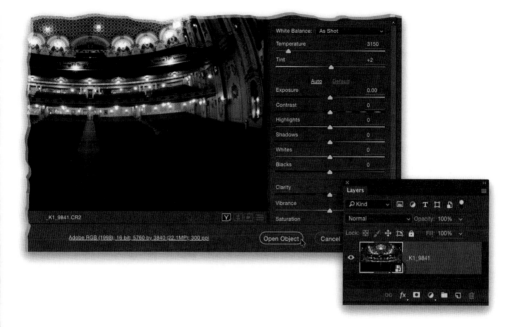

When you're in Camera Raw, before you hit the Open Image button to open your RAW image in Photoshop, press-and-hold the Shift key and you'll notice that Open Image button changes into Open Object. Click that and the image opens as a smart object layer (you'll see that it's a smart object layer because it adds a little page icon to the bottom-right corner of your layer's thumbnail; shown circled above), and that makes your RAW image re-editable at any time by just double-clicking directly on that layer's thumbnail. When you do that, it re-opens the original RAW image in Camera Raw, so you can tweak or change it, and when you click OK, it updates the layer.

How to Adjust Your Image

Tweaking Your Image

Is there anything that matters more than how your image looks? Well, there is the goal of world peace and all that stuff, but beside world peace and raising our families in an environment that respects and values them, how an image looks matters most. Well, perhaps I left out affordable healthcare for everyone, everywhere. That certainly matters, but those aside (and not counting being fully prepared to survive in the coming zombie apocalypse), I have to imagine how your image looks is really important (as long as we're not counting things like access to fresh water, the basic rights of freedom, access to high-speed Internet without limits on your data plan, and the fact that all people should have either a Netflix or Hulu subscription provided by their government). Well, that and the ability to have a walk-on, speaking role on your favorite TV sitcom. I mean that should be an unalienable right, but I'm not sure how that would play out because only so many people can be on any one episode of anything. So, let's go back to the image thing, which for me, and many photographers out there, is the #1 thing, as long as nobody's counting Miranda rights, because those are pretty important because your chances of being arrested while using a tripod are significantly higher than the population at large, including people with unlicensed weapons who have filed the serial number off so it can't be traced. Because, as we all know, the thing we have to fear most as a rational, democratic society is that a photographer should somehow take a shot in a low-light situation and not get a blurry picture. If that happens, society as we know it will collapse, with chaos in the streets, and that leads to voter fraud, which as we all know leads to promiscuous behavior, and that is why we lost the war.

How Do I... Adjust My Image Using Levels?

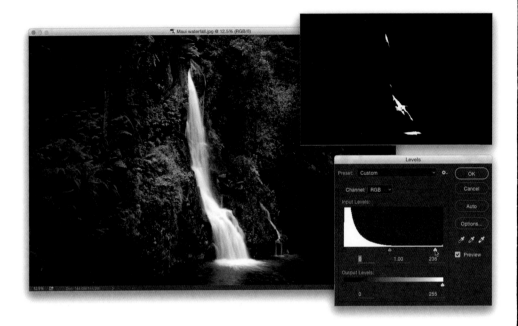

Go under the Image menu, under Adjustments, and choose **Levels** (or use the keyboard shortcut **Command-L [PC: Ctrl-L]**). The first thing we normally do in the Levels dialog is expand the tonal range of the image by making the brightest parts of the image as bright as possible without clipping the highlights, and then do the same thing to the shadows. Here's how: Press-and-hold the Option (PC: Alt) key, and then click-and-hold on the highlights slider (the white slider beneath the histogram). This turns the image black. Start dragging the slider to the left until you see white areas start to appear (as seen in the inset above). Those white areas are a warning, letting you know that those parts of the image have become so bright that they're clipping, so back off a little until they go away. Now do the same thing with the shadows slider (the dark gray slider beneath the histogram), but instead of turning black, the image turns white. Drag to the right, and as you do, the first things that appear in black are the shadows clipping, so back off a little. Lastly, you can control the overall brightness using the center midtones slider (the light gray one beneath the histogram). Now that I've said that, I want you to know that I rarely use Levels in my own workflow. It's kind of an "old school" way to adjust your images (same thing for Curves on the next page). The workflow today is to use Camera Raw, either before you open the image, or as a filter after it's already open in Photoshop (see Chapter 3 for more).

How Do I... Use Curves to Add Contrast?

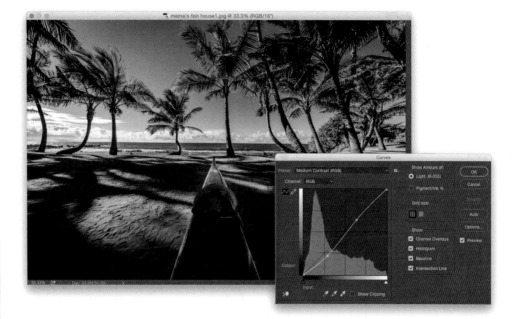

Go under the Image menu, under Adjustments, and choose **Curves** (or use the keyboard shortcut **Command-M [PC: Ctrl-M]**). While you can use Curves to set your overall highlights, midtones, and shadows (like we did with Levels on the previous page), today we mostly use it to add contrast (when you want more contrast than the Contrast slider in Camera Raw will give you). When the Curves dialog opens, you'll see a graph in the center and a diagonal line—we adjust that line to create contrast. At the top of the dialog, you'll see a pop-up menu of presets that add (or take away) contrast. Just for now, choose Medium Contrast (as seen above), and you'll see that diagonal line take the form of a subtle S-shape (we call it an S-curve). The steeper that S-curve gets, the more contrasty your image will look. Now choose Strong Contrast and look at the S-curve—it's much steeper and your image looks much more contrasty. You can edit the curve manually by clicking-and-dragging on the adjustment points that now appear on the curve, or you can add your own points by clicking once anywhere along the curve. To remove a point, click on it and drag it quickly off the curve. Again, as I said on the previous page, for photographers, this is kind of an "old school" way to adjust your image—the more modern workflow is to use Camera Raw, either before you open the image, or as a filter after it's already open in Photoshop (again, see Chapter 3).

How Do I... Remove Color Casts?

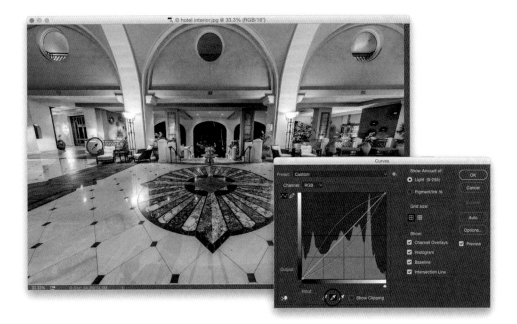

There are a bunch of ways to do this, like by using either Curves or Levels (the way we're doing it here, it works the same way with either). So, press **Command-M (PC: Ctrl-M)** to bring up the Curves dialog, then click on the middle eyedropper (the one half-filled with light gray) beneath the histogram. Now, click on something in your image that's supposed to be a light gray, and that will take care of the color cast. If you click it and it doesn't look right, try clicking it somewhere else. My preferred method, though, would be to open Camera Raw and use the White Balance tool: Go under the Filter menu and choose **Camera Raw Filter**. When the Camera Raw window appears, get the White Balance tool **(I)** from the toolbar up top and click on something in the image that's supposed to be light gray. Again, if you click it and it doesn't look right, try clicking it somewhere else until it looks right to you.

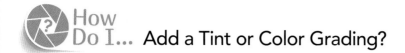

How
Do I... Add a Tint or Color Grading?

Here's what I do: Go to the bottom of the Layers panel, click on the Create New Adjustment Layer icon (it's the fourth one from the left; its icon looks like a circle that's half white/half black), and choose **Color Lookup** from the pop-up menu. When the Color Lookup options in the Properties panel appear, click-and-hold on the 3DLUT File pop-up menu, and you'll find a list of color tints and color grading looks you can apply by just choosing one from this menu (seen above left). These changes appear as their own separate layers in the Layers panel, so you can reduce the intensity of any look by simply lowering the Opacity (near the top right of the panel) of that Color Lookup layer. If you want more of a solid color tint, first trash that Color Lookup adjustment layer you just added (click-and-drag it onto the Trash icon at the bottom of the panel) and try this: From the Create New Adjustment Layer's pop-up menu, choose **Solid Color**. When you do this, it brings up the Color Picker where you can choose the color tint you want. So, choose a color, then click OK. This puts a solid color over your image (not what you want, right?), so change the layer blend mode (near the top left of the Layers panel) from Normal to **Color**. That makes the solid color appear as a tint and blends it with your image (rather than it being a solid color that covers it). Now you can reduce the intensity of your color tint by lowering the Opacity of that Color Fill layer (as shown above right).

How Do I... Deal with Too Much of a Particular Color?

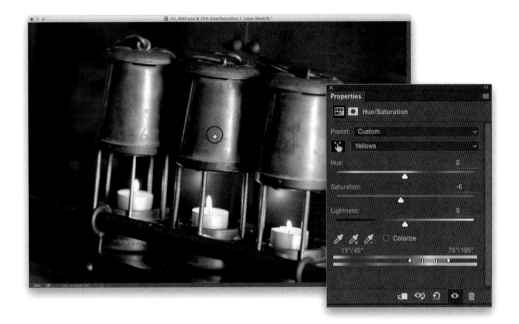

If you have a color that's too intense in your photo (for example, your reds are too red, which is pretty common in some cameras), try this: Go to the bottom of the Layers panel, click on the Create New Adjustment Layer icon (it's the fourth one from the left; its icon looks like a circle that's half white/half black), and choose **Hue/Saturation** from the pop-up menu. When the Properties panel appears, click on the little hand icon to the left of the pop-up menu set to Master (near the top of the panel), then click it on an area in your image that has the color you want to reduce, and drag to the left. This reduces the intensity of that color (and vice versa—dragging it to the right increases the saturation of that color).

How Do I... Match the Color of One Photo to Another Photo?

Open the image that has the overall color tone that you like (we'll call this the "source image"), and then open the photo you want to match the color of your source image to (so you have both photos open). Make sure the photo that has the color you want to change is the active image window, then go under the Image menu, under Adjustments, and choose **Match Color** to bring up the Match Color dialog. Near the bottom of the dialog, in the Image Statistics section, choose the source image (the photo that has the right color tone) from the Source pop-up menu, and it instantly matches the tones in your active image to the tones in the source image. This does a pretty nice job most of the time, but of course it always depends on the image (for example, if you try to match the overall tone of a shot taken at night in a city with one that was taken at high noon in a forest, it's probably not going to be a decent match). The idea here is to match images taken in a similar environment and make them all pretty much look the same, and if that's the case, this technique will usually be spot on.

How
Do I... Use Camera Raw on My Image
Already Opened in Photoshop?

You can apply Camera Raw as a filter to your already opened image by going under the Filter menu and choosing **Camera Raw Filter**. Now you can use Camera Raw like usual (the one thing you'll see missing from it, though, is the Crop tool. When you use it as a filter, the Crop tool doesn't appear—you have to do that manually in Photoshop, which is why I covered cropping in both the Camera Raw chapter [Chapter 3] and in Chapter 5). When you're done, click OK and it applies any changes to your image.

How Do I... Have Photoshop Auto Fix My Photo?

There are a few different auto corrections Photoshop can do, and each of them creates a different look, so you might have to try more than one to see which looks best on your particular photo. First, I'd try Auto Tone: go under the Image menu and, near the top, choose **Auto Tone**, and see how that looks. If it doesn't look good, press **Command-Z (PC: Ctrl-Z)** to Undo that auto correction, and then try Auto Contrast from that same menu (which is focused more on adding contrast, but that may be what your image needs). If that doesn't look good enough, undo that and then try the next one down—Auto Color. If none of those look good to you, go under the Filter menu and choose **Camera Raw Filter**. When the Camera Raw filter window appears, click the Auto button (it looks more like a link than a button—it's under the White Balance sliders). If your image seems too bright now (as is sometimes the case with this auto correction in Camera Raw), just lower the Exposure slider a bit until it looks right to you.

How Do I... Make My Adjustments Un-Doable Forever?

Instead of applying an adjustment directly to your image (by going under the Image menu, under Adjustments, and choosing the adjustments there, like Curves, or Color Lookup, or Hue/Saturation, etc.), choose any one of these adjustments from the Create New Adjustment Layer icon's pop-up menu at the bottom of the Layers panel (it's the fourth icon from the left, and it looks like a circle that's half white/half black). This adds the adjustment as its own separate layer above your current image layer, which you can re-adjust at any time (just click on that adjustment layer and the controls reappear in the Properties panel) or delete permanently by dragging that adjustment layer onto the Trash icon at the bottom of the Layers panel. Here's why this is such a huge advantage: Normally, when you work in Photoshop, you get 20 undos. After that, it won't undo any more steps. However, by applying these image adjustments as adjustment layers (rather than choosing them from the Image menu, under Adjustments), and saving this file as a layered Photoshop file with all those layers intact, you could reopen this layered file and edit or delete an adjustment next week, next year, or even 10 years from now. So, it's like an undo that lives forever. Of course, if you flatten the file, all your layers go away. So, to retain this "edit forever" capability, remember to save a version of your image with all those layers intact (save it in Photoshop [PSD] format—that keeps your layers intact—rather than saving it as a JPEG, which flattens your image).

How Do I... Convert to Black and White?

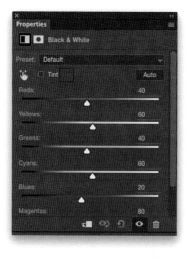
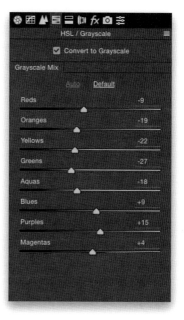

Click on the Create New Adjustment Layer icon at the bottom of the Layers panel (it's the fourth one from the left; its icon looks like a circle that's half white/half black), and choose **Black & White** from the pop-up menu. When the Properties panel appears (shown above left), your image is already converted to black and white, but you can tweak that conversion by moving the color sliders in the panel, and you'll see instantly onscreen how adjusting those colors in the color version of the image affects the black-and-white conversion. At the top of the panel, there is a pop-up menu with a bunch of presets you can try (some are pretty decent, but of course, it all depends on your image, right?), and there's an Auto button below for an auto black-and-white conversion (it's worth clicking on—if you don't like what it does, just press **Command-Z [PC: Ctrl-Z]** to Undo it). Camera Raw has a similar black-and-white conversion feature, if you prefer to do it there. Open a color image, then go under the Filter menu and choose **Camera Raw Filter**. In the Camera Raw filter window, click on the fourth icon from the left, under the histogram, to access the HSL/Grayscale panel (shown above right). Now, turn on the Convert to Grayscale checkbox at the top of the panel to make your image black and white. You can also use the sliders below to tweak your image, just like you would in Photoshop.

155

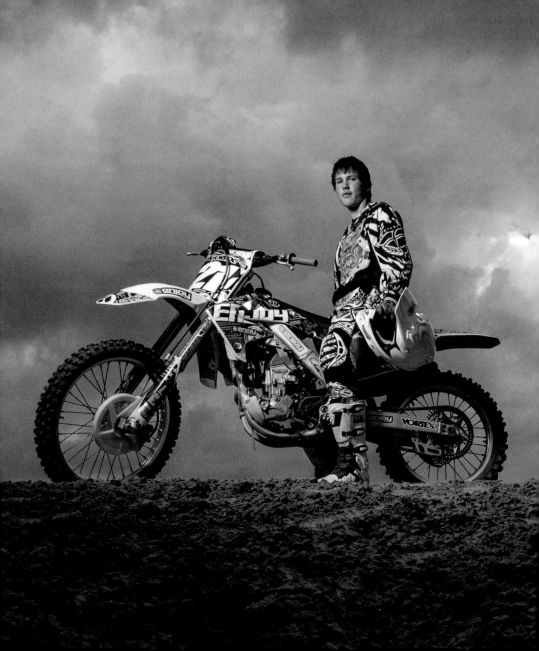

How to Fix Problems

And There Will Be Problems. With Your Images. Not with Photoshop. Well, Hopefully

The human eye is an amazing thing—capable of viewing an incredible range of light, unless of course, you get a tiny eyelash in your eye. Then, not only your eye, but your entire being, becomes fixated on getting this tiny eyelash out, and you basically are paralyzed and unable to do anything else during this time, even though you have another perfectly functioning eye sans the eyelash. You'd think that something as thin as a hair would not be able to stop a 6' tall, moving, breathing miracle of science, but one tiny eyelash, and basically "the jig is up." Now, let's compare that to the sensor in your camera, which cannot capture nearly as wide a range as your eye can. Take an eyelash—heck, take 10 eyelashes—and put them on your lens and see what happens. Nobody cares. You brush them away and keep shooting. This is why we have so many problems caused by either our lenses or our eyes, or our sensors, or the stray eyelash or two. It's kind of like the Death Star—here's this giant planet-sized space station/ weapon, but there's this one little spot where, if you hit it with as much as an Airsoft pellet, it takes the whole thing down. It's the Galactic Empire's version of an eyelash in the eye (and we know how things spiral down from there). Anyway, because of this discrepancy between what your eye sees, and what your sensor captures, you'll have to deal with problems from time to time, and Photoshop is the tool to fix these issues. It actually would have been helpful for hiding a small thermal exhaust port that would later be targeted by a trio of Y-Wings from Red Squadron, and well, let's just say that it all could have been avoided by using the Clone Stamp tool. Just sayin'.

How Do I... Realistically Fill in Gaps in My Image?

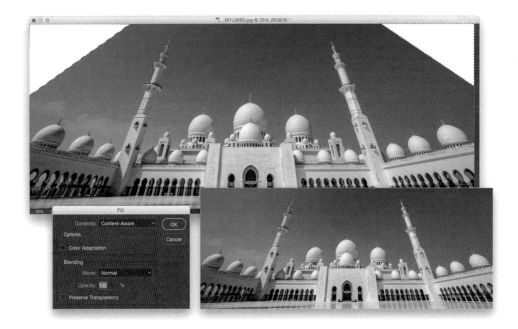

Start by making a selection of the area you need to fill in (like the gaps that appeared when I created this pano. I just clicked in them with the Quick Selection tool **[W]** to easily select them), then go under the Edit menu and choose **Fill**. When the Fill dialog appears, if it's not already selected, choose **Content-Aware** from the Contents pop-up menu. When you click OK, Photoshop looks at the surrounding area, and then rather than just filling with white or black, it makes an intelligent fill based on how that surrounding area looks. It does a pretty brilliant job of it most of the time (as seen in the inset above). When it doesn't, though, it misses by a country mile and it looks terrible. So, if (when) that happens to you, you'll just have to undo it **(Command-Z [PC: Ctrl-Z])** and then find another way to fill it in manually, usually using the Clone Stamp tool (see page 166).

How Do I... Fix Images of Buildings (Lens Problems)?

Lens problems happen quite often, but they're generally the most obvious in photos of buildings (especially when they're taken with a wide-angle lens), where you see a building bowing out or leaning back. Anyway, fixing it is usually just two clicks: (1) Go under the Filter menu and choose **Lens Correction**. (2) In the Auto Correction tab, make sure the Geometric Distortion checkbox is turned on (as seen above left)—this has Photoshop look through its built-in database of lens correction profiles and, if it finds a match (and there's a really good chance it will), it fixes the lens distortion. In the Search Criteria section, if it found a profile for your camera/lens combination, you'll see the make of your camera and the name of your profile. If you see Choose a Camera Make, that's your cue that it didn't automatically find one. The good news is, generally, all you have to do is choose your camera make, and suddenly it figures out the lens (go figure). Anyway, if you need to tweak anything manually after that, click on the Custom tab, where you can tweak everything from the bulging (Remove Distortion) to rotation and the leaning back problem (Vertical Perspective). This is going to sound really simplistic, but it works— just drag each slider all the way to the left, then all the way to the right, and you'll quickly see what each does and how it affects your image. Now that I've said all this, the Lens Correction filter is not my first choice to fix this. I would fix this problem using Camera Raw's Lens Corrections (see Chapter 3) because it has the Automated Upright feature that fixes a lot of this stuff for you automatically. But, if you don't want to use Camera Raw as a filter, then this would be your next best bet.

How Do I... Remove Purple or Green Fringe?

Go under the Filter menu and choose **Lens Correction**, then zoom in really tight on an area that has this color fringe problem (these are chromatic aberrations). Now, click on the Custom tab and drag the Chromatic Aberration slider that matches the color fringe problem you're having to the right until the color fringe is gone (you might have to move more than one slider). That being said, I prefer to use Camera Raw's Lens Corrections to remove chromatic aberrations because it has an automatic function you can turn on, and often doing just that will fix the problem (see Chapter 3 for more). To do it this way, go under the Filter menu and choose **Camera Raw Filter**, and then click on the Lens Corrections icon (it's the fourth one from the right, under the histogram). In the Lens Corrections panel, click on the Color tab at the top of the panel, and then turn on the Remove Chromatic Aberration checkbox. If that doesn't fully do the trick, you can drag the Purple or Green Amount sliders to the right just enough to where the fringe goes away (don't forget to zoom in tight on a fringe area, so you can clearly see the problem before adjusting the sliders. That way you don't overadjust). One more thing: those Hue sliders under the Amount sliders are to help you target the exact hue of purple or green that's causing the problem. So, if raising the amount didn't fix the problem, you might have to move a Hue slider until it targets the right hue of purple or green to make it go away.

How Do I... Safely Stretch My Image to Fit?

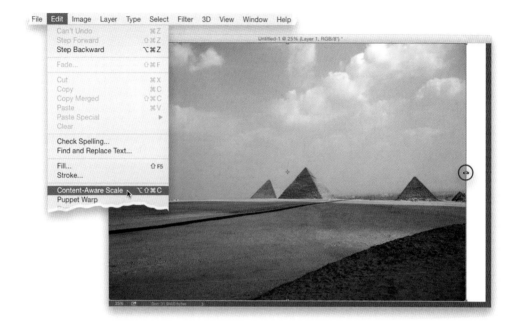

If you need to expand the edge areas of your image (maybe to make it fit a particular size, like a full-bleed to the edges on an 8½x11" paper size), you can use some Photoshop magic that will stretch out unimportant parts of your image (or even shrink them in), usually without stretching the important parts. Here's how it works: Click on the layer you want to stretch, then go under the Edit menu and choose **Content-Aware Scale**. Now, literally, just grab a side or corner point and start dragging in the direction you want (as seen above), and it somehow figures out what's important in the image and it tries to lock that part down—so, if you're adjusting a landscape photo, it would just stretch the sky without pulling the mountains upward. It does a really amazing job, and it's incredible how much you can often stretch without messing up your image. When you're done, just hit **Return (PC: Enter)** to lock in your very smart stretching, thanks to Content-Aware Scale. One more thing: If there are people in your photo, once you choose Content-Aware Scale, but before you actually stretch the image, click on the Protect Skin Tones (the little person) icon up in the Options Bar. That helps it to know to look for people and not stretch them.

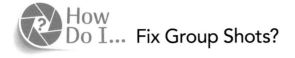

How Do I... Fix Group Shots?

If you have someone in your group shot that's not looking at the camera (as seen in the inset above at the top) or has their eyes closed or a bad facial expression, we generally take their eyes (or expression) from another group shot (you took more than one, right? Always take three or four for just this reason) and replace it with their eyes (or better expression) from the other shot. It's easier than you think. Go to the shot with the good eyes and, using the Lasso tool **(L)**, put a loose selection around their entire eye area (sockets, eyebrows, the whole nine yards). Then, to soften the edges of your selection (so it isn't super-obvious what you did), go under the Select menu, under Modify, and choose **Feather**. It depends on the resolution of your image, but I generally use a Feather Radius amount of 5 to 10 pixels (the higher the image resolution, the higher number you'll need to use. With a 50-megapixel or more camera, you might need 20), and click OK. Now, press **Command-C (PC: Ctrl-C)** to Copy their eyes into memory (if it's their entire facial expression, you do the same thing—just copy their entire face, but not their hair). Next, go to the group shot where everybody else looks fine but them, and press **Command-V (PC: Ctrl-V)** to Paste the eyes (or face) into the photo. They'll appear on their own layer, so you can use the Move tool **(V)** to drag the good eyes over the bad ones. The key to perfectly lining these eyes (or face) up is: once you have them over the other eyes, lower this layer's Opacity, so you can perfectly position them by seeing the original eyes or eye sockets from the layer below. This allows you to line things up, so it's a perfect match (as seen above. Don't forget to raise the Opacity amount back to 100% when you're done).

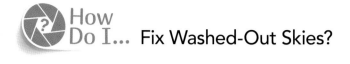

How Do I... Fix Washed-Out Skies?

While there are ways to do this in Photoshop itself, the best results come from using Camera Raw's HSL controls (I know, I sound like a broken record). From the Filter menu choose **Camera Raw Filter** (or, ideally, do this to your RAW image in Camera RAW before you open it in Photoshop as an 8-bit or 16-bit image). Then, click on the HSL/Grayscale icon (it's the fourth one from the left) beneath the histogram. Click on the Luminance tab (that's what the "L" in HSL stands for—Luminance), and then simply drag the Blues slider to the left and your dreary sky turns bluer. If that didn't get you enough blue (or you just didn't like the brand of blue it gives), double-click on the slider to reset it to zero, and then click on the Basic icon (the first icon on the left, beneath the histogram). Drag the Vibrance slider to the right to make any blues in the sky much more vibrant. Okay, lastly, if there isn't any blue in your sky, try this: click on the Adjustment Brush (**K**; it's the sixth tool from the right) in the toolbar, then in the panel on the right, scroll down to Color, and click once on the white box to its right (it has an X through it, indicating that no color has been chosen). Clicking this brings up the Color Picker. Choose the blue color you want for your sky (actually, choose a little bit darker blue than you think you'll want because you'll only get a tint of it), then click OK to set your color to that blue. Now, just paint right over your sky in that blue (as shown above). When you're done, click on that blue color swatch to bring the Color Picker back up, lower the Saturation amount to 0 (that resets the color to "none"), and click OK. Otherwise, that blue stays on all the time.

How Do I... Fix Red-Eye?

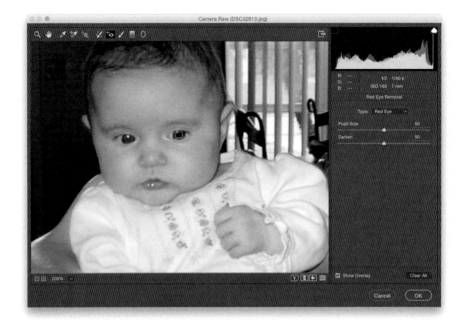

While there's a Red Eye tool in Photoshop, once again, I prefer to do this in Camera Raw. So, go under the Filter menu and choose **Camera Raw Filter**, then get the Red Eye Removal tool (**E**; it's the fourth tool from the right—its icon looks like a creepy eye) from the toolbar up top. Now, click-and-drag this tool right over the entire eye where the red appears, and it'll place a selection over the red area. There are two controls over in the panel on the right: one is for choosing the size of the pupil (if you need to make it larger), and the other lets you darken the pupil if the default doesn't make it dark enough. Also, if the square needs to be moved or resized over either of the eyes, you can click-and-drag it to move it, or drag a side or corner to resize the square. That's pretty much all there is to it. Also, if you want to fix pet eye (that scary look animals sometimes get when they're possessed), choose **Pet Eye** from the Type pop-up menu at the top of the panel, instead.

How Do I... Remove Spots or Distracting Stuff?

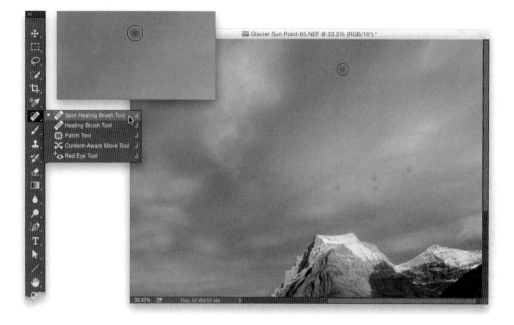

If it's just a spot or a speck or something small like that, get the Spot Healing Brush tool from the Toolbox (**J**; its icon looks like a Band-Aid with a half-circle on the left side), make the brush size just a little larger than the spot or thing you want to remove (use the **Left and Right Bracket keys** on your keyboard [to the right of the letter P] to resize your brush), then just click once and it's gone (as shown above). You don't need to paint a stroke usually—just click once. Of course, if it's something longer (like a crack in a wall), you can paint a stroke. If you want to remove something that's straight (like a power line), then click on one end of the power line, press-and-hold the Shift key, then click on the other end, and it will paint a stroke in a perfectly straight line between the two and remove the power line altogether. *Note:* There are two Healing brushes—the Spot Healing Brush and the Healing Brush. Switch to the Healing Brush **(Shift-J)** when you feel you need to choose the spot (sample area) Photoshop uses to fix the problem area. For example, if you're retouching someone's face, where the tool chooses to sample skin from matters because people's skin goes in different directions on their faces, but the Spot Healing Brush doesn't know that. So, sometimes the results look funky. Just switch to the regular Healing Brush (its icon has no circle on the left—it's just a Band-Aid), then Option-click (PC: Alt-click) on a clean, nearby area of skin, so you know it's sampling texture from a good place.

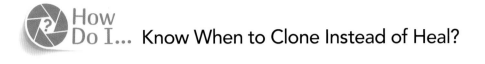

How Do I... Know When to Clone Instead of Heal?

The Healing Brushes work best when what you want to remove is more like an island—it's not touching the edge of anything else. That's because where it touches the edge, it tends to smear (that's why it works so well for blemishes and spots—they are like islands). Let's say, for example, you want to remove a power line. When it touches a power line pole, it's going to smear there for sure, so what I do is switch to the Clone Stamp tool **(S)** and clone away a little part of the power line manually (press-and-hold the Option [PC: Alt] key, click once in the sky near the power line, and than paint right over it and it clones that piece of sky over the power line). This creates a little break on this end of the power line. Do the same thing on the other end of it—create a little break in the line, so there's a gap on each end. It's no longer touching anything because you made those gaps. Now, you can use the Healing Brush tool to quickly get rid of that power line without worrying about any smearing. Another time you'd want to use the Clone Stamp tool is when you need to cover something by repeating something else. For example, if you wanted to repair a wall on an office building and wanted to cover the area with a window, you'd Option-click (PC: Alt-click) on the window to sample it, move your cursor where you want a clone of that window to appear (over the area you want to repair or hide with a window), just start painting, and it paints a window. The Clone Stamp tool is great for repeating patterns or duplicating stuff, like painting nice green grass over a brown patch or painting more hair over a bald spot (not that I would ever do that. Ever. Nope. Not me). The Healing Brushes are for getting rid of stuff.

How Do I... Reduce Noise?

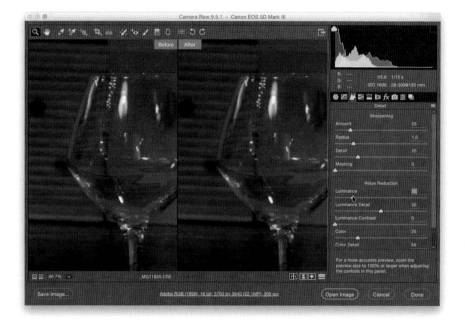

If you shot in RAW format, your absolute best results come from reducing noise while the image is in Camera Raw (while it's still an actual RAW image, not applying it later as a filter to the 8-bit or 16-bit regular Photoshop image). So, click on the Detail icon (it's the third one from the left) under the histogram. In the Noise Reduction section, there are sliders to get rid of the two types of noise: luminance noise (the spots and specks themselves) and color noise (the red, green, and blue specks). The goal is to use as little of an amount of these as possible because noise reduction does its thing by slightly (or majorly) blurring your image to hide the noise. So, zoom in a bit, so you can see the noise, then drag the Luminance or Color slider to the right until the noise is reduced to an amount that lets you sleep at night (knowing full well that the only people in the world that actually care about noise on any level are other photographers). If, after increasing the amount of luminance or color noise reduction, you start to lose detail or contrast in your image, then you can drag the Detail or Contrast slider to the right to help bring some of those back. But, if you find yourself using the Detail or Contrast slider, know that you probably dragged the Luminance or Color slider too far in the first place. Just sayin.' Also, if the noise is just in one area, try this: Get the Adjustment Brush **(K)**, click twice on the + (plus sign) button to the right of the Noise Reduction slider (to set it to +50 and reset all the other sliders to 0), and then paint over just that area. That way, you don't slightly blur your entire image to fix a problem in just one area (see Chapter 4 for more on this).

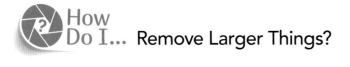

How Do I... Remove Larger Things?

If the thing you need to remove from your image is much larger than a speck, maybe something like a sign, there's a tool or two for that. First, try Content-Aware Fill and see how that works: Get the Lasso tool **(L)**, put a selection around the thing you want to remove (make the selection a little larger than the object—it needs to be a loose selection, not tight right on it), then go under the Edit menu, and choose Fill. In the Fill dialog (seen above left), choose **Content-Aware** from the Contents pop-up menu and click OK. If the fix doesn't look good, undo it **(Command-Z [PC: Ctrl-Z])** and try this: Get the Patch tool from the Toolbox (press **Shift-J** until you have it; it's nested with the Healing Brushes [see above center] its icon looks like a patch). It works kind of like the Lasso tool, so draw a lasso-like selection with the Patch tool around the thing you want to remove. Then, take the Patch tool, click inside the selection you just made, and drag it to a clean nearby area in your image. Release your mouse button, and it removes the object (usually rather well, I might add). The success of this tool is really based on where you dragged that selection to. If you picked a good, clean, nearby area with similar texture, it works really well. If you can't find a clean area that large, it might be…well…kind of a mess. In that case, you'll have to go "old school" and get the Clone Stamp tool **(S;** seen above right) and manually clone over it with stuff nearby (Option-click [PC: Alt-click] on a clean nearby area and start painting that area over the thing you want to remove). It takes longer, and requires a bit more care, but if you're patient and use a small-sized brush, there's just about nothing you can't remove—it just takes time.

How Do I... Cover Up Stuff I Don't Want Seen?

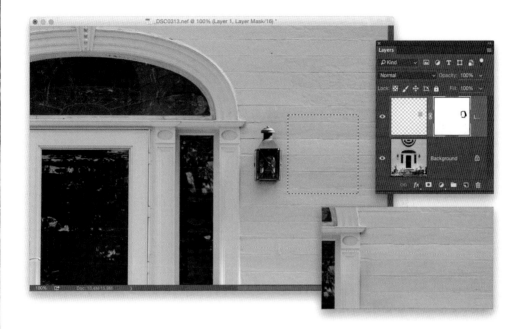

Of course, it depends on what you want to hide, but there are a couple of ways. One is to the use the Clone Stamp tool **(S)** to clone a copy of something nearby right over the thing you want covered up. You Option-click (PC: Alt-click) in a clean, nearby area to sample that area, then start painting over what you want to remove, and it paints the sampled area over it. Another way is to select a piece of the image and use it to cover that area. For example, if you wanted to cover a sconce on a wall, you can put a lasso or rectangular selection around a nearby piece of wall a little larger than the sconce (as seen above; I always say "nearby," so you choose a place that has similar lighting and texture). Then, go under the Select menu, under Modify, and choose **Feather**. Enter 10 pixels to soften the edges of your selected area (so it blends in better), and then press **Command-J (PC: Ctrl-J)** to put a copy of that selected area up on its own layer above your current layer. Now, get the Move tool **(V)** and align that copy over the sconce on the wall, so you're covering it with more wall (as seen in the inset above). The feathering should help it blend, but if you still see an obvious edge on this copy then try this: click on the Add Layer Mask icon at the bottom of the Layers panel, get the Brush tool **(B)** and choose a soft-edged brush from the Brush Picker up in the Options Bar, then paint in black over the edge until it's gone and it blends in with the rest of your image.

How to Make Beautiful Prints

Here's How It's Done

When does an image become real? This is a deeper question than it sounds because when you think about it, our images are trapped behind a sheet of glass. We can't touch them. We can't hold them. We can just look at them trapped behind these sheets of glass on our computers, and so even though we know they exist, they don't seem real. That's because they're not real. Yet. To bring your image to life, you have to print it. Once you print it, you can touch it, you can feel it. It's real at that point, and once something is real, it's going to start asking you for things, like an allowance, and wanting to stay up past its bedtime, and to eat pie after 10 p.m. (which is strictly forbidden in our household, although I have always felt this was a cruel and arbitrary rule). Anyway, once you give a print "life," you'll undoubtedly wind up with some Dr. Frankenstein complex, and it won't be long before villagers will be outside your photography studio with torches and pitchforks because, honestly, that's how these things usually go down, and there's nothing you or I or the ghost of Mary Shelley can do to stop it. You might as well just give the villagers what they want, which is unfettered access to the HBO GO app and a handful of Capri Sun juice pouches. That's it. Give it to them and they're on their way to the next studio. Anyway, this chapter is about how to make beautiful prints (which you probably figured out from the title, "How to Make Beautiful Prints"), but I think it bears repeating since there's still a little room left before I reach the bottom of this page, and we're almost there so if I can just stretch this out for a few more words...there. Got it.

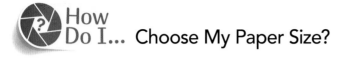

How Do I... Choose My Paper Size?

Press **Command-P (PC: Ctrl-P)** to bring up the Photoshop Print Settings dialog. In the Printer Setup section (in the top right), you'll see a pop-up menu where you can choose the printer you want to print to, and right under that (to the right of the field where you choose how many copies to print), you'll click on the Print Settings button. This brings up your OS Print (PC: Printer Properties) dialog (shown in the bottom right above), where you can choose your size from the Paper Size pop-up menu. (*Note:* I use Canon printers with a Mac, but if you have a different brand, or use a PC, the dialog will have the same basic functions, just in a different layout, or with a slightly different name.) You're only choosing the size of the paper here, not whether you're going wide or tall at this point, so just choose the overall paper size and click Save (PC: OK). That returns you to the Photoshop Print Settings dialog where you started. Now you can choose your orientation (wide or tall) by clicking on the tiny icons to the right of Layout (the icons have a little person posing in front of a tall page or a wide page). Click on the one you want and your orientation is set for the page size you chose (you'll see the print preview on the left side of the dialog update when you make these choices, so you can see if the setup looks right).

How Do I... Set My Page Margins?

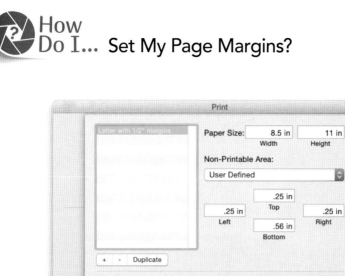

To set your printable area, press **Command-P (PC: Ctrl-P)** to bring up the Photoshop Print Settings dialog, then click on the Print Settings button, in the Printer Setup section, to bring up your OS Print (PC: Printer Properties) dialog. (*Note:* I use Canon printers with a Mac, but if you have a different brand, or use a PC, the dialog will have the same basic functions, just in a different layout, or with a slightly different name.) From the pop-up menu where you choose your paper size, choose **Manage Custom Sizes (PC: User Defined)**. This brings up a dialog where you can type in your margins and even a custom paper size. However, before you do anything, click on the little + (plus sign) button near the bottom-left corner, so you can save the changes you're about to make (you're creating your own custom page size and layout, so this is important). It's going to base this new custom size and layout on whatever you had selected last as your paper size, so if you chose the standard 8½x11" letter size, then that's what it inputs in this dialog for you. Of course, you can change it by typing different dimensions in the Paper Size fields up top. Anyway, once your paper size it correct (and, as I said, it may already be correct), then just enter the margins you want for your custom page. When you're done, *don't* click OK yet. First, go to the list of custom pages on the left side of the dialog, double-click directly on the last one in the list (or the only one in the list), and change the name from "Untitled" to something more descriptive (like "Letter with ¼" margins"), and then click OK. Now, that is saved as a custom preset size you can choose any time from the Paper Size pop-up menu. Pretty handy, eh?

How
Do I... Sharpen for Print?

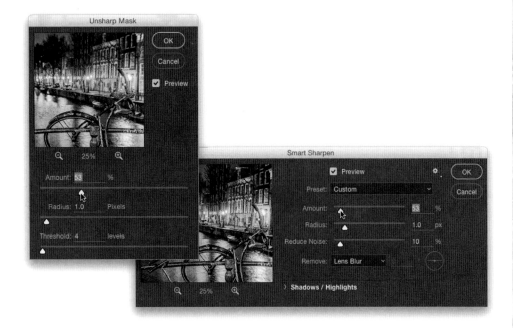

The real secret to sharpening for print is to oversharpen the print using either the Unsharp Mask filter or the Smart Sharpen filter (the sharpening algorithm is actually better in Smart Sharpen, but for some reason everybody still likes using the old Unsharp Mask filter that's been in Photoshop since version 1.0. Few people actually use Smart Sharpen, even though most Photoshop users acknowledge it's better). Anyway, when you get the sharpening looking just right onscreen, that's only good enough for onscreen viewing—it's just not enough for printing. You lose a lot of that sharpness in the transition from your screen to ink and porous paper, so you need to oversharpen for it to look the way you want it to. Here's what I do: If I'm using the Unsharp Mask filter or the Smart Sharpen filter (both found under the Filter menu, under **Sharpen**), I drag the Amount slider to the right until I can see I've gone a little too far, and it starts to look crunchy onscreen. I don't back off, I stop right there when I know it's too sharp onscreen and probably just about right for print. Once you do this a few times, you'll start to learn exactly how far you can push that Amount slider and still get really great-looking sharpness in your prints. Before you do this print sharpening, you might want to duplicate the image first (go under the Image menu and choose **Duplicate**), then do the sharpening, and save the image with the word "Print" at the end of its filename. This way, you'll know this is the copy that you oversharpened for printing, and you'll still have the original image that was sharpened for screen.

How Do I... Get the Best Results from My Printer?

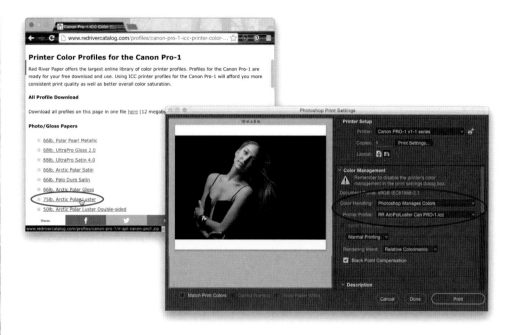

To get the best results, you'll need to find and install an ICC printer color profile for the exact printer you'll be printing to (make and model), and the exact type of paper you'll be printing on. Luckily, paper manufacturers make these color profiles available for free, so all you have to do is visit their website, download the profile, install it in Photoshop (it's simple), and choose the profile when it's time to make your print. Your results will be a lot better because everything is now tuned to the exact printer and paper combination you're using. Here's what to do: Start at the paper company's website (I like RedRiverPaper.com), search for "color profiles," and they'll take you to their color profiles downloads page (in the case of Red River Paper, they take you to a profile locator where you choose your printer brand and model from some pop-up menus, and they take you to a list of free color profiles by type of paper for your exact printer. But, all the sites essentially do the same thing). Here, I clicked on their 75lb. Arctic Polar Luster paper and it downloaded immediately (in a folder with the profile and instructions. It also included a link showing how to install the profile in Mac OS X or Windows, along with a video that shows you exactly where to install it. It's a total no-brainer to install these profiles, you just have to know exactly where to install them, which is why they made those videos). Once installed, you choose this ICC color profile in the Photoshop Print Settings dialog (press **Command-P [PC: Ctrl-P]**): under Color Management, choose Photoshop Manages Colors from the Color Handling pop-up menu, then choose the profile from the Printer Profile pop-up menu, and you're all set.

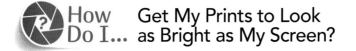

How Do I... Get My Prints to Look as Bright as My Screen?

Since our computer screens are backlit, and paper is not, your prints are generally always going to look darker on paper than they did onscreen. But, of course, we've worked hard to get it looking right onscreen. So, here's what to do to match the brightness: Press **Command-J (PC: Ctrl-J)** to duplicate the Background layer, then at the top of the Layers panel, change this new layer's blend mode from Normal to **Screen**, which makes the entire print much brighter (too bright, in fact). Next, lower the Opacity of this Screen layer to 20%, then make a test print and match the brightness to your screen and see if that's about right. If it's still too dark, try setting the Opacity to 25% and do another test. It might take a few tries, adjusting the opacity each time, to get it perfectly dialed in, but it will be worth it to know the exact amount to get your image's brightness onscreen and the image on paper to perfectly match up.

TIP: IF YOUR COLOR IS OFF, CALIBRATE YOUR MONITOR
Getting the brightness to match is pretty easy (as you just learned), but getting the color spot-on will take buying a hardware-based screen calibrator that measures your screen information and builds a custom profile to match your printer. If your color is way off, it's probably because your screen profile is way off, and the only real way to get there is to buck up and buy a real hardware calibrator. You don't have to spend a bundle (try either the Datacolor Spyder5EXPRESS or the X-Rite ColorMunki Smile).

How Do I... See a Proof Before I Print?

Customize Proof Condition

Custom Proof Condition:	Custom ⌄
Proof Conditions	
Device to Simulate:	RR ArcPolLuster Can PRO-1.icc ⌄
	☐ Preserve RGB Numbers
Rendering Intent:	Relative Colorimetric ⌄
	☑ Black Point Compensation
Display Options (On-Screen)	
☑ Simulate Paper Color	
☑ Simulate Black Ink	

OK
Cancel
Load...
Save...
☑ Preview

You can get a reasonable preview of how your image might look in print using a particular color profile by creating a soft proof. This is an onscreen preview you can see before you print, so you don't waste a bunch of ink and paper. You create a soft proof by going under the View menu, under Proof Setup, and choosing **Custom**. This brings up the Customize Proof Condition dialog, where you can choose which device you want to simulate (you want to simulate printing to your printer, using the ICC color printer profile you down-loaded from your paper manufacturer [as seen above]—see page 175 in this chapter for how to find and install one). Next, choose the Rendering Intent (I always choose Relative Colorimetric, as it seems to provide the best results), then leave the Black Point Compen-sation checkbox turned on (it should be on by default), and then turn on the Simulate Paper Color checkbox. Click OK, and you'll now see a kind of yucky gray preview that, if it actually looked like this, nobody would ever print anything ever. But, luckily, it's overcompensating, and your print won't look nearly this awful. So, what you're seeing is only kinda, sorta, a little bit helpful in some way to some people somewhere, how-ever I find it just about useless and never use it myself (hey, do you want the truth or do you want me to pretend this is good?). Still, some people swear by soft proofing, but I would hate to see their images (just kidding. It's a joke. Etc.). Anyway, at least you know how to use it, and I hope you find it much more useful than I do.

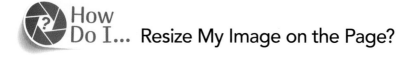

How Do I... Resize My Image on the Page?

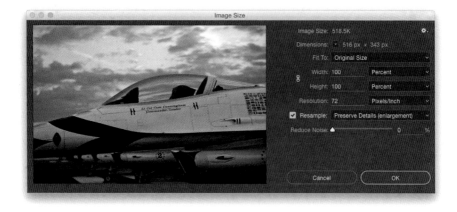

You can resize your image right in the Photoshop Print Settings dialog itself by grabbing a corner handle around the image in the preview window, and just dragging in or out to the size you want. That being said, I would only do it this way when making the image smaller in size (which increases the resolution of the image, which is fine and dandy). I would never ever do this for increasing the size, because just clicking-and-dragging an image to make it much larger will make it soft, blurry, and pixelated. If you need your image bigger on the page, you need to make it bigger before you reach this dialog. Here's what I recommend: Go under the Image menu and choose **Image Size**. When the Image Size dialog appears, first click on the bottom-right corner of the dialog and drag it out, so the preview window on the left is pretty large (you're going to need to see the results clearly). Now, turn on the Resample checkbox (if it's not already on), and then choose **Preserve Details (Enlargement)** from the pop-up menu to the right. This option uses the latest math to let you increase the size of your image, without it getting nearly as blurry or pixelated as clicking-and-dragging it to make it bigger does. Next, go up to the Width and Height fields and either type in your larger desired measurements, or what I usually do is choose Percent from the pop-up menus to the right. You can then enter a percentage of enlargement, like 100, 200, but I don't go higher than 300% (you need specialized software for enlargements bigger than that, if you want to keep the quality intact above 300%). This will give you much better results for enlarging your image for print.

How Do I... Add a Stroke Border Around My Image?

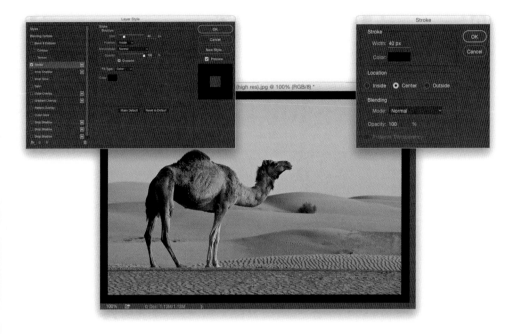

You do this outside of the Photoshop Print Settings dialog, so hit the Cancel button, if you have it open. Now, there are a couple of ways to do this: If the image you want to add a stroke border to is on its own separate layer, then you can click on the Add a Layer Style icon, at the bottom of the Layers panel, and choose **Stroke**. When the Layer Style dialog appears (seen above left), set the Size and Color for your stroke, and I recommend setting the Position to Inside, so your stroke stays nice and sharp. Click OK, and it puts a stroke around your image on that layer. Another method you can use, if your image is on its own layer, is to go to the Layers panel, press-and-hold the Command (PC: Ctrl) key, and click directly on the layer's thumbnail to put a selection around your image. Then, go under the Edit menu and choose **Stroke**. When the Stroke dialog appears (seen above right), choose how thick you want it and the color you want. I recommend setting the stroke Location, here, to Center, then click OK to apply a stroke around your image on that layer, and press **Command-D (PC: Ctrl-D)** to Deselect. If your image is not on a layer (it's on the flattened Background layer), get the Rectangular Marquee tool **(M)** from the Toolbox and drag out a selection around it, then just do the second method I mentioned above.

How Do I... Create a Fine-Art Print Border?

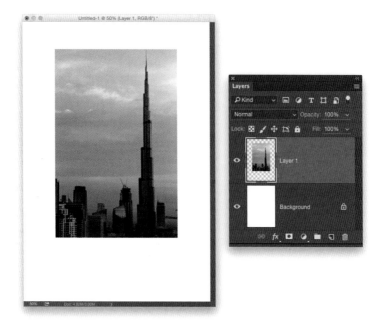

The trick to creating a fine-art print border is simply to position your image on the page so that there's a lot of empty blank space below it. Here's how I do it: First, create a blank document at the size and resolution you'd like. For this example, let's create a 13x19" tall print. So, press **Command-N (PC: Ctrl-N)** and create a new document at that size and, for printing, I use a resolution of 240 pixels per inch. Next, open the image you want to print, press **Command-A (PC: Ctrl-A)** to select it, and then press **Command-C (PC: Ctrl-C)** to Copy it. Go back to the new document and press **Command-V (PC: Ctrl-V)** to Paste the image into the 13x19" document. The image appears on its own layer, above the Background layer. Now, get the Move tool **(V)** and position it so there is a border on the top, left, and right sides. To get it to the size you want, press **Command-T (PC: Ctrl-T)** to bring up Free Transform, then press-and-hold the Shift key (to keep things proportional), click on one of the corner points, and drag inward to shrink the size down until there's an equal amount of space on each side of the image and a lot more space below. To get that empty space below, you might have to shrink the image size down 20% or 30%, but to get the fine-art poster look, you'll need to leave a lot of room at the bottom. If you really want to emphasize the look, I often see (and have done myself many times) a horizontal image used in the top third of a tall document. That leaves plenty of room if you want to add some text below your image and still have lots of blank space for that airy gallery look (see the next page for more on this look).

How Do I... Add My Logo to My Print Layout?

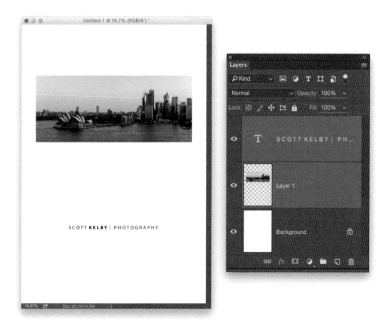

Adding your logo to a print is as simple as opening the logo, pressing **Command-A (PC: Ctrl-A)** to Select All, then copying-and-pasting it into the image where you want it to appear. Once it's in that document, it will appear on its own layer. You can reposition it on the page using the Move tool **(V)**, and you can resize it using Free Transform (press **Command-T [PC: Ctrl-T]**). Just make sure you press-and-hold the Shift key when you resize it, so it stays proportional.

How Do I... Choose My Print Resolution?

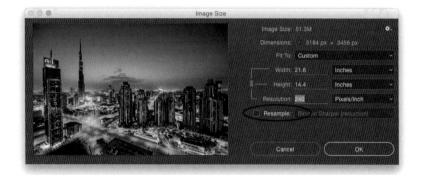

Press **Command-Shift-I (PC: Ctrl-Shift-I)** and choose the print resolution for your image in the Image Size dialog's Resolution field. If you took your image with any of today's digital cameras, or even a recent smart phone, you probably have more than enough resolution to print a pretty large image without a problem whatsoever, without doing a thing (you can at least probably print up to 16x20". Heck, I can print images larger than that taken from my iPhone). Okay, that being said, the target resolution we're usually shooting for—for a typical color inkjet printer—is 240 pixels per inch. Now, if you open the Image Size dialog, it's likely that in the Resolution field, you'll see 72 Pixels/Inch, and you'll think this isn't nearly enough to make a good-sized print. But, to actually see how large a print you can make, turn off the Resample checkbox near the bottom of the dialog, and then type 240 in the Resolution field. Look at your height and width—it now shows you the largest native size you can make your image at a resolution of 240 pixels per inch (by the way, the changes you just made did not affect the quality of the image whatsoever). You can actually print much larger than that using the image size trick I showed on page 178, but that gives you an idea of the minimum native size you can print to without doing any Photoshop acrobatics at all.

How Do I... Let My Printer Handle Everything?

If you don't want to get all involved in your color management for your print, you don't have to—you can have Photoshop tell your printer to take over all the color management duties itself. Now you won't have to worry about color profiles or paper profiles or really pretty much anything outside choosing the paper size and orientation. Just press **Command-P (PC: Ctrl-P)** to bring up the Photoshop Print Settings dialog, and from the Color Handling pop-up menu (in the Color Management section), choose **Printer Manages Colors**, and off you go. (*Note:* Once you choose this, you might need to click on the Print Settings button in the Printer Setup section, and make sure your printer's color management is turned on, as well.) Now, I will say this: years ago, I never would have told you to ever let the printer manage the color—never—but today's printers have gotten so darn good that they actually don't do too bad a job when you choose Printer Manages Colors. I actually know a number of pros who now go this route and are perfectly happy with the results. That should give you some idea of how far this printing technology has actually come in the past few years.

How to Edit Video

It Does It Better Than You'd Think

If you're thinking, "What?! Photoshop can edit video?!" Well, actually not only can it edit video, it does a pretty decent job of it to boot. Well, from a photographer's standpoint, it does just what we need it to do—it puts video clips and stills together on a timeline, it lets us add background music and even a voice-over on top of that if we'd like, it lets us use simple transitions, and it's a great tool for doing things like making short wedding videos, or making a quick promo for your studio, or even a 30- or 60-second commercial for a client. What it's not great for is making a major motion picture, and while it's true that the 2015 Hollywood hit movie *Bridge of Spies* (starring Courteney Cox and Carrot Top) was edited entirely using other much more expensive software, they certainly could have chosen to use Photoshop to edit the movie. Of course, if they had chosen to go that route, it wouldn't have been nominated for an Academy Award for Best Picture (like it was in 2015) because it still wouldn't have been released— while Photoshop is well-suited to editing short videos, if you tried to edit a major motion picture (or even *Hot Tub Time Machine 2*), you would become suicidal during just the opening title sequence because…well…it just ain't made for that stuff. I guess, technically, you could make a bunch of mini-movies, all as separate documents, and then somehow try to copy-and-paste it all together. But, the director of *Bridge of Spies* is Steven Spielberg, and I have a feeling that after watching you stumble around trying to make it all work within Photoshop, not only would he fire you, but he would get your whole family simultaneously fired from their jobs, too. Before long, you'd be back to editing short wedding videos, just trying to feed everybody, so why don't you save us all a lot of aggravation and just let Mr. Spielberg choose which video editing program to use. See, was that so hard?

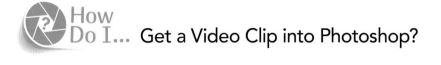

How Do I... Get a Video Clip into Photoshop?

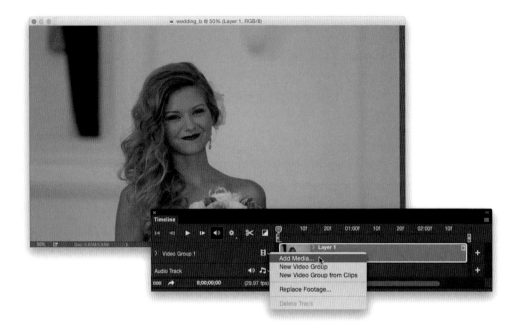

You open your first video clip one way, but you add more clips in a slightly different way. Luckily, to open the first video clip in Photoshop, you do it the same way you do any other file: choose **Open** from the File menu, then choose the video clip, click the Open button, and it opens right into Photoshop. When you open a video clip, it automatically opens the Timeline panel across the bottom of the screen (this is pretty much command central for video editing in Photoshop). You'll see your clip appear on the right side of the panel (movies are put together going from left to right, so the first video clip you see on the left plays first, then when you add a clip to the right of it, it plays next, and so on). To add a second clip (and any other clips you want added to this particular movie), click-and-hold on the little filmstrip icon that appears just to the left of your first video clip in the panel and choose **Add Media** from the pop-up menu that appears. Select the video clip you want to appear next in your movie, click the Open button, and now that clip appears right after your first video clip. To see your very short movie, tap the **Spacebar** on your keyboard and it starts playing (you'll see the little playhead and video scrubber line—it's that red vertical line—moving right along with where you are in the movie). It'll play through the first clip, followed by the second clip, and so on. (*Note:* If pressing the Spacebar doesn't start your movie, click on the little line icon at the top right of the Timeline panel and, from the flyout menu, choose **Enable Shortcut Keys** to turn on your shortcuts for the panel.)

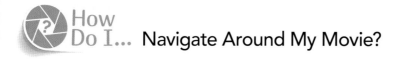

How Do I... Navigate Around My Movie?

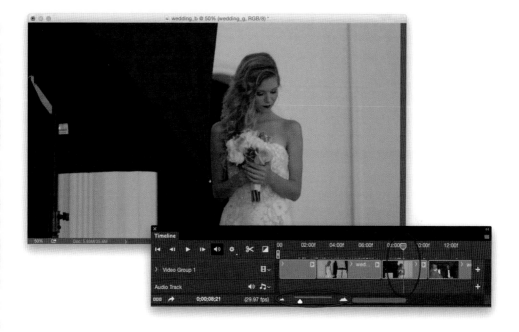

In the top left of the Timeline panel, you'll see the standard icons for navigating around your movie (Rewind [Go to First Frame], Rewind [Go to Previous Frame], Play, and Fast-Forward [Go to Next Frame]). To the right of those controls, there's a little speaker icon for hearing or muting your audio (that wins the "obvious, duh!" award of the week, I know). As you add more clips, they automatically appear in the timeline in the order you added them. Before long, your timeline can grow off to the right side, and you'll find yourself scrolling to the right and back quite a bit. You can actually control the size of your timeline using the little slider right under your first clip (seen circled above; it has little mountains on the left and bigger mountains on the right). Give that a slide back and forth, and it will become immediately obvious what it does. If you hit Play right now, you'll see the playhead and vertical scrubber line (also circled above) moving right along with your movie down the timeline. Wherever that playhead is, that's where your movie is (it's kind of like that little info bar you see at the bottom of your screen when you watch a pay-per-view movie). What's nice is that you can click-and-drag that playhead manually to any spot you want in your movie (and you'll wind up doing this a lot). So, if you wanted to see a particular clip in your movie, you'd drag that playhead to the clip you wanted to see, and then you'd either click the Play icon and it would start playing from there, or you could just "scrub through it" manually by dragging the playhead at any speed you wanted.

187

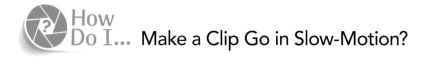

How Do I... Make a Clip Go in Slow-Motion?

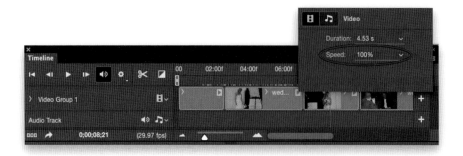

On the right side of each clip in the timeline, you'll see a little right-facing triangle. Click on one and it brings up a settings dialog where you can type in a speed for that clip. Use a number lower than 100% for a slow-motion effect or higher than 100% to speed up the clip (ideal if you wanted to zoom through a clip where people were walking from one place to another in your video).

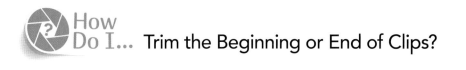

How Do I... Trim the Beginning or End of Clips?

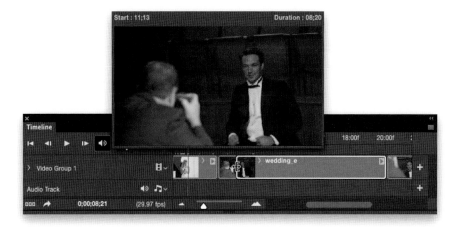

Move your cursor directly over the left or right edge of any clip in the timeline, and you'll see it change into what can best be described as a "capital E, with a double-headed arrow in the center." When you see that, click-and-drag in the direction you want to trim the clip. The nice thing is, as soon as you start dragging, a little preview window pops-up right onscreen, so you can see what you're editing. That way, if you have something at the beginning of your clip that you don't want seen in the video (perhaps you walking back into position after starting the video camera on a tripod), just click right on that left edge of the clip, and drag to the right until you're past that part. When you let go of your mouse button, that part is now hidden. *Note:* If you decide you want that trimmed area back for some reason, just click on that edge, drag it back out to the left, and it reappears. Same thing for trimming the end of a clip—click on the right edge, start dragging to the left, and a preview window pops up as you drag. When the stuff you don't want seen is no longer visible, just stop dragging. That's it.

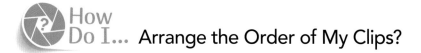

How Do I... Arrange the Order of My Clips?

It's a drag-and-drop thing: you can click on any clip in the timeline and drag it before or after any other clip (as seen above at the top), but sometimes this is a little tricky to do—especially if some of the clips you're dragging-and-dropping are short. That's why I recommend doing this dragging-and-dropping in Photoshop's regular ol' Layers panel (as seen above at the bottom). That's right, the clips are all in the Layers panel, just like if you were making a multi-layered document. The order is the same here as it would be with regular images—whatever is on the bottom of the layer stack is the first clip in your movie, whatever is right above that is the next clip, and so on—and changing the order here is a lot easier. Of course, you can use whichever method you like—they both work fine—but I thought you should know about both, so you can use whichever one you're most comfortable with. Plus, I got to introduce you to the idea that your video clips wind up stacked in the Layers panel, because this will come into play in a different way later in this chapter, so it's a good thing to know now.

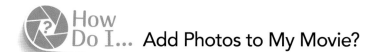

How Do I... Add Photos to My Movie?

You add photos the same way you would add another video clip: click-and-hold on the little filmstrip icon to the left of your first clip in the timeline and, from the pop-up menu that appears, choose **Add Media**. Now, just select a photo, click Open, and the photo will insert itself at the end of the timeline. You can then drag-and-drop it wherever you'd like it to appear in the timeline, or if you want to do it the easy way, just drag-and-drop it in the Layers panel. Now, when your photo appears in your movie, by default, it appears for a very short time, but you can have it stay onscreen for as long as you'd like by clicking-and-dragging on the right edge of the purple clip that represents it in the timeline (video clips appear in blue in the timeline; photos appear in purple. This just helps you keep visual track of what's what). Just drag that right edge out as long as you'd like it to run (a pop-up appears showing how long the duration will be as you drag; as seen above at the top).

How Do I... Add Transitions Between Clips?

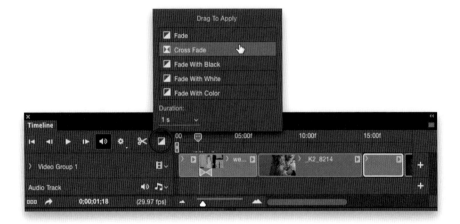

Right above the little filmstrip icon in the Timeline panel (the one to the left of your first clip, where we click to open more clips or photos) is the Transition icon (circled above; it looks like a square with a diagonal line). Click on it and a pop-up dialog appears with your transition choices. To add one of these transitions between two clips, just click on the transition and drag-and-drop it between any two clips (try Cross Fade, which is like the standard dissolve you'd normally use between two still images in a slide show). Now, to see how it looks, drag the playhead to the first of the two clips you just dragged that transition to, then hit Play. Now, instead of just a hard cut between the two clips, you see a smooth blend (dissolve) between them. If you look at the second of the two clips in the timeline, you'll also see a rectangular box with an X inside it has been added to the bottom of that second clip. That represents the transition. If you want the transition to be longer, click on that little X box (it highlights), then click-and-drag the right edge of that transition out to the right, and now it will take longer to dissolve (fade) between the two clips. If you want to delete the transition altogether, click on that little X box to select it, then hit the Delete (PC: Backspace) key, and it's gone. *Note:* When you choose a transition from that pop-up dialog, you can also choose its duration before you drag-and-drop it into the timeline—you'll see a Duration field at the bottom of the dialog where you can type in, in seconds, how long you want that particular transition to be between the two clips.

How
Do I... Add Background Music?

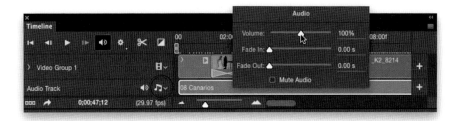

In the Timeline panel, right under your clips, you'll see an empty track. That's the audio track and, right under the little filmstrip icon (that we use to open more video clips and photos), you'll see a little music notes icon (circled above). Click on that icon, choose **Add Audio** from the pop-up menu, and then choose the audio file you want to use as your background music (Photoshop supports most common audio file formats, from AAC to MP3). Click Open, and that file is added to your audio track (it appears as a green track). Now, if you add a track that's 6 minutes and 23 seconds long, it's going to extend that audio clip out that long. So, if you only planned on having a 2-minute video, you'll need to trim it down just like you'd trim a video clip. In the timeline, scroll all the way to the right until you reach the end of the song, then click on the right edge of the clip and drag to the left until you reach the end of your video (in this case, we're assuming you're making a 2-minute video, so drag it back to the 2-minute mark). This will keep you from having your movie end after 2 minutes, but then the music keeps playing over a black screen for 4 minutes and 23 seconds longer, until the song finally ends (that would be brutal. Or it would be "art." I'm not sure which). By the way, if you wanted to add a narration or voice-over audio track, click on that same music notes icon, choose **New Audio Track**, and then choose your voice-over audio file. Otherwise, if you don't create a second audio track, any other audio you import would just replace your background music track. Lastly, to control the volume of a track, Right-click directly on the green clip and click-and-drag the Volume slider in the pop-up dialog that appears (as shown above).

How Do I... Fade Out My Background Music at the End?

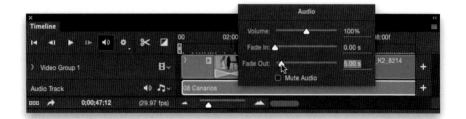

Right-click directly on your green audio track in the timeline, and a pop-up dialog will appear. In that dialog, you'll see two Fade settings: one for fading in your music (if you want that), and one for fading it out, which you'll probably use a lot—unless you happen to pick background music tracks that are the exact perfect length for your video (hey, it could happen). What's kinda weird is you choose how many seconds from the end of the background music track you want the fade out to begin. So, for example, if you wanted it to fade out in the last five seconds of where you trimmed the song, you would drag the Fade Out slider to 5.00 s. The longer you choose, the longer it takes to fade out.

How Do I... Add Titles to My Movie?

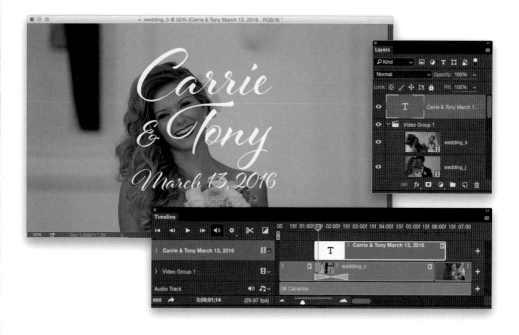

There are two ways to do this: (1) Create a slide with your text already on it, save it, and bring it into your video. Here's how: Press **Command-N (PC: Ctrl-N)** and create a new document that's the same size as your video (in the New dialog, choose your video file from the Document Type pop-up menu to automatically fill in the size), fill it with white or black (or you can open an image and copy-and-paste it into that new document as your background), and then add your text. Choose **Flatten Image** from the Layers panel's flyout menu, save it as a JPEG, then open it into your video, just like you would any other photo (drag-and-drop it in the timeline wherever you'd like it to appear). Now, if you want your text to appear over some moving video, while keeping it editable, then (2) create it right in your video document itself. To do this, you'll use the Horizontal Type tool **(T)**, but you'll notice that when you click the tool and start typing, it adds this text at the end of your video, instead of floating the text over your clips. To make the text float over a particular clip, you'll need to go to the Layers panel, and click-and-drag that type layer out of the video group (it's grouped in the folder called "Video Group 1"). Just click right on that type layer and drag it up and out of that group, and now it appears on its own, floating above your video track. You'll also see this created a new video track above your existing one. You can now click-and-drag this type clip above any video clip in your time-line, and the text will appear on top of the video with a transparent background. You can edit the type any way you want just like it was regular old Photoshop type at this point— change the color, size, font, etc., any way you'd like.

How Do I... Add Filter Effects to My Movie?

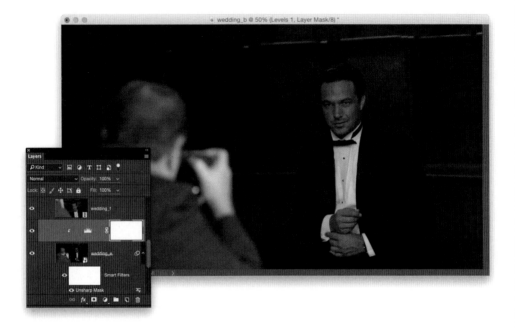

You can add regular Photoshop filters, like Gaussian Blur or Unsharp Mask, to any video clip. You just have to do one simple thing before it lets you do that, otherwise applying a filter will only actually apply it to a single frame of the video clip, not the whole clip. Making this one little move first will apply the filter to the whole clip. So, go to the Layers panel and click on the video clip layer that you want to apply a filter to, then go under the Filter menu and choose **Convert for Smart Filters**. Now, when you apply a filter, it applies it to the entire video clip you selected in the Layers panel (you can see the Unsharp Mask smart filter at the bottom of the Layers panel above). If you want to apply an adjustment instead (like Levels or Curves or Hue/Saturation) to a clip, it's a little different (easy, but you just use a different method). In the Layers panel, click on the layer for the clip you want to add an adjustment to, then click on the Create New Adjustment Layer icon at the bottom of the panel (it's the fourth one from the left; it looks like a half black/half white circle), and choose Levels (or Curves or Hue/Saturation or whatever you want) from the pop-up menu. Now you can make adjustments in the Properties panel that appears (like adjusting the curve or Levels) and that change is immediately applied to just that video clip (I added a Levels adjustment above). You can also add multiple adjustments to this same clip—just choose a different one from the Create New Adjustment Layer icon's pop-up menu, and it stacks right on top.

How Do I... Make a Clip Black and White?

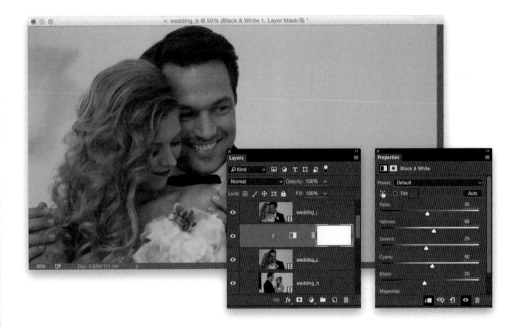

In the Layers panel, click on the layer for the clip you want to appear in black and white. Then, click on the Create New Adjustment Layer icon at the bottom of the panel (it's the fourth one from the left; it looks like a half black/half white circle), and choose **Black & White**. Now, your clip is black and white—it's just that easy. You can make adjustments to this black-and-white conversion using the sliders in the Properties panel.

How Do I... Fade In or Fade Out to Black?

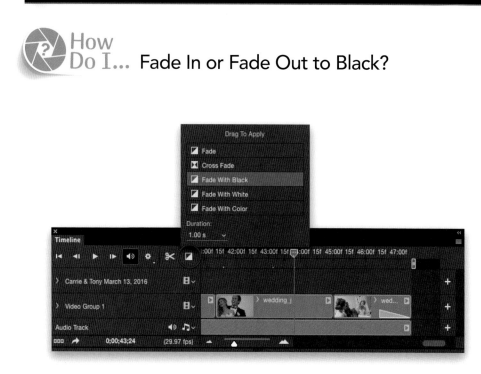

To have your movie fade in from black, click once on the Transition icon (it's just to the right of the little scissors icon, at the top left of the Timeline panel, and circled above in red), and click on Fade With Black in the dialog that pops up. At the bottom of this dialog, you'll see a Duration field. Enter how long you want that fade in to last, then drag-and-drop the Fade With Black transition onto the front of the first clip in your timeline. Now, when you hit Play, your movie will fade in from black. You fade out at the end of your movie pretty much the same way—scroll to the last clip in your movie, click on the Transition icon, click on Fade With Black, choose how long you want to fade out from the Duration field, and then drag-and-drop the Fade With Black transition onto the end of the last clip in your movie (as seen above, where a triangle has been added to the bottom right of the clip). Now your movie will fade out at the end.

How Do I... **Mute the Audio from My Camera's Built-In Mic?**

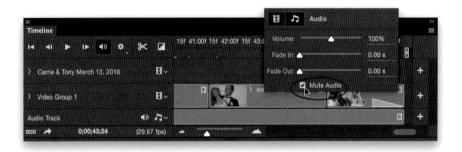

In the Timeline panel, Right-click on the clip that has the audio from your camera's built-in microphone that you want to mute. A dialog will appear with two icons at the top: a filmstrip icon and a music notes icon. Click on the music notes icon and, at the bottom of the dialog, turn on the Mute Audio checkbox. That's it.

How Do I... Split a Clip into Two Parts?

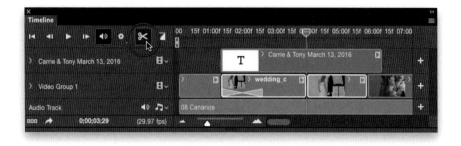

To split a clip into two clips, first click on the clip you want to split in the timeline, and then drag the playhead to the exact point where you want to split it. At the top left of the Timeline panel, click on the Split at Playhead icon (as shown circled above; it looks like a little pair of scissors) to split your clip in two. If you move the playhead now, you'll see the clip has split into two clips right at that spot. Now you can move these two clips independently of each other anywhere you want.

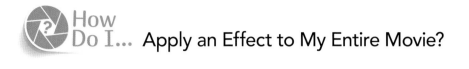

How Do I... Apply an Effect to My Entire Movie?

Earlier, we looked at how to apply an effect to a single clip, but what if you wanted that effect to extend for the entire movie—like having your whole movie in black and white, or having the whole thing look more contrasty, or having a slight warm tint added to it? Then you'd do this: Go to the Layers panel and click on the clip at the bottom of the layer stack (that should be the first clip in your movie). Now, click on the Create New Adjustment Layer icon at the bottom of the panel (it's the fourth one from the left; it looks like a half black/half white circle) and choose **Black & White** from the pop-up menu. That makes just that one clip black and white, but we're about to change that. In the Layers panel, click on the Black & White adjustment layer (it's right above your first layer), and drag it all the way to the top of the Layers panel—above and outside the group folder (just like we did with adding text earlier). By doing this, it applies the black-and-white effect to all of your clips at once, rather than having to do it on a clip-by-clip basis manually.

How Do I... Add Movement to My Still Photos?

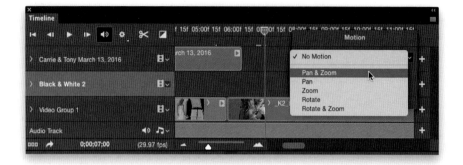

To add a "Ken Burns-like" slow-panning effect to the photos in your video, Right-click on any photo you want to apply this movement to. In the Motion dialog that appears, click-and-hold on the pop-up menu and you'll get a list of movement effects, like Pan & Zoom, Pan, Zoom, Rotate, and so on. Just choose the one that sounds good to you, then click anywhere in your clip to close that dialog.

How Do I... Export My Video?

Render Video

Location

Name: CarrieTonyWedding.mp4

Render

Cancel

Select Folder... Macintosh HD:Desktop

☐ Create New Subfolder:

Adobe Media Encoder ⌄

Format: H.264 ⌄ Preset: High Quality ⌄

Size: Document Size ⌄ 1920 x 1080

Frame Rate: Document Frame Rate ⌄ 29.97 fps

Field Order: Preset (Progressive) ⌄ Aspect: Document (1.0) ⌄

☑ Color Manage

Range **Render Options**

◉ All Frames Alpha Channel: None ⌄

◯ Start Frame: 0 End Frame: 1422 3D Quality: Interactive OpenGL ⌄

◯ Work Area: 0 to 1422 High Quality Threshold: 5

In the bottom-left corner of the Timeline panel, click on the Render Video icon (it looks like a right-facing, curved arrow). This brings up the Render Video dialog (shown above), where you render the final video and save it in a format based on where you're going to be sharing it. At the top, give your movie file a name, and then choose where you want to save it on your computer. In the Adobe Media Encoder section, to the right of the Format pop-up menu, is the Preset pop-up menu, which has a bunch of presets for common types of exporting, like saving for YouTube, or Vimeo, or for exporting to an iPhone or Android device, and so on. The other settings, here, are for more advanced video exporting, so if the rest of these options look like, "What?!" at least you won't feel bad. Okay, once you've selected a preset, click the Render button at the top right, and it starts rendering and exporting your video. Don't be surprised if this takes a while (don't be surprised if it takes 5 or 10 minutes either)—of course, the longer your video, the longer it will take to export. Once it's done, your movie is complete, and now it's time to share it with the world, and sit back while throngs of angry, bitter, disaffected Internet trolls tell you that your video is total rubbish. Or, of course, it could go the other way, and Hollywood immediately contacts you to direct the next *Star Wars*. There's no in-between— it'll be either A or B. I thought you should at least know that up front.

How to Do the Most Popular Special Effects

And Making Stuff Look Cool

If there's one thing that Photoshop is well-known for, it's for creating special effects. Well, it's known for that, and for processing images taken with your camera, and for creating art and illustrations, and for web graphics, and for designing billboards and brochures, and stuff like that. But, sure, special effects, too. Let's go with that. Okay, well here's the thing: lots of programs (like Lightroom, for example) can do basic, even some advanced, image editing, but the mack daddy of special effects is definitely Photoshop. If you want flaming text, where else would you go? That's right—it's a P-thing. See what I did there? Just now. That's right, I just coined a cool new phrase—"P-thing". (Slang for "Photoshop Thing".) Now, all I have to do is use it a whole bunch of times on Snapchat or Wishbone or some other app disaffected teens use, and then it will "go viral." Everybody will be using it, and once you hear Beyoncé say it, then it becomes official. Maybe she could look at someone's photo on Instagram, maybe a Kardashian or two, and she could be all catty and reshare their photo with a caption saying, "That's a P-thing," implying that the image was highly retouched in Photoshop. See, this is exactly how things go viral. You're getting the inside track on all this, which is the subject of my next book (well, it is now) on how to make up your own slang words, and then make them go viral. Chapter 1 will be: "Get Beyoncé to Say It." Chapter 2 will be: "Get Taylor Swift to Use It in a Song Lyric." Chapter 3 could be: "Making Sure It's Not Already in the Urban Dictionary Meaning Something Startlingly Naughty, of Which There Is a 73% Chance That It Is There, and It Means Something Like That. Or Worse."

How Do I... Create a Lens Flare Effect?

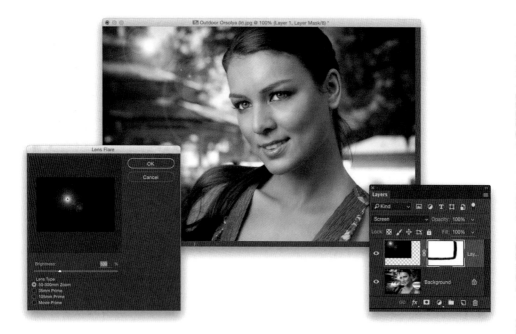

Add a new blank layer by clicking on the Create a New Layer icon at the bottom of the Layers panel. Press **D** to set your Foreground color to black, then press **Option-Delete (PC: Alt-Backspace)** to fill this layer with black. Next, go under the Filter menu, under Render, and choose **Lens Flare**. When the dialog appears (seen above left), you can mess around with the settings if you like, but the default settings are probably the best. So, at this point, just click OK and it applies a lens flare to the black layer. Now, to get that lens flare to blend into your image, go to the top of the Layers panel and change this black layer's blend mode from Normal to **Screen**, and the lens flare becomes part of your image. You can reposition your lens flare using the Move tool **(V)**, but depending on how you reposition it, you might see a hard edge along one or more sides. If that happens, click on the Add Layer Mask icon at the bottom of the Layers panel (it's the third one from the left), get the Brush tool **(B)**, choose a large soft-edged brush from the Brush Picker up in the Options Bar, and then paint in black over the hard edge to blend it.

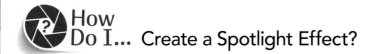

How Do I... Create a Spotlight Effect?

There are two ways to do this, and the one I use most often is this (which we also looked at in Chapter 4): Go under the Filter menu and choose **Camera Raw Filter**. Click on the last tool in the toolbar at the top—that's the Radial Filter **(J)**. In the Radial Filter panel on the right side of the window, click on the – (minus sign) button to the left of the Exposure slider four times. This resets all the other sliders to zero, but lowers (darkens) the Exposure to –2.00. At the bottom of the panel, make sure Effect is set to Outside, and then click-and-drag the Radial Filter over the part of the image you want to have a spotlight effect added to. As you drag, it creates an oval shape, and because you chose Outside for where the effect is applied, everything outside that oval is darkened by 2 stops (–2.00), and it creates that spotlight effect. To resize the oval, click-and-drag any of the little control handles on the top, bottom, or sides of it. To rotate it, move your cursor just outside its border, and it changes into a double-headed arrow. Now, you can just click-and-drag up/down to rotate it. The other method for creating a spotlight effect is to open an image, then go under the Filter menu, under Render, and choose **Lighting Effects**. This adds a spotlight effect, but the default one is pretty bad. I recommend going up to the Presets pop-up menu (in the left side of the Options Bar), and choosing **Flashlight**. Once it appears over your image, you can click-and-drag the spotlight where you want it. To change the size, click-and-drag the outside circle. To change the brightness (intensity) of it, click-and-drag around the white part of the inside circle.

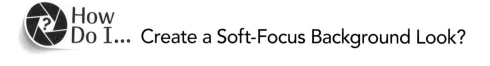

How Do I... Create a Soft-Focus Background Look?

Go under the Filter menu, under Blur Gallery, and choose **Iris Blur**. When you do this, it creates a large oval in the center of your image with a slight blurring outside the oval. To resize the oval, click-and-drag on the edge of it. To move it, click on the pin in the center and drag it where you'd like it. To rotate it, move your cursor near one of the control points on the oval, and it changes into a double-headed arrow. Now, you can just click-and-drag up/down to rotate it. You can increase the amount of blur by going to the Blur Tools panel (which now appears on the right side of your screen) and dragging the Blur slider to the right (or just click on the white part of the ring around the pin and drag). This is kind of designed to emulate the soft-focus, shallow depth-of-field from shooting a telephoto lens with a wide aperture (creating a bokeh effect when you have bright areas in the background). Because of that, in the Effects panel (which also appears on the right), you can control the brightest out-of-focus areas, as well as the color of the bokeh and range of light where it appears. Drag the Light Bokeh slider to the right a bit, and you'll instantly see how it affects the bright areas in the blurred background area. I normally don't mess with these sliders, but it's nice to know they're there...ya know...just in case.

How Do I... Create a Tilt-Shift ("Tiny Town") Effect?

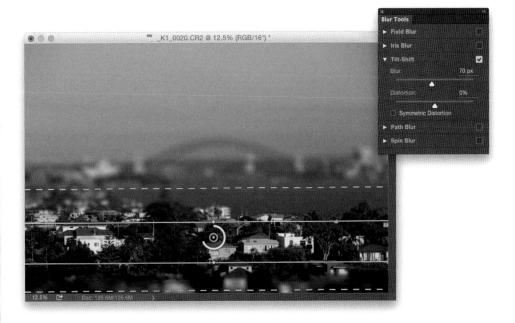

Go under the Filter menu, under Blur Gallery, and choose **Tilt-Shift**. This brings up the Blur Tools panel on the right side of the screen, and you'll see four horizontal lines appear over your image. The area inside of the two solid lines in the middle is sharp, the two dotted lines on either side are transition areas where it blends from sharp to very blurry, and everything outside those dotted lines is very blurry. The area inside these lines is where the effect is most visible, but for this effect to work, honestly, it really depends on the type of image. The images that seem to work best (and make the scene look most like a toy model) are those that were taken from a high vantage point, looking down into a town or scene. With that type of image, it usually looks really good. You can increase the intensity of the effect by going to the Blur Tools panel and dragging the Blur slider to the right (or just click on the white part of the ring around the pin in the center and drag). You can rotate the lines by moving your cursor near a control point on one of the solid lines, and your cursor will change into a double-headed arrow. Now, just click-and-drag to rotate. To move them, click on the pin and drag it where you'd like it. To expand the transition area (the area that goes from sharp to blurry), just click directly on the lines and drag in/out.

How Do I... Get a Dreamy-Focus Look?

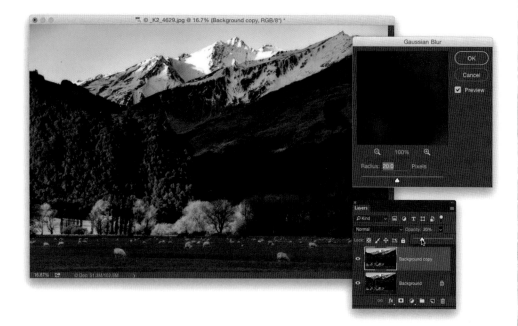

There are a number of different ways to do this, but I'll tell you what I do: In the Layers panel, duplicate the Background layer by clicking-and-dragging it onto the Create a New Layer icon at the bottom of the panel (it's the second one from the right). Then, go under the Filter menu, under Blur, and choose **Gaussian Blur**. When the filter dialog appears, enter 20 pixels, then click OK. Now, go back to the Layers panel and, near the top right, lower the Opacity amount to 20%. This gives you that soft-focus effect without making your image look too blurry.

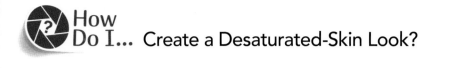

How Do I... Create a Desaturated-Skin Look?

There are a number of different ways to do this, and one way is to first duplicate the Background layer by clicking-and-dragging it onto the Create a New Layer icon at the bottom of the Layers panel (it's the second one from the right). Then, go under the Filter menu and choose **Camera Raw Filter**. In the Basic panel, simply drag the Vibrance slider to the left until the skin looks desaturated. This actually desaturates the color from the entire layer, but that's why we created this duplicate layer before applying the Camera Raw filter. Click OK, and now we can add a layer mask to this layer and just paint the de-saturated look over the subject's skin. So, click on the Add Layer Mask icon at the bottom of the Layers panel (it's the third one from the left), then press **Command-I (PC: Ctrl-I)** to Invert this mask, filling it with black. This hides your desaturated layer behind a black mask. Press **X** to set your Foreground color to white, get the Brush tool **(B)** and choose a soft-edged brush from the Brush Picker up in the Options Bar, then paint over your subject's skin, and it now has the desaturated look. You'll find another way to do this effect on the next page, where we'll look at adding a high-contrast look to your image.

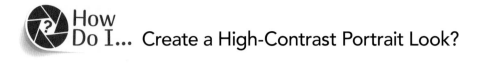

How Do I... Create a High-Contrast Portrait Look?

Duplicate your Background layer twice by pressing **Command-J (PC: Ctrl-J)** twice. You should now have three layers in the Layers panel that all look exactly the same. Click on the middle layer, then press **Command-Shift–U (PC: Ctrl-Shift-U)** to completely desaturate this layer, making it black and white. Of course, you can only see this black-and-white version in the layer's thumbnail because it's covered by another color layer above it. Now, click on the top layer in the layer stack and, near the top left of the Layers panel, change the layer's blend mode from Normal to **Soft Light** to complete the effect. If you wanted to apply this look only on your subject's skin to get another type of the desaturated skin look (like we did on the previous page), then first press **Command-E (PC: Ctrl-E)** to merge the two duplicate layers into one single layer. Press-and-hold the Option (PC: Alt) key and click on the Add Layer Mask icon at the bottom of the Layers panel (it's the third icon from the left), and now the effect is hidden behind a black mask. Get the Brush tool **(B)**, choose a soft-edged brush from the Brush Picker up in the Options Bar, and then paint in white over just the skin areas to apply the desaturated skin look.

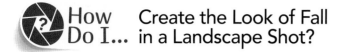

How Do I... Create the Look of Fall in a Landscape Shot?

First, go under the Image menu, under Mode, and choose **LAB Color**. Then, go under the Image menu again, and choose **Apply Image**. When the dialog appears, choose **b** from the Channel pop-up menu, then choose **Overlay** from the Blending pop-up menu, and that creates the fall-look effect. But, you're not done yet. You have to convert your image back to RGB mode, so go back under the Image menu, under Mode, and choose **RGB Color**. Okay, now you're done.

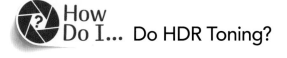

How Do I... Do HDR Toning?

Go under the File menu, under Automate, and choose **Merge to HDR Pro**. Click on the Browse button and find the bracketed images you want to combine into a single HDR image, click Open, and then click OK. This brings up the Merge to HDR Pro dialog (seen above left). From the Preset pop-up menu in the top right, choose **Scott5** (that's a preset I created that Adobe included in Merge to HDR Pro. Yes, I was totally psyched that they asked). This applies an HDR grunge effect to your image, but it's kind of harsh. So, to smooth that harshness, turn on the Edge Smoothness checkbox, then click OK, and it renders your HDR image. Now, this is a bit too "over the top" for most folks, so we're going to take the intensity down a bit. Open the original normal exposure image from your set of bracketed images, press **Command-A (PC: Ctrl-A)** to select the entire image, and then copy-and-paste this normal exposure image on top of your HDR image (it will appear on its own separate layer). Click on the Eye icon to the left of the top layer's thumbnail a few times to turn it off/on to make sure it's aligned perfectly with the layer below it. If the alignment is off at all, Command-click (PC: Ctrl-click) on the Background layer to select both layers, then go under the Edit menu and choose **Auto-Align Layers**. When the dialog appears, make sure Auto is selected, and click OK to have Photoshop automatically align these layers (again, you only have to do this if the layers didn't align perfectly in the first place). The final step is to lower the Opacity of this top layer (usually to around 50%) to add back in some of original realistic look to the HDR grunge effect, which finishes it off.

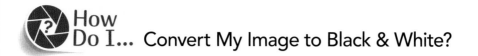 How Do I... Convert My Image to Black & White?

Like with many of the other effects in this chapter, there are a number of ways to convert to black and white (we covered another method for this in Chapter 7), so I'll show you the way I do it: Go under the Filter menu and choose **Camera Raw Filter**. Click on the HSL/Grayscale icon (the fourth one from the left) beneath the histogram, and then turn on the Convert to Grayscale checkbox. Now, click back on the Basic icon (the first one from the left) beneath the histogram to return to the Basic panel—this is where you're really going to make your conversion to black and white sing! To me, what makes a great black-and-white image is lots of depth and lots of contrast. So, what I do here is drag the Contrast slider quite a bit to the right, then drag the Clarity slider a bit to the right, as well, to enhance the texture in the image. Of course, things like adjusting the Exposure and Whites and Blacks settings all depend on the image, but if I know what I'm going for is a very high-contrast look, I know I'm gonna spend most of my time making sure the image looks very contrasty—mostly by using the Contrast and Clarity sliders. But, also by making sure the blacks are deep and rich enough by dragging the Blacks slider to the left until they're good and black.

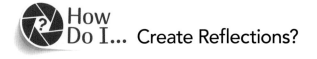

How Do I... Create Reflections?

I'm going to assume that you're doing this reflection effect to a landscape or cityscape photo, but you can also use this on everything from people to products. For a landscape photo, here's what I would do: Get the Rectangular Marquee tool **(M)** from the Toolbox and make a selection that goes from the horizon line all the way up to the top of the image. Now, press **Command–J (PC: Ctrl-J)** to put this selected area up on its own layer. Next, press **Command-T (PC: Ctrl-T)** to bring up Free Transform, then Right-click anywhere inside the Free Transform bounding box and, from the pop-up menu that appears, choose **Flip Vertical** to flip the image on this layer upside down. Press the **Return (PC: Enter) key** to lock in your transformation. Now, switch to the Move tool **(V)**, press-and-hold the Shift key (to keep things perfectly straight as you drag), then click-and-drag this flipped layer down until the top of it touches the horizon line in your original image, and that creates the mirror reflection. That's all there is to it.

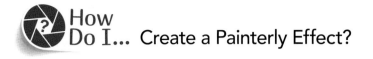

How
Do I... Create a Painterly Effect?

There's actually a filter for this, and you'll find it by going under the Filter menu, under Stylize, and choosing **Oil Paint**. This brings up the Oil Paint filter dialog, but before you start dragging sliders, I would make sure you zoom in on your image, so you can clearly see the effect as you're tweaking it (and before you apply it). To see the effect onscreen as you work in this filter dialog, make sure you turn on the Preview checkbox (near the top right). The rest, as they say, is art! (*Note:* If Oil Paint is grayed out for you, go under the Photoshop menu, under Preferences, and choose Performance. In the Graphics Processor Settings section, click on the Advanced Settings button and, in the dialog that appears, make sure the Use OpenCL checkbox is turned on. If this option is grayed out, your version of OpenCL is not supported to use this filter.)

217

How Do I... Make a Panorama?

Go under the File menu, under Automate, and choose **Photomerge**. In the resulting dialog (seen above right), click on the Browse button and find the individual images you want to combine into one single panoramic image, click Open, and then click OK. As long as you overlapped each individual image by 20% when you took the shots, Photoshop will combine them into a seamless pano. Now, it's very possible that this left gaps on one or more sides of your image. So, the next step is usually to use the Crop tool **(C)** to crop away the gaps. If they're mostly in places like the sky or in grass at the bottom of the image, instead of cropping the image, try this: Get the Magic Wand tool (press **Shift-W**) and click in one of those white gaps to select that area. Now, press-and-hold the **Shift key** and click in any other gappy areas until they are all selected (pressing-and-holding that Shift key is what lets you add to your first selection). Next, go under the Select menu, under Modify, and choose **Expand**. Enter 4 pixels and click OK (this helps set up the next step for greater success). Now, go under the Edit menu and choose Fill. When the dialog appears, choose **Content-Aware** from the Contents pop-up menu, click OK, and either something amazingly good will happen—it fills in the gaps incredibly realistically (using the area around the gaps as a guide of what should fill them in)—or it will be an absolute train wreck. So, all you can really do is undo it by pressing **Command-Z (PC: Ctrl-Z)**, and then go back to the "crop away the gaps" method I mentioned earlier. It's worth trying either way, because you'll be surprised at how well this works a lot of the time, but of course, it just depends on the image.

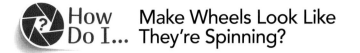

How Do I... Make Wheels Look Like They're Spinning?

There's a filter for that. Go under the Filter menu, under Blur Gallery, and choose **Spin Blur**. This puts a circle shape in the middle of your image and it has basically just one control, but it's a really powerful one. First, you'll need to make sure the circle is sized to the object that you want to look like it's spinning, like a wheel on a racecar or a motorcycle. So, click on the pin in the center of the circle to move it over the object, and then you can click on the edge of the circle and drag to resize it. If you put your cursor near one of the control handles around the circle, it will change into a double-headed arrow, and you can then click-and-drag to rotate the circle. Once it's in place, it's just a matter of moving the Blur Angle slider in the Blur Tools panel that appears on the right side of your screen (or just click on the white part of the ring around the pin and drag), until it looks like it's spinning in the direction you want it. That's it. By the way, this works better than the description sounds.

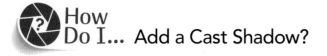

How Do I... Add a Cast Shadow?

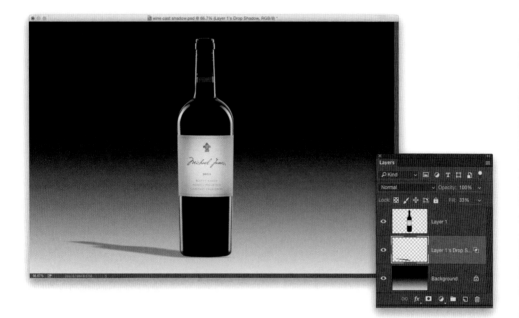

To add a cast shadow, where an object on a layer (or text) seems to be casting a shadow like it's being lit from a late-day sun, try this: After creating a Drop Shadow layer style (we looked at how to do this on page 126, in the Layers chapter), click OK in the Layer Style dialog, then go under the Layer menu, under Layer Style, and choose **Create Layer**. This removes the drop shadow from the current layer it's on and puts it on its own separate layer, so you can edit it separately. In the Layers panel, click on that separate drop shadow layer, then press **Command T (PC: Ctrl-T)** to bring up Free Transform. Once the Free Transform bounding box is in place, press-and-hold the Command (PC: Ctrl) key and click-and-drag the top-center point to the right or left to where you want the shadow to cast. To move the cast shadow, just put your cursor inside that bounding box and drag it where you want it. When you're done, press the **Return (PC: Enter) key** to lock in your transformation. To finish off the cast shadow above, I clicked on the Add a Layer Style icon at the bottom of the Layers panel (the second one from the left), chose **Blending Options**, and then lowered the Fill Opacity to around 30%.

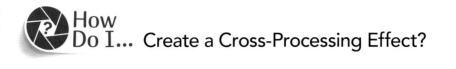

How Do I... Create a Cross-Processing Effect?

If you want the look that everybody's putting on fashion images these days, you can do it easily by applying Camera Raw as a filter (no plug-ins required). Here's how it's done: Open the image you want to use, then go under the Filter menu and choose **Camera Raw Filter**. When the window appears, click on the SplitToning icon (the fifth one from the left) beneath the histogram, to bring up the SplitToning panel. Now, set the Highlights Hue to 70, the Highlights Saturation to 25, the Shadows Hue to 200, and the Shadows Saturation to 25. That's it—you're in business. Okay, that's only one cross-processing look (there are a bunch of them), but that's one of the most popular. To try other looks, just change the Hue settings for the Highlights and Shadows (leave the Saturation amounts where they are). Here are a couple more to try: Set the Highlights Hue to 55, and the Shadows Hue to 165. Or, set the Highlights Hue to 70, and the Shadows Hue to 220. One more: set the Highlights Hue to 80, the Shadows Hue to 235, and then set both Saturation amounts to 35.

How Do I... Add Texture to My Image?

©ISTOCK/DAVID M. SCHRADER

First, open the image you want to apply a texture effect to, then open an image that has the texture you want to use (I generally use very inexpensive stock photography images of things like crumpled paper, old parchment, cracked concrete—you'll find a ton of them for sale cheap. I bought most of mine for $1 each. You can also use free images that you'll find online by searching for "creative commons license + paper textures"). Once you've found one you like, press **Command-A (PC: Ctrl-A)** to select the entire image, then copy-and-paste your texture image into the document with your original image (your texture image will appear on a layer directly above it). The final step to get this texture to blend perfectly with your image is to try out different layer blend modes and see which one looks best. The trick is to press **Shift-+** (plus sign) over and over again, and each time you do, it tries out another blend mode. In just a few seconds, you'll usually find a perfect match (my guess is it will be either Multiply [as seen above], Soft Light, or Overlay, but of course, not always—it just depends on the image). If you find a blend mode that looks good, but the texture is too intense, just lower the Opacity of that layer (near the top right of the Layers panel) until it looks right to you.

How Do I... Create a Duotone Look?

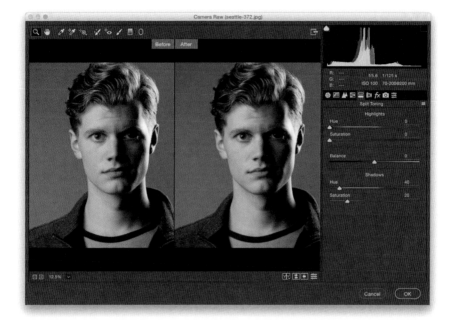

Open the image you want to apply the effect to, then go under the Filter menu and choose **Camera Raw Filter**. When the window appears, click on the HSL/Grayscale icon (it's the fourth one from the left) beneath the histogram and turn on the Convert to Grayscale checkbox to make your image black and white. Now, click on the Split Toning icon (it's the fifth one from the left) beneath the histogram. You're going to input some numbers here, but only in the Shadows section at the bottom of the panel (not in the Highlights section up top, and we're not going to touch the Balance slider either—leave that in the center at zero). Drag the Shadows Saturation slider over to 20, so you can see the color appear, and then drag the Shadows Hue slider to the duotone color you'd like for your image (I usually choose something between 35 and 42 for a warm brownish tone). That's all there is to it! The biggest hurdle is a psychological one—having the discipline not to touch the Highlights Hue and Saturation sliders or the Balance slider. Just move those two Shadows sliders, and slowly walk away.

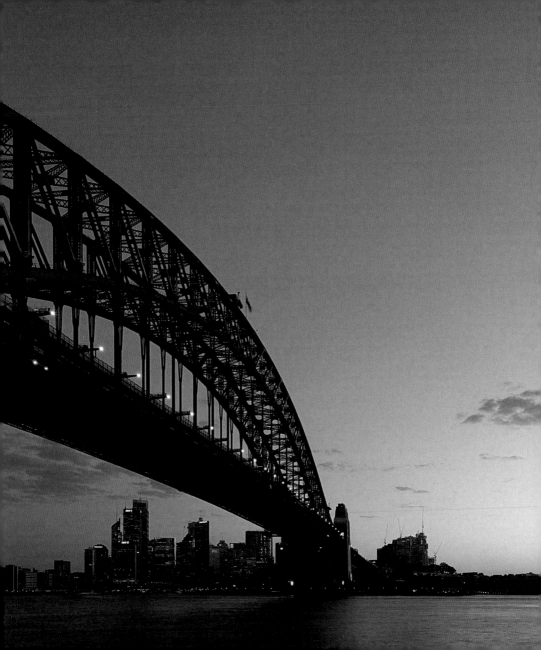

How to Sharpen Your Images

If It's Not Sharp, It's Blurry

You see that line up there that seems totally "duh!"? The subtitle? The one that says, "If It's Not Sharp, It's Blurry"? That seems obvious, but it's deeper than it sounds because lots of people post blurry images, and never thought for a second about sharpening them. That's because they didn't know how to sharpen them, which is a clear failure of the national school system—which for some reason puts academics, and a universal hatred of Facebook by preteens, with a school lunch system that is not only corrupt, but obfuscates the gray line between right and wrong, dodging-and-burning, Bartles & Jaymes, Hall & Oates, and everything we hold dear, from the use of silent letters to requiring a license to go fishing. Sharpening is at the core of all this and, without it, it's like seeing the world through someone else's prescription glasses—they put them on and the first thing they say is, "Dude, you're blind!" Of course, you get all defensive and you're like, "I am not blind. That's just not the right prescription for your eyes." But, they're still like, "I dunno know, dude. I think you better see a doctor. This could be venereal." And, you're like, "Venereal?! Are you out of your mind?" And, they're all like, "Listen, I'm not here to judge, but when someone's eyesight is off by that much, it usually turns out to be from an untreated…." And, you stop them right there with that look that means "this is about to go to fists," and of course, they don't actually want to fight because they clearly need glasses themselves, and probably have depth perception issues. So, you'd be able to easily clock them a good one, and they wouldn't see it coming until it was too late, and then you'd both realize it's all just a "P-thing," and everybody chills. *Note:* Why does "P-thing" sound a lot naughtier here than it did in the last chapter?

How Do I... Do Basic Sharpening?

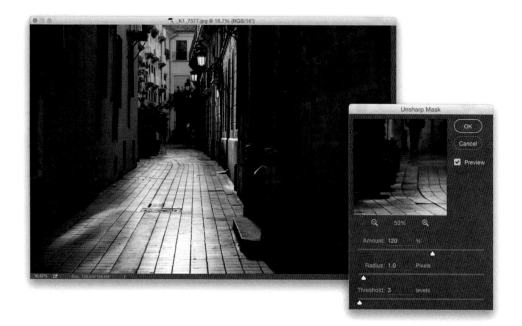

For your average, everyday sharpening, you can use the Unsharp Mask filter. There are actually more advanced ways to sharpen your image, but for some reason this is still the go-to method for many professionals. Go under the Filter menu, under Sharpen, and choose **Unsharp Mask**. When the dialog appears, you'll see three sliders: the Amount slider controls the amount of sharpening applied to your image (I'm sorry I even had to explain that one, but if I didn't, I would get emails asking, "What does the Amount slider do in the Unsharp Mask filter?" I am not making this up). The Radius slider determines how many pixels out from the edge the sharpening will affect, and the Threshold slider determines how different a pixel must be from the surrounding area before it's considered an edge pixel. (*Note:* When it comes to adjusting the Threshold amount, the lower the number, the more intense the sharpening effect.) Okay, now that I've said all that, what settings do I actually use myself for my own work? My go-to sharpening settings for my average, everyday image from my DSLR are Amount: 120%, Radius: 1, Threshold: 3. Hope that helps.

How
Do I... Do Advanced Sharpening?

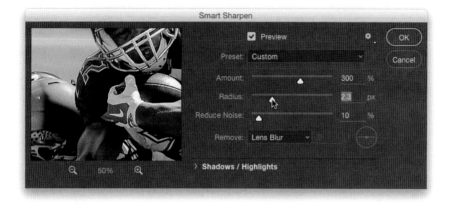

Go under the Filter menu, under Sharpen, and choose **Smart Sharpen**. As the name implies, this is a smarter way to sharpen your image (with new math that's much more advanced than the Unsharp Mask filter, which believe it or not, was in Photoshop version 1.0). The Smart Sharpen filter lets you apply more sharpening with less of the "bad stuff" associated with sharpening (like increased noise, halos that appear around the edges of objects, or little specks or artifacts in the sharpened image). Here's how Adobe recommends you use this filter: First, make sure the Remove pop-up menu is set to **Lens Blur** (so it uses the latest math), then increase the Amount slider to at least 300%, and slowly drag the Radius slider to the right until you start to see halos appear around the edges. When they appear, back the slider off by just a bit (until the halos go away), and you're all set.

How Do I... Sharpen Detail Areas, Like Eyes?

Get the Sharpen tool from the Toolbox (it's nested with the Blur tool), then up in the Options Bar, make sure the Protect Detail checkbox is turned on (so it's using the new math, and by the way, the mathematical algorithm behind this tool is the best sharpening in all of Photoshop). Now, simply paint over the areas you want sharpened. I use this on the irises in portraits and it works wonders. To help you see a before/after, you might want to press **Command-J (PC: Ctrl-J)** to duplicate the Background layer first, then apply the sharpening. You can then click on the Eye icon to the left of the duplicate layer to toggle it off/on, so you can compare it to the original. That way, you don't accidentally overapply it.

How Do I... Do High Pass (Heavy) Sharpening?

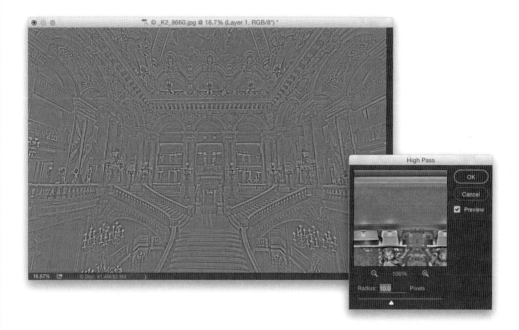

When you want "mega-sharpening," this is the route to go because it accentuates all the edges in the photo, and making those edges stand out can really give the impression of mega-sharpening. Start by duplicating the Background layer (press **Command-J [PC: Ctrl-J]**), then go under the Filter menu, under Other, and choose **High Pass**. Drag the Radius slider all the way to the left (this turns the layer solid gray), then drag it over to the right until you see the edges of objects in the image start to appear. The farther you drag, the more intense the sharpening will be. But, if you drag too far, you'll start to get large, white glows appearing around the edges of stuff, so don't drag too far. Just drag until you see the edges clearly appear, then stop. Now, go to the Layers panel, and change the blend mode of this gray layer from Normal to **Hard Light** for maximum strength (or try Overlay for a less intense effect, or Soft Light for an even lighter effect). This removes the gray from the layer, but leaves the edges accentuated, making the entire photo appear much sharper. If the sharpening seems too intense, you can control the amount of it by lowering the layer's Opacity in the top right of the Layers panel.

How Do I... Do Capture Sharpening?

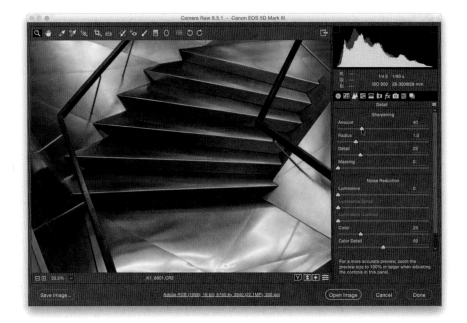

When you shoot in RAW format, you're telling your camera to turn off any sharpening done in-camera. So, by default, Camera Raw applies a little bit of sharpening, so your images don't look like soft bunnies. In Camera Raw, click on the Detail icon (it's the third one from the right) beneath the histogram and, in the Detail panel, you'll see that the Amount is set to +25. For JPEG or TIFF images, it's set to zero because they already had sharpening applied in the camera itself, so it figures those don't need it. Anyway, this is called "capture sharpening," and it's there to bring back some of the sharpness that's lost when you take a photo in RAW format. I feel like that +25 amount is a bit too low, and if you agree, go ahead and crank that up a bit (to at least +35, if not +40), while the image is still in RAW format (before you open it in Photoshop). Capture sharpening is kind of "pre-sharpening"—so, think of it that way—and everything needs a little pre-sharpening, whether you do it in Camera Raw to a RAW image, or in-camera to a JPEG or TIFF.

How Do I... Sharpen Just Specific Parts of My Image?

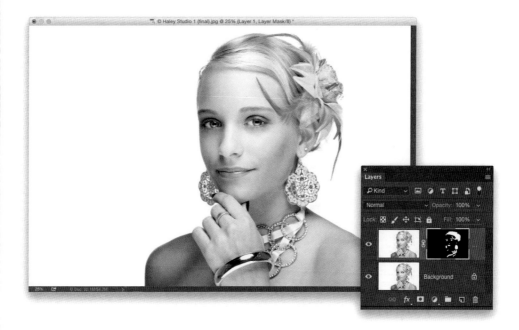

There are three ways, and I covered one already on page 228 (using the Sharpen tool). But, this is probably the way I do it most often: Start by pressing **Command-J (PC: Ctrl-J)** to duplicate the Background layer, then apply your sharpening using whichever filter or method you like best. Now, press-and-hold the **Option (PC: Alt) key**, and click on the Add Layer Mask icon at the bottom of the Layers panel (it's the third icon from the left). This adds a black layer mask over your sharpened duplicate layer. Get the Brush tool **(B)** from the Toolbox, choose a soft-edged brush from the Brush Picker up in the Options Bar, make sure your Foreground color is set to white, and then paint over any areas in your image you want to appear sharpened (I painted over her eyes, eyebrows, lips, hair, and jewelry above). As you paint, you're painting sharpness. Another way do this is to go under the Filter menu and choose **Camera Raw Filter**. When the window appears, get the Adjustment Brush **(K)** from the toolbar at the top (it's the third tool from the right). Then, in the Adjustment Brush panel on the right, click on the + (plus sign) button to the right of Sharpness twice. This resets all the other sliders to zero and increases the Sharpeness amount to +50. Now, just paint over the areas you want to appear sharpened. Once you've done that, you can increase or decrease the amount of sharpening you applied to those areas using the Sharpness slider.

How Do I... Sharpen in Camera Raw?

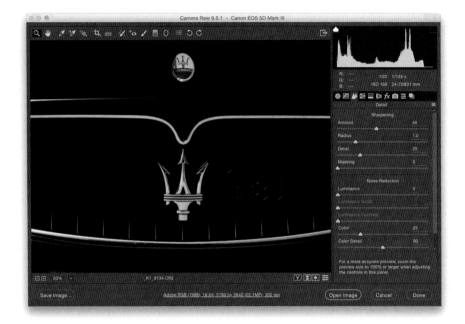

If you want to do all your sharpening in Camera Raw (you don't plan on doing anything in Photoshop—you're going to process your image in Camera Raw, and save it right from there as a JPEG, using the Save Image button in the bottom-left corner), then here's how to do it: First, click on the Detail icon (it's the third icon from the left) beneath the histogram, and you'll see the Sharpening settings at the top of the panel on the right. (*Note:* So you don't oversharpen by accident, I recommend zooming in to at least 50%, if not 100%, so you can actually see what the sharpening is doing.) The Amount slider (obviously) controls the amount of sharpening. The Radius slider determines how many pixels out from the edge the sharpening will affect, and personally, I leave this set at 1. If I need some heavier sharpening, I'll bump it up to 1.2 or 1.3, but that's rare. The Detail slider acts as a halo prevention control, so it lets you apply more sharpening without seeing halos around the edges of objects. I leave it at its default setting of 25 pretty much all the time. The Masking slider lets you control where the sharpening is applied. It's perfect for portraits of women or children, where you want the detail areas to be sharpened, but you don't want to sharpen their skin (I cover this in Chapter 3, so check back there for more on this slider).

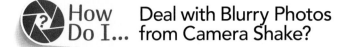

How Do I... Deal with Blurry Photos from Camera Shake?

Open an image that's blurry, and where you feel the blurriness was caused by not hold-ing the camera steady enough when you took the shot in low light (hey, it happens). Then, go under the Filter menu, under Sharpen, and choose **Shake Reduction**. (*Note:* This filter doesn't work if what made your photo blurry was your subject moving when you were shooting in low light.) When the dialog opens, it automatically analyzes your image, starting in the middle (where most blurring occurs), and then it searches outward from there. You'll see a progress bar appear at the bottom of the little Detail Loupe on the right side. Once it's done, it shows you its blur correction, and it either did a pretty good job (it won't be sharp as a tack, but certainly visibly better), or if it didn't really work, it'll seem like it hardly did anything at all. If you think it's "close," then try adjusting the Blur Trace Bounds slider in the top right, or press **Q** to have the Detail Loupe float over your image. You can then reposition it anywhere you'd like, click on the circular button in the bottom left, and it'll analyze the area right under the Loupe. One last thing you can try is expanding the Advanced section and, using the Blur Estimation tool, click-and-drag around areas that you want analyzed (as seen above). For most cases, all I do is open the filter, let it do its thing, and if it looks good, I'm happy. If not, I move the Loupe until I either get better results or I bail on using this filter altogether, because it doesn't always work (hey, at least ya know, right?).

Chapter 13

Other Stuff You'll Want to Know

All That Other Stuff? It's in This Chapter

In every book, there has to be a catch-all chapter. A place where all the stuff that wouldn't fit in any other chapter can live. Maybe it's stuff that actually belongs in another chapter, but maybe the author was too lazy to put the technique where it belongs because he's finally on the last chapter, and books are hard to write. It's a lot of long lonely hours, just you and your friend Jim Beam, throwin' 'em back in a dimly lit concrete room with little ventilation, where your publisher (to protect their identity, we'll call them "Rocky Nook") locks you up until you're finished. Oh sure, you do get one hour a day out "in the yard" to see some daylight and maybe work out, or try to fashion a small shiv out of the bar of soap they give you, small enough to slip inside your belt, so the guards don't find it when you're heading back to the "library," where you create your work for "The Man." By the way, that's how they insist I refer to them (even during contract negotiations), especially when I'm talking to other guys on the outside (authors who finished their books by their deadlines). When they ask how I'm doing, I say stuff like, "Still working for The Man" or "The Man is always watching" or "Why am I always out of soap?" and stuff like that. But, you know it's all good because when you get to that last chapter, even "The Man" wants you to get it done, and he says stuff to you like, "The Man wants you to get it done," and I don't know about you, but when you hear words like that—words you can tell are from the heart—for me, that just makes it all worthwhile (and it makes me feel bad that I shanked one of my editors on visitor's day last month. That cost me two packs).

How
Do I... Troubleshoot Photoshop Problems?

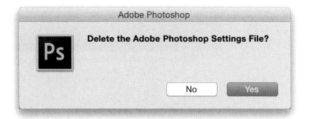

If Photoshop seems like it's not acting right, or something just isn't working the way you know it should, your Photoshop Preferences file has probably become corrupt. Don't feel bad, though, it's not you. This is a fairly common thing that happens, and luckily, replacing these preferences will usually fix about 99% of the problems you might run into. Here's how to do it: Quit Photoshop, then press-and-hold Command-Option-Shift (PC: Ctrl-Alt-Shift) and restart Photoshop. Keep holding down those keys while Photoshop relaunches, and a dialog will pop up onscreen asking if you want to "Delete the Adobe Photoshop Settings File?" Click Yes, and Photoshop builds a brand-new, factory-fresh set of preferences, and that usually fixes whatever Photoshop problems you were having. If for some reason that doesn't work, the next thing you'll need to do (and I hate to tell you this one) is to uninstall and then reinstall Photoshop from scratch. Luckily, with Creative Cloud this is really a pretty easy thing to do. Just run the Uninstall Adobe Photoshop CC application that came with Photoshop CC when you installed it, and that will take care of getting rid of the old copy. Then, go to the Adobe Creative Cloud app, install a fresh new version of Photoshop, and whatever the problem was, chances are it's gone now.

How Do I... Save an Image with a Transparent Background?

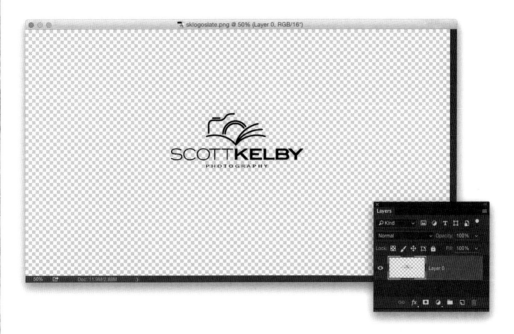

The trick to saving an image with a transparent background (maybe something like your company logo or a graphic) is to put the image on a transparent layer all by itself, and then delete the Background layer by dragging-and-dropping it onto the Trash icon at the bottom of the Layers panel. After you've deleted the Background layer, save this file as a PNG ("ping") file. This is a specific file format that supports transparency in many other programs. You do that by going under Photoshop's File menu and choosing **Save As**. When the Save As dialog appears, from the Format pop-up menu at the bottom of the dialog, choose **PNG**. That's it—now you can open that file into other programs, or even put it on the web, without having a solid, colored background around it. One last thing: For this to work, your image has to be on a layer with a transparent background already. If, when you opened your logo in Photoshop, it had a solid background around it, you'll need to remove that background first. Probably the easiest way to do this is to drag the Background layer's Lock icon onto the Trash icon at the bottom of the panel, then get the Magic Wand tool **(Shift-W)**, click it once in the background area around your logo to select it, then hit the Delete (PC: Backspace) key to remove that background area. If you need to select multiple areas, press-and-hold the Shift key, then click on those areas, and it will add them to your selection to delete. Lastly, if the Magic Wand tool didn't work well for you (hey, it happens), deselect by pressing **Command-D (PC: Ctrl-D)**, then switch to the Quick Selection tool (it's nested with the Magic Wand tool) and paint over that background area to select it. Once selected, hit the Delete key.

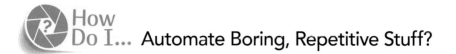

How Do I... Automate Boring, Repetitive Stuff?

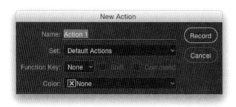

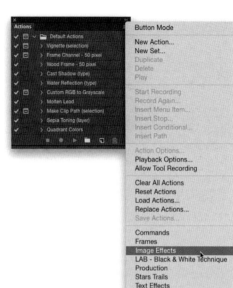

Go under the Window menu and choose **Actions** to bring up the Actions panel. This is Photoshop's built-in tape recorder, where we basically record boring, repetitive tasks, and then have Photoshop automate the process by playing them back for us super-fast. To create a new recording (or action, as it's called in Photoshop), click on the Create New Action icon at the bottom of the Actions panel (it looks the same as the Layers panel's Create a New Layer icon). In the New Action dialog, name your action, then assign a Function Key (F-key on your keyboard) to it, so this repetitive task can launch anytime you press that F-key. You'll notice that this dialog doesn't have an OK button, but instead, has a Record button. When you click that button, it starts recording, and now, as you do things in Photoshop, it records those steps exactly as you do them. When you're done, click on the Stop Recording icon at the bottom of the Actions panel (its icon looks like a square), and then it's a good idea to test the action to make sure it recorded correctly by clicking on the Play Selection icon at the bottom of the panel (it looks just like any other play icon). Now, it's helpful to know that the Actions panel won't record every single thing you could possibly do in Photoshop. For example, it doesn't record brush strokes made with the Brush tool, so it's not really for creating art—it's for automating those boring, repetitive tasks that you sometimes do on a daily basis. By the way, Photoshop comes with a few sets of design actions that you can access from the Actions panel's flyout menu. Click on the little icon in the top right, and you'll see a list of actions you can load at the bottom of this menu (as seen above right).

How Do I... Put a Frame Around My Image?

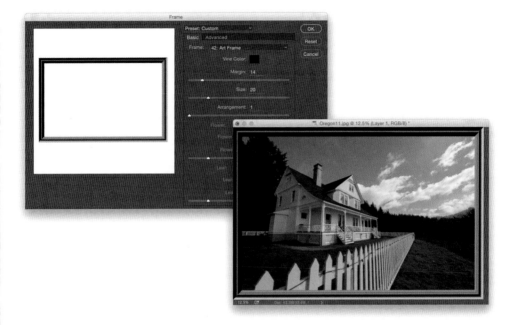

First, create a new blank layer by clicking on the Create a New Layer icon at the bottom of the Layers panel (it's the second one from the right). Next, go under the Filter menu, under Render, and choose **Picture Frame** to bring up the Frame filter dialog. Now, I have to admit, the default frame that Adobe chose here is pretty lame, but thankfully, you're not stuck with it. In the Frame pop-up menu, near the top right, you'll see a whole list of built-in frame choices, from traditional frames towards the bottom (like #42: Art Frame; as seen above) to some funky-looking graphic frames (like #31: Zen Garden). Depending on which frame you choose, you'll either have a lot of options or just a few. These appear right below the Frame pop-up menu, and you can use them to tweak how your final frame looks—you can tweak everything from spacing to color. I hate to say, "Hey, just move the sliders and see what they do," but since there are 40-something frames, and each one is very different, that's kinda what you have to do. Once you have the frame looking like you want it to, click OK and it creates this frame on that empty layer you created. To resize it to fit your image, press **Command-T (PC: Ctrl-T)** to bring up Free Transform. Press-and-hold the Shift key, if you need to resize proportionally, otherwise just click on a top, corner, or side control point and drag in the direction you need it to go to fit your image, then just press **Return (PC: Enter)** to lock in your transformation.

How Do I... Draw a Straight Line with the Brush?

Get the Brush tool (**B**), click once where you want your straight line to start, then click again where you want your straight line to end, and Photoshop will automatically draw a straight line between those two spots (as seen above).

How Do I... Set My Color Space?

If you know the color space you want to use in Photoshop, go under the Edit menu and choose **Color Settings**. In the Working Spaces section (at the top left of the dialog), choose your color space from the RGB pop-up menu. As a general rule, if you work exclusively with Lightroom, then you would set your color space to ProPhoto RGB, so it matches Lightroom's native color space. If you're not working with Lightroom, and you're mostly making prints in Photoshop, then you might want to choose Adobe RGB (1998) as your color space. Finally, if your images are destined for the web, then you might want to work in a color space designed for web browsers, which is sRGB. These are just general guidelines, but if you were looking for some general guidelines, well there you go.

How Do I... Get More Than Just One Undo?

To get more than just one undo (which you get when you press **Command-Z [PC: Ctrl-Z]**), press **Command-Option-Z (PC: Ctrl-Alt-Z)**. Each time you press that, it will go back one step at a time until you reach a maximum of 50 steps of undo. What you are actually doing here is stepping back through your history, which keeps track of each step you do as you do it. You can see a list of the steps by going under the Window menu and choosing **History**. This brings up the History panel, where you can see your last 50 steps (that's the default. You can increase or decrease this number by going under the Photoshop CC [PC: Edit] menu, under Preferences, choosing **Performance**, and then changing the number of History States). To jump back to any one of those steps just click on it in the panel.

How Do I... Use Bridge to Quickly Find an Image or Rename Images?

Since I use Lightroom to manage all of my images, I think of Adobe Bridge as a quick file browser—something I can use when I need to quickly find one or two images inside a folder full of images. Simply drag-and-drop a folder of images right onto the Bridge icon on your desktop and it shows you thumbnails of all of the images inside that folder. To change the size of the thumbnails, click-and-drag the slider near the bottom-right corner to the left/right to make them smaller/larger. To see a full-screen view of any thumbnail, click on it, and then press the **Spacebar**. To return to the thumbnails, just press it again. To open any of these thumbnails in Camera Raw, click on the thumbnail you want to open, and then press **Command-R (PC: Ctrl-R)**. To open any of these images directly in Photoshop, just double-click on a thumbnail. To have Bridge rename your photos, first Command-click (PC: Ctrl-click) on all the photos you want to rename to select them (Shift-click on the images, if they're contiguous, or if you want to rename all the photos in the folder, press **Command-A [PC: Ctrl-A]** to select them all), then go under the Tools menu and choose **Batch Rename**. When the Batch Rename dialog appears, in the New Filenames section, choose the new name you want for your files. Use the + (plus sign) and – (minus sign) buttons to the right of your filename to add and remove fields. For example, you can choose a numeric sequence from the pop-up menu to have it automatically number your images (as seen above bottom). If you want to see a preview of how your new filenames will look when changed, click on the Preview button near the top right (or just look down in the Preview section).

243

How Do I... Save My Selection to Reuse Again?

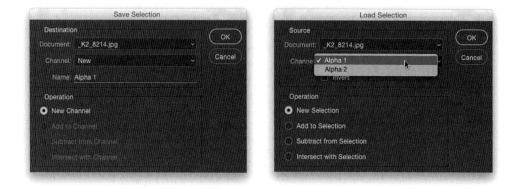

If you make a complex selection, or one that's kind of a pain in the butt to make, you might want to save it, so if you have to bring it back later, you don't have to start from scratch. Once your selection is in place, go under the Select menu and choose **Save Selection**. This brings up a dialog where you can name your selection (seen above left), if you like. If you don't want to name it, it will be named Alpha 1, by default (any others you save will be named Alpha 2, Alpha 3, and so on). Once you save it, you can go and do anything else you want in Photoshop knowing that you can always come back and reload this selection. To reload the selection, go under the Select menu and choose **Load Selection**. When the Load Selection dialog appears (seen above right), choose whichever saved selection you want to load (Alpha 1, Alpha 2, whatever) from the Channel pop-up menu, click OK, and your selection is right back in place. By the way, if you save your file as a PSD (Photoshop's native file format), your saved selection will be saved right along with the file, so you can use it again at a later time. If you save your file as a JPEG, the selection won't be saved with it.

How Do I... Save Images in Multiple Sizes and Formats?

There is a pretty awesome little feature in Photoshop that lets you open a folder full of images and save them into multiple file formats or sizes (just in case you need that). Go under the File menu, under Scripts, and choose **Image Processor**. In the Image Processor dialog, the first thing it wants you to tell it (in section #1) is where the folder of images that you want to process is located. So, do that first by clicking on the Select Folder button. Next (in section #2), choose where you want these new images, in their new formats (or sizes), to be saved (in other words, which folder they should be placed into when it's done doing its thing). In section #3, you get to choose which file formats (and sizes) you want those copies saved as. You can choose to save them as JPEGs, PSDs, TIFFs, or even all three (so it would save three copies of each image in the folder you selected—one in each format). In the last section (section #4), you can type in any copyright information you want embedded into the files and, if you created an action, you can choose to apply it to these images, here. For example, if you created an action that made a watermark, you could apply it automatically on these images as they're processed—just turn on the Run Action checkbox, and then choose the action from the pop-up menus to the right. When you're done making your choices, click the Run button, and it does its thing—and it does it really quickly. When it's done, you'll find a subfolder inside the main folder you chose, with each file format's images inside the proper folder (hey, at least it doesn't just toss them all loose in one big folder, right?).

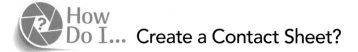

How Do I... Create a Contact Sheet?

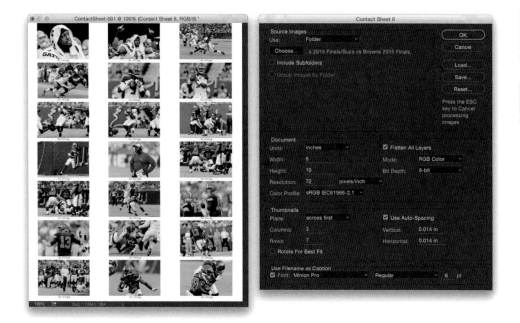

Go under the File menu, under Automate, and choose **Contact Sheet II**. This brings up the Contact Sheet II dialog, where you can choose how you want your contact sheet to look. In the Source Images section, at the top, from the Use pop-up menu, choose if you want to open a folder of images, use images that are already open in Photoshop, or bring over photos from Bridge. In the Document section, choose the size of your contact sheet (this part is kind of like the New document dialog), and then in the Thumbnails section, choose how many rows and how many columns you want. To have your thumbnails automatically spaced, turn on the Use Auto-Spacing checkbox (or you can enter your own settings in the fields below for how you want your thumbnails spaced). If you want to use filenames as captions, at the very bottom of this dialog, you can choose to display those beneath the images by turning on the Font checkbox, and you also get to choose the size and font. When you're done making all those choices, click the OK button and it builds your contact sheet for you automatically.

How Do I... Reduce the Intensity of an Edit?

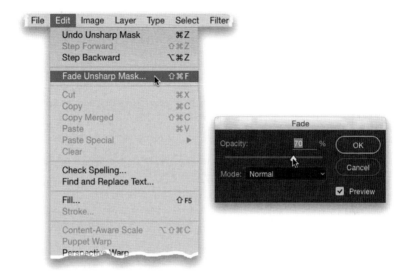

If you've applied a filter (like Gaussian Blur or Unsharp Mask), or maybe even an adjustment (like Levels or Curves), and you think your changes were too intense, you can back those off using the Fade feature. The Fade feature is kind of like undo on a slider. To use it, immediately after you apply a filter or adjustment, go under the Edit menu and choose **Fade**. You'll actually see the name of what you just did appear right after the word Fade in the menu, so if you applied Unsharp Mask, it will read "Fade Unsharp Mask" (as seen above left). Dragging the Opacity slider to the left, in the resulting Fade dialog, lowers the intensity of the filter or adjustment you just applied. *Note:* This Fade feature only works immediately after you apply a filter or adjustment. So, if you decide you want to use it, go use it immediately because if you do even one more thing beforehand—click anywhere or do anything else—the Fade option goes away and it'll be grayed out.

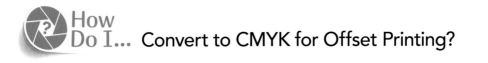

How Do I... Convert to CMYK for Offset Printing?

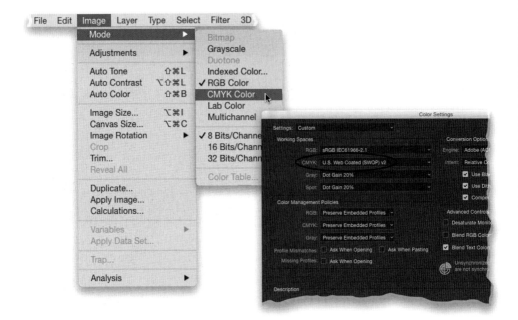

If your image is going to be printed on an actual offset printing press or a web press, you may need to convert the image to CMYK mode first. Photoshop can do this, but before you even consider this, you need to contact the print shop first and ask for their exact CMYK conversion settings. They may even provide you with a downloadable settings file that you can upload into Photoshop, so you can do the conversion exactly to their specs. So, that's Step One: contact the company that's going to print your image and ask them for their CMYK conversion specs. Once you've done that, converting your RGB image to CMYK is really pretty easy. Just go under the Image menu, under Mode, and choose **CMYK Color**. A little warning dialog will appear onscreen letting you know which color profile is being used to convert your image to CMYK. If you want to choose your own CMYK color profile, or input the information you got from your print shop, go under the Edit menu and choose **Color Settings**. In the Working Spaces section, in the CMYK pop-up menu (seen above right), you'll see a list of popular conversions. At the top, you'll see Load CMYK, which is what you would choose if you have the CMYK color conversion profile from the print shop. One last thing, this is only necessary if your image is going to be printed on a printing press—do not do this if you're sending your image to be printed by a standard color printing lab (like Mpix or Millers, etc.).

How Do I... Open My RAW Image in 16-Bit Mode?

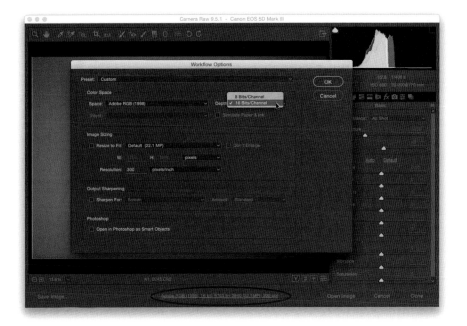

When you open a RAW image from Camera Raw into Photoshop, you'll have the option of opening it in standard 8-bit mode (which is the regular ol' mode for editing images in Photoshop) or in the larger 16-bit color mode. Without going into all the pros and cons (and yes there are both pros and cons, which are argued endlessly on the Internet), here's how to do it: When you're in Camera Raw, at the bottom center of the window, you'll see a list of specs that looks like an underlined web link (circled above). Click on that link and it brings up Camera Raw's Workflow Options dialog. This is where you choose how you'll actually open your images in Photoshop and, near the top right, you'll see a pop-up menu for bit depth. Choose **16-Bits/Channel** from the Depth pop-up menu, click OK, and now your RAW image will open in Photoshop in 16-bit mode. (*Note:* JPEG images are captured in 8-bit mode. So, if you shoot in JPEG, choosing 16-bit mode won't add anything but more file size to your image, so I don't recommend it.) Once you're done editing your image in Photoshop, if you want to convert back to 8-bit mode, just go under the Image menu, under Mode, and choose **8-Bits/Channel**.

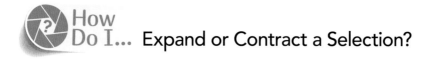

How Do I... Expand or Contract a Selection?

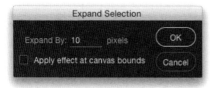 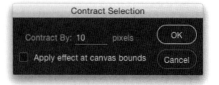

Once you have a selection in place, if you want it to be larger or smaller, go under the Select menu, under Modify, and choose either **Expand** or **Contract**. Enter how many pixels you want to expand out, or contract in, click OK, and you're done. One thing you might notice if you're expanding a selection that is square or rectangular, is that if you use a high number, like 20 or 30 pixels, when it expands, the corners start to get rounded. If you need them to stay nice and straight, instead of using Expand, go under the Select menu and choose **Transform Selection**. Now you can resize the selection, just like you would any other object on a layer using Free Transform, and the edges won't get rounded.

How Do I... Save Files as JPEGs or TIFFs?

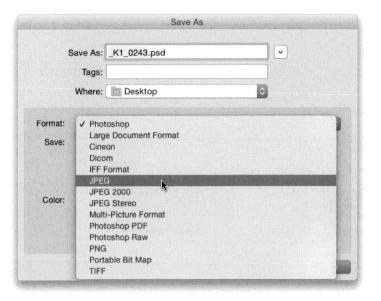

When you're done editing your file, if you want to save it as a JPEG or a TIFF or a PSD (which is Photoshop's native file format, and keeps all your layers intact), go under the File menu and choose **Save As** (or press **Command-Shift-S [PC: Ctrl-Shift-S]**). This brings up the Save As dialog. Just click on the Format pop-up menu, and you will see a whole bunch of file formats you can choose from.

How Do I... Make My JPEGs Automatically Open in Camera Raw?

Go under the Photoshop CC (PC: Edit) menu, under Preferences, and choose **Camera Raw** (all the way at the bottom). When the Camera Raw Preferences dialog opens, near the bottom, you'll see the JPEG and TIFF Handling section. From the JPEG pop-up menu, choose **Automatically Open All Supported JPEGs**, and then click OK. Now, your JPEG images will all open automatically in Camera Raw for processing there first before you open them in Photoshop.

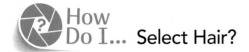

How Do I... Select Hair?

Get the Quick Selection tool **(W)** from the Toolbox and paint over the person's hair, but stop short of painting over the edges of it. So, at this point, just make a very basic selection, avoiding the outside edge areas (that's the tricky part). Avoid selecting any of the background area, as well. Once your selection is in place, go up to the Options Bar and click on the Refine Edge button. When the dialog appears, from the View Mode pop-up menu, choose **Overlay**. This view puts a red mask over the areas that aren't selected, and I think this is the easiest way to work with hair, because you can see what you're doing as you do it. Next, turn on the Smart Radius checkbox, and then drag the Radius slider to the right to around 2.0 px. Now comes the fun part: move your cursor outside the dialog, onto your image, and it changes into a selection brush. Paint over the edge areas of the hair, and it automatically senses where the areas are and makes a selection of those tough-to-select areas. In most cases, it does an amazing job, especially if the person is on a simple background (light gray backgrounds seem to work best, but as long as it's a simple background, it will probably be okay). As you paint along the edges of the hair, you'll see those areas are no longer red and they become the natural color of the image. That lets you know those areas are now added to your selection. If it selects too much, press-and-hold the **Option (PC: Alt) key** and paint to deselect those areas. At the bottom of the dialog is the OutputTo pop-up menu. From this menu, I generally choose **New Layer**, so when I click OK, the selected area is placed on its own separate layer, and I can then easily put a different background behind my subject.

How Do I... Remove Tourists from a Scene?

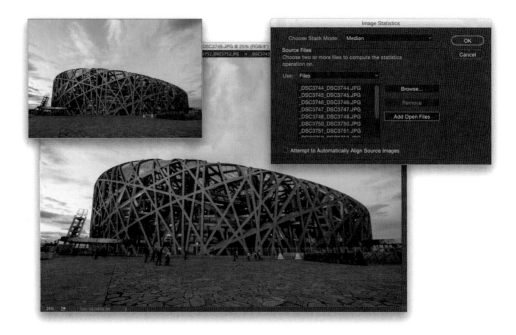

Okay, this is part camera technique and part Photoshop magic, but it's some pretty cool magic I have to admit. It starts with you, ideally, shooting on a tripod, so your camera is perfectly still while you do the camera technique. So, first, put your camera on the tripod, and then take a shot every 10 to 15 seconds. Do this until you have about 10 or 15 images of the scene. Open those 10 or 15 images in Photoshop, so all of the images are open at the same time in different windows (or tabs, if you have this preference turned on). Next, go under the File menu, under Scripts, and choose **Statistics**. From the Choose Stack Mode pop-up menu, at the top of the dialog, choose **Median**. Now, click on the Add Open Files button to include all the 10 or 15 images you just opened. Click the OK button, and Photoshop analyzes the images looking for movement. As it compares all 10 or 15 images, anything that moves gets removed—as long as the tourists are moving through your images, they get removed. If one of your tourists decides to sit down, they'll still be there when the process is done. So, the key is to get everybody to move (and yes, I have had to have a friend go and ask someone to move while doing this technique. But, all I had to do was get them to move just a couple of feet—that was all I needed for it to work, and it did). If it leaves anything behind that you'd like to clean up, just grab the Clone Stamp tool **(S)**, Option-click (PC: Alt-click) on a clean area to sample, and then just clone over what you want to remove.

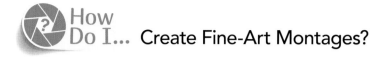

How Do I... Create Fine-Art Montages?

To blend multiple images in kind of a fine-art montage look, first go under the File menu, under Scripts, and choose **Load Files into Stack**. Choose your images, click OK, and each one opens into the same document, with each on its own layer. You could also open each one and copy-and-paste them all into one document, but this is just easier and faster. If you already have the images open in Photoshop, you can still use this script to put them on layers for you. Anyway, once they're all in one document, on their own layers, click on the top layer in the layer stack, then double-click on its thumbnail to bring up the Blending Options in the Layer Style dialog. In the Blend If section, at the bottom of the dialog (seen above left), are two sliders you'll use to create your montage. Now, if you just start dragging, things will look very harsh and jaggy. To get a nice, smooth blend, press-and-hold the Option (PC: Alt) key, and then click-and-drag one of the four slider knobs. This splits the knob in two and makes the transition nice and smooth. Try this technique on each of the layers to create different looks. Different sliders will affect each image in different ways, so it's a great way to artistically create montages on the fly. Also, try this same technique on a type layer, where it works really well for blending text with an image. I often see script fonts used in these montages, especially old-world looking fonts (like Cezanne; seen above), and they look really cool (worth trying, for sure). (*Note:* For my montage above, in addition to using the Blend If sliders, I also used a couple layer masks with gradients, and different layer blend modes and opacity settings to get this look. We looked at all of these in Chapter 6.)

255

Index

DON'T QUIT YOUR DAYDREAM

This is your friendly reminder from the world around you.
You can make something today that didn't exist yesterday.
You can try something that's never been done before or just
try something that you've never done. But just doing something
is the first step toward doing something great. Fuel your creativity.

Image by Frank Doorhof | KelbyOne Instructor
Learn to create like Frank